CW00835815

PAUL NASH

OUTLINE

An Autobiography

PAUL NASH

OUTLINE

An Autobiography

A New Edition

incorporating Margaret Nash's
'Memoirs of Paul Nash, 1913–1946'

Edited and with an Introduction by David Boyd Haycock

LUND HUMPHRIES

This edition of *Paul Nash: Outline, An Autobiography*
first published in 2016 by

Lund Humphries
Office 3, Book House
261A City Road
London
EC1V 1JX
UK

Outline, an autobiography and other writings by Paul Nash with a preface by
Herbert Read first published in 1949 by Faber and Faber Limited

ISBN: 978-1-84822-188-8

A Cataloguing-in-Publication record for this book is available
from the British Library

Designed by Crow Books
Set in Adobe Caslon Pro and Caslon Open Face
Printed in China

DEDICATION
To Margaret 1914–1946

'So are you to my thoughts, as food to life
Or as sweet-season'd showers are to the ground;
And for the peace of you I hold such strife
As 'twixt a miser and his wealth is found:'
SONNET LXXV

Contents

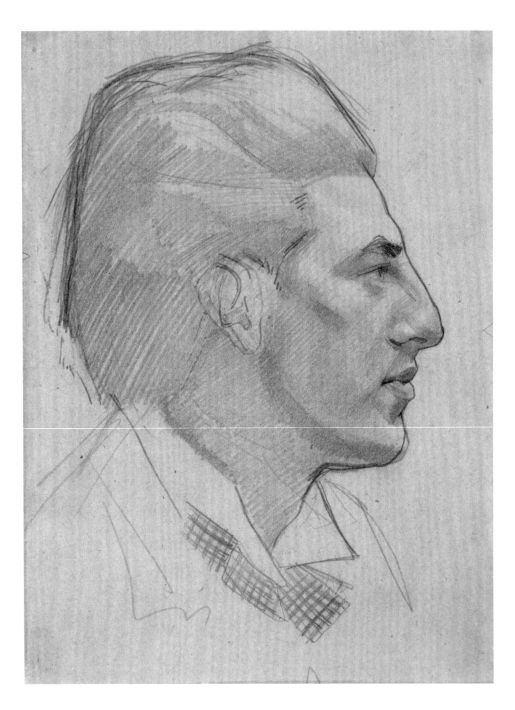

Rupert Lee, *Paul Nash*, 1913, pen and pencil, National Portrait Gallery, London

Author's Preface to the original edition

Since it is impossible to give a full picture of any life by means of an autobiography suitable for publication, I have called this personal history OUTLINE.

But there is another reason. Although it is an autobiography, it aims at telling the story of the development of an artist's life, a development which, on looking back, appears to have a curious 'inevitable' quality, like a line of fate in the palm of the hand.

I do not wish to exaggerate the significance of this impression, or to suggest anything mystical. In writing this slight history I found it could never be forced either in pace or length. For a time it would flow with ease, then, suddenly, or gradually, give out.

After an interval, the 'bounding line', as Blake called it, would again become clear and I could see the way to continue. On these terms I proceeded for a considerable distance and was pausing once more obediently, if impatiently, when my whole vision was eclipsed by the abrupt darkness of the war (1939). For many reasons which it would be tedious to describe, some months passed before I was able to resume. By then I had been given my own particular war job, so that my time for writing was not only difficult to find, but often impossible to use when at my disposal. From all these causes it became clear that if the book were to be published at all it would have to be in two volumes in succession. . . .

PAUL NASH

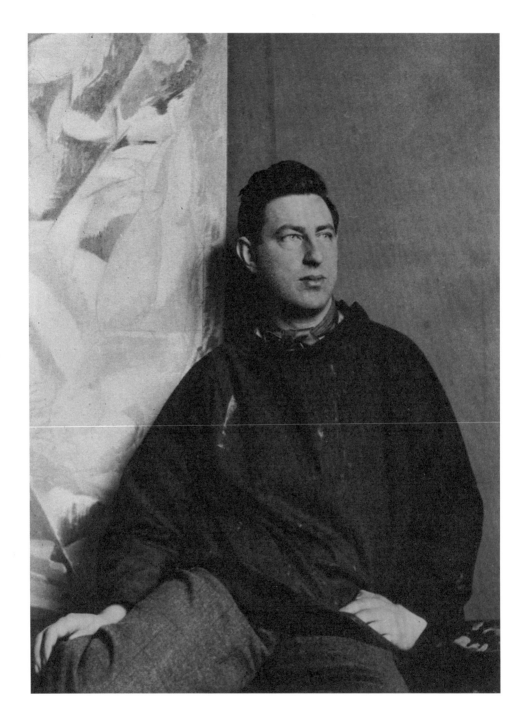

Lance Sieveking, *Paul Nash*, c.1924, photograph, National Portrait Gallery, London

Introduction by David Boyd Haycock

Paul Nash was born on 11 May 1889 in a house (still standing) in Sunningdale Gardens, Earl's Court, London. The son of an affectionate barrister father and an anxious, distant mother, he would grow up to become one of the most significant British artists of the first half of the twentieth century, and *Outline* is one of the finest autobiographies by an English artist of any era. Filled with insights not only into his own childhood, his upper middle-class upbringing in London and Buckinghamshire, and the slow development of his artistic temperament, it is also an account of everyday life growing up in late Victorian and Edwardian England. All is seen and described in the simple but lucid prose of a man who devoted himself to carefully recording and interpreting the world around him, and who humbly placed himself in a line of poet-painters that lead back to Dante Gabriel Rossetti and William Blake.

Throughout the early part of *Outline* Nash draws attention to the importance of particular places – curious corners of the urban parkland of Kensington Gardens, the landscape of southern England where he visited relatives, or the locations of childhood holidays. Indeed, the original title he had in mind for his autobiography was *Genius Loci* – the 'spirit of place'.[1] Equally significant to the story he told, however, were the people he met – first as a child (servants, aunts and uncles, family friends, his paternal grandfather), then as a young man. Nash possessed a remarkable facility for meeting interesting (and sometimes famous) people, and for making friends. A random encounter on a trip to Norfolk, for example, found him swept into the extraordinary home of Conrad Noel, the so-called 'Red Vicar' of Thaxted. Later, as a volunteer with the Artists' Rifles in 1914, he

befriended the writer Edward Thomas, a fellow lover of poetry and long country walks. And so it goes on through Nash's life, a long list of extraordinary encounters, from the talented young students who surrounded him at the Slade School of Art in London – Ben Nicholson, Stanley Spencer, Mark Gertler, C.R.W. Nevinson, David Bomberg, Dora Carrington – to the theatrical genius and important early influence Gordon Craig.[2]

Whilst at points Nash's childhood appears idyllic and almost dreamlike, his account is tinged with more than a little nostalgia. His early life (as he admits) was not without its intense emotional strains – particularly once he started formal education, first at prep school, then at St Paul's School, Hammersmith. 'My liberty had been taken from me,' he would recall. 'In all the years that followed, until I left school at seventeen, I was never free.'[3] The English public school system had a lot to answer for: Nash's exact contemporary, C.R.W. Nevinson, decried the similar impact of his time at Uppingham School, and Nash's plaintive description of his experiences at St Paul's is almost identical with the recollections of Dion Clayton Calthrop, elder brother of Nash's school-friend, the future actor Donald Calthrop: 'It was the first place where my freedom, almost the freedom of my soul, was denied me.'[4] The impact of these early struggles would last a lifetime.

Nash did not excel at school, where his earliest influences and interests were more literary than artistic. He describes his excitement awaiting the next installment of Sherlock Holmes in *The Strand* magazine, and one can easily picture Nash, as child and youth, seeking sanctuary in literature. Formative books included George Borrow's classic 1851 autobiographical novel, *Lavengro: The Scholar, the Gypsy, the Priest*, a Victorian classic that would inspire the subject of one of Nash's early works. Later inspiration would come from poets such as William Blake, Samuel Taylor Coleridge and Lord Tennyson, and it is unsurprising that his first patron (as well as life-long friend and correspondent) was the poet and playwright Gordon Bottomley. Nash's wife, Margaret, would later write that Paul

> would have liked to come up to the University as a young man, and I
> often wish he could have had the opportunity of living in one of the
> stately old Colleges at Oxford, dreaming in the University gardens
> and possibly becoming a writer instead of an artist. Paul had a very
> intellectual makeup and knew a good deal about literature, especially
> about poetry, for he was a constant reader of poetry and of drama, and of
> course he was naturally a good writer.[5]

His decision, aged seventeen, to become an artist of some sort was sudden – his parents had intended a career for him in the Royal Navy, an aspiration annulled by his ineptitude at mathematics. He alludes in *Outline* to the early influence of Edward Lear's 'luminous water-colours' (as well as his nonsense poetry), his infant eyes 'feeding upon them'.[6] There was clearly an artistic streak in the family, for his younger brother, John, also grew up to become a successful artist. Yet as a young art student in London Paul struggled: the critic John Rothenstein would later write of Nash's early 'incompetence at rendering natural appearance' and the 'apparent want of talent and the downright silliness of some of his drawings'.[7] Despite some recognition prior to 1914, Nash stood outside the mainstream of modern British art: he admits in *Outline* that during his early years after leaving the Slade in 1911 he pursued 'a course which seemed hardly connected with the main purpose of contemporary painting in my own country and was drawn by none of the strong Continental currents'.[8] These early works harked back to Rossetti and the Pre-Raphaelites in particular, though their sense of mysticism can also be related to the early death of his mother on Valentine's Day 1910. This significant event is passed over relatively swiftly in *Outline*. 'Often mother seemed disinclined to eat,' he recorded. 'I think she seemed always delicate, subject to headaches and so often obviously worried.'[9] He was with her when she died in London, aged only 50; the death certificate gives 'chronic neurasthenia 6 years', 'extreme emaciation' and 'exhaustion' as the causes – what doctors today would no doubt diagnose as anorexia nervosa.[10] It was around this time that he approached – and met – W.B. Yeats, with the suggestion of illustrating one of his books. Nash had a life-long love of poetry, and the mix of mysticism, lyricism and romanticism inherent in the Irishman's verse was exactly the sort of thing that appealed to his own visionary nature.

John Rothenstein argued that it was the Great War that made Nash a great artist, and it was 1914 that marked the point at which Nash eventually abandoned his autobiography.[11] Ending with the war had by no means been his original intention. When he started work on the narrative of his life in 1936 or 1937 he was an established member of the British avant garde, well known not just for his watercolours, oil paintings and prints, but also for his work as a writer and critic. This included regular essays and articles in the press, *Dorset: Shell Guide*, written under the editorial direction of the poet John Betjeman, and an illustrated collection of poetry, *Places*.[12] He was also vocally involved with Modernist movements such as Surrealism,

and in 1933 he founded the short-lived contemporary art group Unit One, whose members included Henry Moore, Barbara Hepworth and Ben Nicholson. When he started work on *Outline*, he and Margaret were living in Hampstead, and enthusing to his task Nash rose early each morning to write. At first he progressed well, and soon had ambitious thoughts of publishing his memoirs in two volumes.[13] But ever since the end of the war his health had been deteriorating: he suffered increasingly from asthma and a weak heart, conditions which his wife blamed on his inhaling gas whilst serving as an official war artist in Passchendaele (claims that would never be proven). This and the outbreak of the Second World War interrupted his progress, and he found himself struggling to get past 1914. By July 1945, as he entered the final months of his life, Nash was looking back over his artistic career. The early works that John Rothenstein so dismissed were among the highpoints. As he wrote to Gordon Bottomley,

> When I came to look into the early drawings I lived again that wonderful hour. I could feel myself making those drawings – in some ways the best I ever did to this day. And because of this I suddenly saw the way to finish my 'life' ... I feel I could make a complete thing by taking it up to 1914 – just up to the war. After that it was another life, another world.[14]

And that is where *Outline* ends – his last completed chapter is titled 'End of a World'. After that, only brief notes survive.

Nash's story is continued in this volume, however, up to his sudden death in 1946, firstly through a selection of the letters he wrote to his wife, Margaret, during his period of military service in 1917, and secondly through Margaret Nash's 'Memoirs of Paul Nash, 1913-1946'. Written in 1951, and surviving as a typescript in the Tate Gallery Archive, Margaret's account is published here (albeit in abridged form) for the first time. Effectively it completes, through Margaret's eyes, and in her less polished, less poetic and sometimes rather digressive prose, the unwritten second volume of Paul's autobiography. It provides numerous intimate insights into his artistic progress, the many homes and friendships they made together, their frequent travels overseas, and the vicissitudes of Paul's declining health. Though close and passionate in its early years, theirs was not always a happy relationship. In 1925 Margaret suffered a miscarriage which meant that they would never have children. As Nash admitted in *Outline*, 'The question of marriage was the most perplexing ... We should

be tied up, we should be tied down, fidelity would be impossible, boredom inevitable.'[15] Nash's attitude to women was idealistic and romanticized and he had a number of affairs throughout the course of his life.

Paul met Margaret Theodosia Odeh ('Bunty', as he usually called her) in February 1913; within a month they were engaged, and 18 months later, following the outbreak of war, they married. As Paul's description of Margaret in *Outline* makes clear, she was a remarkable woman. Her father, the Reverend Naser Odeh, was Arabian: he had been born in a village just outside Jerusalem, which was then a part of the Ottoman Empire, though he claimed descent from an Irish family that had settled in Palestine after the Crusades.[16] Baptized in the Greek Orthodox Church, as a young man unable to speak English he had travelled to London, joined the Anglican Church, and enrolled at the Church Missionary Society Training College in Islington. Ordained in Jerusalem in 1880, Odeh married Mary Dickson, of Dumfriesshire, in 1884, and Margaret – their only child – was born in Jerusalem in 1886–7. Having spent her early years in Cairo, Margaret returned with her parents to England in the late 1890s; she was educated at Cheltenham Ladies' College and in 1905 went up to St Hilda's College, Oxford, to study for a degree in Modern History.[17] During this time her parents also settled in Oxford, her father giving lessons in Arabic to University students (his pupils included T.E. Lawrence, then an undergraduate at Jesus College).

As one of three women-only colleges in Oxford, St Hilda's had close links with the Women's Suffrage movement. When Margaret first met Paul she was living in London and working for the Women's Tax Resistance League. Paul's close friend, Lance Sieveking, would describe Margaret as 'an intelligent, sympathetic listener' with a vivid personality, instilling into 'the ordinary events of every day a mysterious – an almost magical – element'. Life with her was 'infused with a sort of transcendental quality'. She also claimed to be clairvoyant – a belief expressed a number of times in her memoir of Paul, though he himself did not take it seriously. Sieveking records that when Margaret made 'one of her more astounding statements [Paul] would purse his rather full lips and give a high, incredulous exclamation ... "Hueh! Bunty is airborne again!"'[18] Other friends, including Mark Gertler and Edward Burra, would find Margaret rather trying company.

Another friend later recorded that once she married Paul, Margaret's 'life and interests were indissolubly merged with his.'[19] Her memoir makes

this very apparent. Her commitment to him continued even after his death, and 'she devoted her energies entirely to the perpetuation of her husband's memory'. Margaret organized the Memorial Exhibition held at the Tate Gallery in 1948, she ensured that the unfinished manuscript of *Outline* was published, and she brought to press Paul's correspondence with Gordon Bottomley. She died in a car accident near Chipping Norton, Oxfordshire, on 4 October 1960. 'To those who knew her,' her obituary in *The Times* stated, 'Margaret Nash's courage, gaiety, and wisdom will long remain a treasured memory, but they will not greatly grieve at her sudden passing, since her increasing infirmity was, despite her indomitable spirit, an intolerable burden to her.'[20] This volume is a perfect opportunity to allow her voice to speak in print for the first time, and for her text to complete the story of Paul Nash's fascinating life.

OUTLINE

PAUL NASH

I Recollections of Childhood

I was born in a house called Ghuznee Lodge, Kensington. It was not an attractive house and I never loved it. But there was an odd character about it and certain vivid aspects I can remember. When I look back at Ghuznee Lodge I see a grey, high house facing across the line of vision taken by the other houses in the street, bending its gaze past the church and over Earl's Court Road, away to the more attractive expanses to the west, where lay amiable squares and genteel crescents, and where, no doubt, it would have looked more comfortable. Somehow, it was a pariah of a house with its outlandish name and pretentious conservatory where nothing, ever, would grow. Certainly, it did not belong where it was and I don't think the Vicar liked living opposite even to its blind side.

On climbing its three or four steps and getting inside the front door, I see a dim room across the narrow hall. This is the dining-room which lived in a sort of warm gloom, like a jungle, and looked onto a meaningless garden, actually only an 'ornamental' promenade about twenty yards across between two blocks of houses. I associate it with one impression only, the passage by the window of a stout foreign neighbour called Mr Koko. His huge, kind, yellow face would turn upwards out of the dark little shrubbery, slightly smiling. Opposite the dining-room was the drawing-room, an entirely unreal place to me, which led, quite logically, to the mocking glass void with its withered plants.

From this floor two stairways started. One down to the kitchen premises in the basement, the other, steep and branching, up to the lighter and airier apartments of the nurseries. On the way was the floor of the important bedrooms and the bathroom. The spare-room, for some unaccountable

reason, mounted at the far end to a little stage where it was, we knew, quite impossible for our guests to see anything in the dressing-table mirror.

Undoubtedly, the nurseries left the pleasantest impression on my memory. But even these are clouded by a curious recollection. As a child I suffered from certain recurrent dreams, some of which had a nightmare complexion. When I recall them, they take shape obscurely and may be described almost in pictorial terms. One was undoubtedly a formal dream of a non-figurative or non-representational idiom. But it was not static. The horror consisted in being hemmed in by vast perpendiculars of changing dimensions, as though the building of walls and columns might begin a deliberate animation, like a slow-motion film, its architectural features changing position, eccentrically. Yet all the while height, breadth and thickness were increasing – not to the release of the dreamer into wider spaces and restful perspectives, but always in some way encroaching, towering and massive, until, at length, about to envelop and overwhelm one.

My other dreams had a more realistic form, although one at least might be called 'abstract'. It was indeterminate, unconfined, but there was a dreadful moment ahead when I would find myself in a tunnel which was either closing in or had narrowed imperceptibly, and I was trapped, horribly, unable to squeeze through or to back out. Neither of these nightmares had a familiar background, but two other dreams often took place on or near our staircase. The first was always a pleasant experience and not, I believe, uncommon. It consisted, simply, of flying or floating, usually downstairs and round about the top of the hall. Sometimes, I would find myself in other places, unknown country perhaps, easily traversed by a process of leaping and, by some act of will, keeping afloat for a good distance before sinking slowly to earth, when another spring from the purchase of the ground would carry me up again and again unaccountably onward, slightly twirling at times, like a leaf on the still air, but always able, just sufficiently, to steer a course. All my life, from time to time, I have enjoyed this mysterious, exciting experience. No other adventure of sleep is so disappointing to wake from or so bitterly relinquished as 'unreal', for while indulged in, it has a compelling reality like no other fantasy.

The second dream, although persistent in the first years of childhood, became only a memory as I grew up. But when it was recurrent it had a peculiar terror for me. I would be climbing the stairs from the middle landing to reach the nursery. As I mounted, a feeling of uneasiness grew upon me. Just ahead was a turn of the stairs which made a dark corner.

Here, suddenly, I knew I must encounter – yes, as I turned up the last flight I saw in a quick side glance into the gloom – a dog, a black dog, silent and still. It would not pursue, but I would run terrified, with failing strength, rattling the wicket gate upon the nursery landing, beyond which sanctuary seemed to lie. At other times my brother and sister and I would be playing together in one of the nursery rooms when abruptly the black dog would appear, though visible only to me. Or, at a party I would gradually become aware, not of its presence, but of its approach. I knew, alas! that it was about to appear to the scandal and alarm of the party, should it become manifest beyond my own anguished vision. There it would stand, without snarl or bark, with hardly a threatening move, dire only by its presence, but oh, how dire!

For all that it was thus haunted for me, this upper area of the house was by far the happiest. And although they now come only indistinctly into the focus of memory, many wonderful and thrilling happenings occurred there. Wonderful, I mean, in the gauge of a child. For instance, there were games as well as dreams. We were richly endowed in this respect, both naturally, in the range of our imaginations, and materially, by the gifts of a devoted and generous friend known as Mr Dry. Mr Dry's Christmas presents were on such a scale and of such a quality as to take the breath away. Soldiers arrived in battalions and army corps, superbly made, the best, obviously, that could be bought. Animals by the zoo, as it were, realistically modelled, each covered with its appropriate skin, for all we could tell, it *was* its skin. Oxen and giraffes had smooth leather coverings, bears had hard harsh hair on their bodies – tremendously convincing. Two bears have survived to this day.

Thirty or forty years ago there were no monsters among toys, no sentimental character either that I remember. A bear was a bear, not a 'Teddy' bear. Dolls had a decent infancy about them and neither wore sophisticated clothes nor went naked with bows of satin under their distended navels. Lewis Carroll had not too long ago written *Alice in Wonderland* and *Alice Through the Looking Glass.* A child's world was peopled by *his* creatures, I think, or those of Edward Lear, the Yonghy Bonghy Bò or the Dong with the Luminous Nose. Or it was haunted by the stories of Hans Andersen and Grimm. I can remember a time when the adventures of the Snow Queen completely enthralled me. For a while I seemed able to break off from my normal life as soon as the reading of the story began, and to escape into its lovely, terrifying scene where I was absorbed in

Gerda's pursuit. Presently, I was so familiar with this process that I could, at any time, exchange my environment for the cruel snow landscapes and be racing with the reindeer under the Northern lights.

At some period in my childhood, Kipling's *Just So Stories* appeared, and I can still recall the slight suspicion they roused in my mind. Here was a changed view. Although improbable, these things had a too realistic interpretation; they amused me, but what was it? Looking back, I suppose it was the first whiff of quaintness on the pure air, the faint odour of whimsicality which my sensitive nostrils detected and instantly disliked. But for the most part, we were happily free in those days. Our fancies were influenced only by irrational images and happenings. My personal education at that time was, I believe, ideal.

If Mr Dry is a figure to remember in my childhood, another, who became most important a little later on, was Aunt Gussie. To her I owe my first encounter with pure nonsense – the poetry of Edward Lear, of which we were given coloured copies, no doubt first editions. She it was who possessed all the Walter Crane fairy books which she read to me. She read quite beautifully, with just enough sense of drama to enhance the tale.

Aunt Gussie was a very small woman of great dignity. Her head was fine with strong, delicate features. She was not a true aunt, only an aunt by marriage, but she had a powerful influence in our family, particularly among the younger generation. Although she was very small and gentle, she could be terrible. Her father had been the famous Lord Chancellor Westbury who used to say things like – 'perhaps when Your Lordship has turned the matter over in what you are pleased to call your mind' – and Aunt Gussie inherited or acquired a considerable talent for this kind of sarcasm. She could paralyse impertinence with a word or a look, for, like her dreaded papa, her 'words were honey, yet they were very swords'. To me she was infinitely kind, although she could be stern.

She and my uncle were made behaviour bogies by my parents. If our nails were dirty or if I tried to whistle through my teeth like the errand boys, it would be always – 'What would Aunt Gussie say?' or, I don't know what Uncle Tom would think!' It is true my uncle was an extremely sensitive creature with a nice feeling for exaggeration. My dear fellow,' he would say to my father, 'I feel the cold more than any man in London.' He was, nevertheless, a member of the Alpine Club and had made in his time some daring assaults on mountains. Of all his brothers he alone was really well-read, a witty conversationalist and able to write. Early in his

career at the Bar he fell under the spell of Lord Westbury's personality and began to write his life. So it came about that he met his future wife, then already a widow. How strange, yet simple, is the mystery of association! Only the other day I was turning the pages of Max Ernst's *La Femme 100 Têtes* and looking at the 'collage' of a gentleman's head with a little woman tied under his chin instead of a beard. And I remember my father telling a story of my Uncle Tom's courtship, which apparently involved him in growing a small, nicely shaped beard, and how his younger brother Hubert, an inveterate joker, said one day, 'Tom, there's a woman in that beard.' Then the reel turns again and I am back in Aunt Gussie's drawing-room, sitting on a small stool listening to her soft voice reading, in slightly exaggerated tones—

There was an old man with a beard,
Who said it is just as I feared,
Four larks and a wren, two owls and a hen
Have all built their nests in my beard.

Aunt Gussie read these nonsense rhymes and songs so well, because, she must I think, have heard Edward Lear read them. He was a friend of the Bethell family and known to be in love with Aunt Gussie. When he was sad and failing in his solitude at St Remo, he begged her to come out and choose his burial place.

Her drawing-room at Elm Park Gardens was full of his dry, luminous water-colours. These were almost the first water-colours I had seen. Our drawing-room walls at Ghuznee Lodge were hung with the tender, limpid paintings of our soldier uncle, Colonel Hugh Jackson, my mother's brother. A very handsome, dark, tall man with sweeping moustaches and very few words, who must have enjoyed sketching the plains and rivers of India with his deft brush. But whereas Uncle Hugh was a skilful amateur working to a formula, Edward Lear was a professional landscape artist of the topographical school descended from the great English tradition. He liked to number himself among the Pre-Raphaelites, but when he was not thinking about them, he got carried away into surprising beauties of landscape painting and his drawings seldom lacked structure.

My infant eyes fed upon these, the blue vales of Albania, the cedars of Lebanon, or a group of flamingos mirrored in a pool. All were of foreign subjects, places abroad, as, too, were the pictures at Ghuznee Lodge. In

consequence, I began to associate water-colours with foreign scenes, so that when I saw our own countryside reflected in this medium for the first time, it was something of a surprise and, maybe, the initial encouragement I had to begin painting myself.

My brother and I had drawn for amusement as far back as I can remember. It was a recognized part of our games, being, on the whole, a quiet recreation involving no overseers. We used pencil and waxy coloured chalks and had bouts of smearing and daubing with cheap water-colours. But on Sunday, although we might draw, we were not allowed to paint. This was to ensure that Sunday should be *different* from other days, an idea adhered to by my father throughout his life. In later years he deplored my working on Sundays for another reason. While sanctioning the recreation as legitimate, there remained for him the disquieting thought that the picture I painted that day might afterwards sell.

While we were still very young my father was appointed Revising Barrister for the Tewkesbury Division of Gloucestershire, and as a result the house became gradually inundated by queer, large, flimsy tomes, rather like the telephone books of to-day. Their leaves were printed with the names and addresses of the people on the Register, but on one side only. The other page was blank, so that the appointment, so far as we could see, consisted merely in providing us with unlimited drawing paper, and in consequence we drew more than ever.

One of the clearest figures of my childhood is our nurse. She was a country girl recruited from my grandfather's village in Buckinghamshire, Harriet Luckett, a lovable character, sweet and firm, with a well-balanced mind. At that period of our lives we naturally saw more of her than of our mother, yet she never jealously absorbed our affection or imposed her will. Her voice was quiet, without trace of a 'common' accent and musical enough to sing in tune. She was tolerant even of such really maddening games as the Matchbox Railway. How this began I cannot remember. By acute wheedling we somehow became possessed of several reels of cotton. Then round and round, back and forth, across and across, the cotton was spun in the nursery. No one could come in. If the door opened, agonising yells of warning arrested any sudden intrusion. Or, in real emergency, the outsider was allowed to creep in, doubled like a hunchback, dodging the little matchbox cases threaded on the cotton which rapidly traversed this aerial complex. But when it all became a bore for everyone except ourselves, Harriet would stop the game without a mutiny or bringing us to tears.

Then I would have my hour with my mother, usually spent in the rather unfriendly drawing-room. She was always anxious for our progress, quick to rally us out of laziness or stupidity, yet tender and encouraging, too. I think she seemed always delicate, subject to headaches and so often obviously worried. Life was difficult in those early years before my father's practice was established. We lived very carefully, though now and then as children we enjoyed tastes of luxury and splendour through our wealthier friends and relations who gave us holidays and parties. Then one day my mother unexpectedly inherited a modest fortune and we began to make plans for leaving London to build a house in the country.

But long before that I can remember the evenings in the drawing-room where I had spread my expensive soldiers or the ironically 'de luxe' animals all about the floor, while my mother waited for my father's return from that mysterious place, the Temple. I would look up from my battle at her beautiful dark head with its agate eyes and abundant hair. Her mouth would be parted rather sadly. The shades thickened in the corners of the room; the conservatory, now emptied of light, became a ghost-house; only the fire kept the darkness away until my mother shook off her reverie and rang for the lamp. At the same time a foot would sound on the steps outside and my father's key tinkled in the lock.

Then bedtime would come and we would climb the steep stairs to our happier rooms above. Before we went to sleep, perhaps Harriet would be persuaded to sing 'The Ash Grove' or 'The Banks of Allan Water', both, indeed, rather depressing ballads, but nice to sleep on.

We would wake next day to find the sun shining. If it was summer time, or at least warm and dry enough, a picnic might be planned for Kensington Gardens. We never took our lunch there and our tea preparations were frugal. A bottle of milk, a bottle of hot tea and plenty of bread and butter. Sometimes we took cold tea, but it was not popular. For me one of the small delights of these expeditions lay in watching Harriet cut the bread and butter. This she did with extreme skill, holding the loaf rather like a violin, but pressed against her bosom which, neatly clad in a black stuff, was a repository for pins. How no pin got into the bread I often wondered. The whole feat looked dangerous, for Harriet cut towards herself with a thin sharp knife at great speed. The knife would flash, the pins would flash back and the even, oval-shaped slices buttered and cut would pile up on the plate to be wrapped up in grease paper and packed into a flat tin box ready for the Gardens.

Kensington Gardens was more than our first playground. It was the first place where we could make our escape. In all other environments you were conscious of circumvention, either imposed or implied. At home the range of movement was necessarily restricted, and even in the streets you were always, as it were, on the lead. If you ran too far ahead, you were called back; if you dawdled behind, scandalously, the main body in front would halt and insist on waiting for you, not always with patience. But in the Gardens it would be different. With a shout and a sudden turn of speed you had broken through the invisible barrier. There you were at last – alone! I remember that sense of freedom. It was an escape, not only from the others, but in some queer way from oneself. Perhaps it was like the bird bursting through the shell of the egg. Certainly, it was an immense enlargement of life, for the Gardens were my first taste of the country. Here I became aware of trees, felt the grass for the first time, saw an expanse of water, listened to a new kind of silence. I was fortunate in being born some time before Barrie took over Kensington Gardens. You could look at a tree without misgiving; it was unlikely ever to resolve into something by Mr Rackham. The place was not *infested* by fairies; you found them just in one special place, if you wanted them. As I remember the Gardens, they were gloriously free of 'whimsies'! The great open spaces, they were for us, with wild tracts here and there, mostly peopled by Red Indians. We hunted, explored and conquered the tribes, or dropped all that and joined the odd world which circled the Round Pond.

There were three kinds of life at the Round Pond – variously fascinating. The water birds, the boats, and the people who sailed the boats. These last formed a strange community, by no means composed of large and small boys. I shall not forget being almost knocked into the water by a large bearded man with spectacles. He wore some sort of waders against the waves and a curious tweed cap with ear flaps, to deaden the screaming of the gulls and ducks, perhaps. He carried a long bamboo cane with a hook at the end. There were many of his kind; big and little men, all eager and serious, scanning the waters, striding round to meet their boats, hardly ever talking and never laughing. A grim sort of game it seemed, mixed with the children's games. But its very seriousness was rather infectious. As I grew bigger I wished I had a boat hook, or whatever it was called, especially as I now possessed a considerable boat with a romantic origin. This was a broad-beamed cutter which had been built by one of the sailors in my naval grandfather's ship. It proved

a formidable and somewhat unpopular intruder amongst the slender model yachts of the Round Pond squadron, but I remember nothing about its adventures until the dramatic incident years later on the perilous shores of Black Park.

It was beyond the Round Pond going towards the Tea Gardens that I came upon my first authentic *place*. Hereabouts the Gardens have almost a wild quality and coming in from the open spaces round the Pond, you have a sense of entering a wood. On the outskirts stands an ancient beech, leaning precariously forward and, for some years now, held up by a crutch. Oddly enough, I think it escaped the regard of the whimsicals, but it is full of personality as a tree and dangerously like a witch, if that is how your mind works. For me it held a compelling charm. It was conspicuously ghastly on dark days in the beam of a low sun, or it shone steely blue in its metallic mood in early spring. Sometimes it was poetically pale and enchanted and could suggest a magical presence, not, however, by its personal figuration, but by some evocative spell which conjured up fantastic images in the mind. You might say it was haunted, but indeed that influence was spread all round its neighbourhood. This tree merely guarded the threshold of a domain, which, for me, was like hallowed ground. I can say hardly more than that by way of definition. There are places, just as there are people and objects and works of art, whose relationship of parts creates a mystery, an enchantment, which cannot be analysed. This place of mine was not remarkable for any unusual features which stood out. Yet there was a peculiar spacing in the disposal of the trees, or it was their height in relation to these intervals, which suggested some inner design of very, subtle purpose, altogether defeating the conventional lay-out of the Gardens and ignoring their respectable character. In that it was like a wild streak in a well-brought-up family, a break-away from tradition. Simply, it was not the same as the rest. In addition, it was strangely beautiful and excitingly unsafe! Who came here came at his peril; that I well knew. It was here the Indians lurked behind the trees, or an ogre might appear – according to my mood. Later, less articulated images inhabited those paths and grass ways until, years later, they took on human shape. Yet whatever happened to me there throughout my life, I was conscious always of the influence of the place at work upon my nerves – but never in any sinister degree, rather with a force gentle but insistent, charged with sweetness beyond physical experience, the promise of a joy utterly unreal.

If I were asked to say exactly where the place is I should find it difficult to define. It has no fixed boundaries and, in element, is more like the sea whose tides determine its confines, now encroaching, now receding on its shores. But if you were walking from the Pond to the Tea Gardens you would pass through the region I have described. And I *have* emerged from its shades onto a sunlit space which slopes down to a small house, beyond which can be seen the lines of the Serpentine. On the south? Definition becomes more unsure. I should not like to be positive about the southern edge until the shrubbery of the Flower Walk leaves no doubt. In any case this region is not evenly potent. It has a centre of radiation, as it were, but even that is not fixed in locality or constant in power. Many, of course, will never experience the sensations I describe. I tell of an adventure in childhood which happened, may be, only within myself and persists only there, like my early recurrent dreams.

Yet, as I grew up and discovered new places and later began to record them in drawings and paintings, it was always the inner life of the subject rather than its characteristic lineaments which appealed to me, though that life, of course, is inseparable, actually, from its physical features. So that the secret of a place lies there for everyone to find, though not, perhaps, to understand. I shall tell of places infinitely far removed from each other in character. Some of these can be painted and written about endlessly, like the scene of Fujiyama and Cezanne's landscape of Mont St. Victoire. Others, again, cannot be described, but can only be indicated dumbly with a shiver or a smile.

Meanwhile the Gardens still lie about me. Harriet's gentle voice calls us back from our exploring. It is too far, we are warned, that country of the Serpentine which lies beyond the broad road on the other side of the Tea Gardens. Another day perhaps. We turn, setting our faces for home. It will be pleasant to go back through the Flower Walk. As we move away I take a last look between the black trees, up into their branches, down on to the grass where the shades are gathering. Nothing is there except a few sooty sheep cropping the thin grass. A hoop moves across the luminous space; for a moment the tree trunks hide the child that silently follows. Two heavy ring doves are making a soft clatter above our heads. Then, as I turn to follow the others, I have a strange impression. Away to the left, perhaps a hundred yards distant, there seems to be a part of the Gardens I have never seen before. I feel an almost cold thrill stir me, as may a traveller in the desert who beholds a mirage, or a sailor in the archipelago

who, just as the sun dips below the horizon, thinks he sees an unknown island standing to the west. 'Harriet, Harriet, wait for me! I want to look at something over there.' 'What is it?' 'Only a place.' 'No, come along, it's getting late, it will be there to-morrow.' 'No, no.' 'Nonsense, come along, you can find it another day.'

II Learning

I

It was not until I was sent on a visit to my aunt and uncle at Yately that I became aware of any plan for my education. But I had been only a day in my aunt's house when she insisted that I should learn to tell the time. I cannot remember that she taught me anything else, except at a later date a subversive game called golf croquet and later still how to tie up a parcel.

This aunt was to become, among all our relatives, perhaps the most beloved. As I recall her then she is merged a little with Uncle George. But not long after my early visit Uncle George Chapman, who was a handsome man of serious mien and of a rather military bearing, was thrown from his horse and died as a result of the accident. From that time Aunt Molly grew steadily in personality. She was shrewd and very capable and kind, but her great gift was for making other people happy, or at least less depressed or dull. She was a sort of human tonic and her energy was endless.

As soon as I could read the clock and had become fluent about the time, I was taken for a purposeful walk which began by going across an angle of the common and led on to a field path up to the Flats – as the small moors of heather extending on either side of the Portsmouth Road were called. My aunt had a large black retriever of a most lovable disposition, and we three set off with a good deal of barking and dog-quelling shouts over the common towards the little copse adjoining the churchyard which was the opening to the fields. The retriever and I were to get to know this path pretty well in course of time, but to-day we spent mostly off the path, racing about the field, while Aunt Molly marched briskly along with her rather masterful nose and bright blue eye steering like a ship's prow for our

objective. Over a little wooden bridge crossing a stream, then a stile and another spinney, and so out again, we three went over the fields – a wide piece of ploughed land running down and up hill to the sky-line where stood a rambling house on the very edge of the heath, a spot known as Cricket Hill, whether from the game or the insect I never could discover. A path worn over the plough brought us to the confines of the fields, and soon we were ringing the bell of the rambling house.

I found it rambled because it was not a normal house, but a Dame's School. We waited in a comfortable-looking room until the door opened and a rather stout lady with a sweet, smiling face glided in. I was presented and was astonished and alarmed to find I was to be enrolled as an extra special member of the school, the only boy among an unknown number of girls. By degrees my alarm subsided as I met other members of the staff. They were very different from what I had imagined school teachers to be. Mrs Wilding and her two daughters were the principals, and it was by their characters, naturally, that the school was influenced. It grew in time from the rambling dame's school on the heath to be a famous girls' school in fashionable Camberley, but I believe it never lost its atmosphere of friendliness, good humour and good sense.

I do not remember learning very much there except not to be afraid of girls and how to get things done for me. Being the only male I suffered chiefly from being spoilt or resented. On the whole I was well treated and enjoyed my school hours. But mostly I enjoyed the walk over the fields to and from school.

On the way, as I have described, the path ran through a small spinney. Here was a shallow stream moving quickly over a sandy bed. It was traversed by a light wooden platform by way of a bridge, beyond which was a stile. On the other side of the stile the path continued under very different conditions. Whereas in the open fields it seemed to run unhindered at top speed, abreast of the hedgerow, it now appeared to falter and creep along in the twilight of the wood. Its colour changed from a bright resilient tone to a purplish brown. Its surface now became heavy, damp and unsure, its form confused by dead leaves or encroaching undergrowth. I, too, was influenced by the atmosphere of the wood. Here I trod more circumspectly, glancing from side to side. It was very quiet and still. Outside, the fields and sky, on a fine day, might be shouting at the tops of their voices, but in the wood everything seemed to be listening. The only sound was a bird's song, a wren's, generally, or a robin's, in this winter month.

On the far side of the wood I started to run, not from panic, but because there was just that impulse to quicken step and meet the welcome of the space outside. In this impulse I felt myself identified with the little path, especially as we approached the opening by the stile on my return journey from school. It was always a joyous moment for me, because, while still in the shadow of the wood, as I climbed the stile, I could catch sight of Aunt Molly and Sambo, the black retriever, coming to meet me. There would be a moment when, as I emerged, Sambo paused and drew himself back in a rather theatrical way, then, with an hysterical bark, bounded forward. At the same moment I seemed to feel the path quicken under my feet and sweep outward on its course over the field with ever-increasing speed. Thus the path and the dog would meet, the path doubling beneath the darting shadow of Sambo's curly black belly and in under Aunt Molly's trim skirts and feet and away over the open to disappear at last into the obscurity of the church copse. How long my visit at Yately lasted I do not remember. It was sufficient, I suppose, to see me grounded in the simpler school subjects and to discover perhaps that disastrous deficiency which was to influence the whole course of my early life – my fatal inaptitude for mathematics. But it was a happy period, abandoned with regrets. I think it awoke in me my first love of winter country. The brittle ice pools with their dark thin rushes on the common, the rich weather stains and bruises on the dripping trees in the deep lanes which led up to the Flats, the colour of faded, rotting paling in the pure distilled beam of the winter sun – these I absorbed, I realise, along with my more conscious studies, and retained long afterwards when those others were forgotten.

Most of my holidays, both before and after I went to a proper school, were spent with relatives. Their invitations did not take me very much beyond the Home Counties, but as a very small boy I got as far as Hornsey in Yorkshire and on another occasion to some cousins in Devonshire. In both places I was nearly drowned; first in the sea and then by falling into a moat. I remember nothing of Devonshire except this ducking and the steep banks of primroses in the winding lanes. But I can still hear the alarming rattle of the pebbles sucked back by the ebb and the frantic cries of paddling children and nursemaids confused with the yelling of the gulls. As the wave enveloped me Harriet groped and grabbed me just in time.

This must have been my first encounter with the sea, unless I had then already been to stay with my Brighton cousins. If I had, both seas must have been spring or winter seas, for I associate them with cold and

cruel waters usually in a threatening mood, pounding and rattling along the shore – a fascinating but rather fearful joy. It is not until I think of Swanage that I recall the sea blue and beguiling.

We lodged at Hornsey in the corner of a terrace facing the sea. The shingle was just below. I felt I could never grow tired of listening to the sound of the crash and roar of the waves followed by the pause in which the shingle hissed and the pebbles rattled before there came again the rising murmur of the sea voice returning and, again, that loud or gentle crash and roar.

All this must have had something to do with a visit to my mother's relations, and was, moreover, the introduction to my maternal heritage – the North and the sea. My grandmother came of a Yorkshire family, the Cattleys of Hull. She was a person of a direct and downright character, but very kind and lovable. The Cattleys were Russian timber merchants. A branch of the family had settled in St Petersburg early in the 18th century. My grandfather I never knew, but the tradition of his family was a force destined to affect my life considerably. The Jacksons, an aristocratic-looking people, had served as officers in the Royal Navy for four generations. In the Painted Hall at Greenwich I had been shown my great-grandfather's ship, the *Hebrus*, gaining a fierce victory over the French frigate, *L'Étoile*. The family tradition had broken in our time with Uncle Hugh Jackson who elected to go into the Army and was now a Lieutenant-Colonel in the Royal Engineers. His son also was to be a soldier. When I appeared, the family, between them, decided apparently that I should go into the Navy. This led to considerable trouble and disappointment. It might have been better, perhaps, had someone taken an oblique glance down the family line and noticed that my great-great uncle was not only a sailor, but had spent his life in travelling and in writing books which he illustrated with designs of undoubted character. I have reproduced one of the best of these from *An Account of the Empire of Morocco* (to which is added an account of shipwrecks off the western coast of Africa and an account of Timbuctoo)[1] to which I would gladly sign my name, yet I never saw it until a year ago or knew of the existence of its interesting author, James Grey Jackson. If anyone recognised any sign of latent talent in me, I suppose this was not urgent enough to warrant being given first consideration as material for a career. Uncle Hugh seemed to have painted as many water-colours as the family could conveniently hang on its drawing-room walls, but this, presumably, had not delayed him from rising to a distinguished position in his profession. He was an artist in the best, that is to say in the most convenient, conception of the calling

– one who had not to depend upon his art for a living. Certainly, I cannot blame my parents for not dedicating me to art, but in offering me to the sea I think they were a little casual. Even respect for the quaint tradition that the fool of the family goes into the Navy hardly justified this policy, for I was the kind of fool whose particular imbecility must prevent any success in a profession where accurate mathematical calculation is as essential as the breath of life. No doubt they thought I should overcome my weakness or grow out of it, so they decided my course, and I pursued it to my defeat and loss. But before I describe my school career, two memorable episodes of my boyhood come to my mind. Both concern two places, the homes, one temporary, the other permanent, of my respective grandparents.

I cannot remember how old I was when my brother and I were taken to stay in Hampshire where my grandmother and Aunt Rhoda had rented a house called The Grange. It must have been before Barbara was born, for I recall that event being announced at Langley. When I was asked whether I should like to have a small sister, I repudiated the suggestion passionately, thinking it meant an exchange for my brother.

The Grange was everything that the name suggests; or is it that I have always identified that name with the character of the house I knew? It was rambling and shady, shut in by shrubberies and heavy trees. It had a sense of airlessness and gloom. I see it always shrinking into the obscurity of twilight. Its character depressed me to an unnatural degree. If ever a house could be said to be haunted – in the abstract – without the illustration of a ghost, The Grange was haunted. Or, was it I who was haunted? Certainly, I was in a strange, unhappy state of mind, my nerves constantly assailed by small alarms or preyed on by apprehensions. These fears had definite causes, even though they were exaggerated.

The part of Hampshire we were staying in was heath country, wild and little populated. One of my first discoveries was that on every walk we took we saw a snake and sometimes many. The place was alive with reptiles. In the meadows and woods there were huge grass snakes, on the heath adders, blind worms and lizards abounded. For a child accustomed to explore the countryside in freedom and safety these frequent encounters robbed my walks of all pleasure. One day in the orchard I went to pick up an apple when, almost from under my hand, a snake rose up hissing, and turning, moved away between the trees seeming to bound along on its monstrous length. No doubt it was only a large, harmless grass snake, but I had begun to exaggerate forms and sounds. So many

innocent things now began to have a sinister nature. I can remember two curious examples. In the evening when I was in the garden alone I used to dread hearing two sounds. One was a far, insistent beating, in a high key, a sound inexplicable, terrifying, because I could not imagine how it was made. But its effect was heightened so often by the sudden breaking in of another noise I hated as much and which was somehow implicated. It was a cry, so sudden and unreal that it chilled me where I stood rooted to the ground, listening. It was made by a bird, but what was dreadful about it was that I knew the bird. It was the blackbird who by day poured out the sweetest melodious song up in the branches, but who now rushed across the lawn in a low hurried flight uttering this wild haunted cry which, like that other distant metallic noise, throbbed in my ears. Later, at Langley in a normal mood, I got used to the blackbird's alarm, and the sound of egg whisking coming from the distant kitchen ceased to have any terror for me.

Yet these terrors by day were nothing to what I often suffered by night. I slept in an upper part of the house which, I think, must have been just below the lumber room. When my light was put out and I was left alone a sound of far off galloping would begin overhead. It would die away, then come again. The first time this occurred I called for Harriet and made her listen. I could see she was uneasy, though she made light of it at the time. But another night when Harriet was out, the galloping seemed louder and nearer. I cried out to one of the maids and she sat on my bed listening. Presently a distant drumming began and, becoming louder, went softly thudding over our heads. 'It's the rats,' whispered the maid, 'they're hunting, have you heard their horn?' This idea terrified me – the rats' horn! How would it sound? High and thin and faint – sometimes I thought I heard it. I would crouch in bed straining my ears, falling asleep, hearing it in a nightmare and struggling awake to hear the galloping sound dying away and the faint call of the horn.

Presently, I got sick. My malady was one of those strange child's epidemics which seem to fall from the air. Its nature, too, at once alarming and ludicrous, was like something in a dream and seemed to express with cruel mockery my haunted state, for the symptoms of my illness became evident, not as a rash or a swelling, but as a noise. I had developed whooping-cough. It was like being pursued by a demon. With each paroxysm that choked me came out this daft, half-animal voice. Soon my brother was infected and my misery and fear deepened.

This infectious plague with its intolerable clamour was banished from The Grange by our being sent into quarantine at a small villa on the edge of the heath. Here we lived for a time with Harriet and a few auxiliaries, and here the strangest phase of my obsession took place.

I have described The Grange as having every ghostly attribute without being actually haunted in my experience. The villa on the heath, which was the usual ugly modern building with no frightening features, was a quite different affair. It was *peopled* with ghosts. I cannot describe them now. They seemed unsubstantial presences, featureless bodies infesting the steep stairway or hiding under beds or in cupboards. I used to run distractedly for Harriet's protection. But one day she and two of the servants were standing together talking in one of the upper rooms when, as I rushed forward to catch at Harriet's hand, something drew my attention to the window. I looked over my shoulder at the space of sky. A cloud mounting up, parted, and I saw a figure in white lean out looking at me, it seemed, and holding up a warning finger. It was as meaningless as the ghosts and the haunted bird, but after that apparition I do not remember any more horrors. Gradually they ceased to be; my sickness died away and my brother and I became happy once more. We made a new friend; his name, I think, was Mr Rose, who collected moths and butterflies. Soon we had begun our own collection.

Now the scene changes and I am in very different surroundings. It is a year or two later and I am being driven along in my grandfather's dogcart from Slough Station to Langley Rectory. In place of the wild heath, grass meadows and cultivated fields stretch out on either hand as the road winds between well-kept hedges and pollarded trees. I am no longer haunted by vague fears, but am happy and full of half suppressed excitement. It is my second visit to Langley and I am looking forward eagerly to seeing again its places and people.

My first visit to my father's home had impressed me deeply. It was like finding my own home, my true home, for somehow it was far more convincing than our so-called home in London. I realised, without expressing the thought, that I belonged to the country. The mere sight of it disturbed my senses. Its scenes, and sounds, and smells intoxicated me anew.

The Rectory at Langley Marish was the home of the lay rector and owner of the tithes. My grandfather was a yeoman farmer whose family could be traced in a succession of uneventful Williams, Johns and Henrys to Henrie Nashe in the fifteenth century. As a people they

seem to have been curiously nomadic for their kind, deriving, so far as could be seen without special research, from a place called Oving in the north of Buckinghamshire and gradually descending the county until they arrived in the extreme south not far short of the Berkshire border. They farmed a hundred years at three places, Penn, Beaconsfield and Upton together with Langley. They began very humbly, I think. In a little Bible of 1633, belonging to William and Eleanor Nash, is this record on ploughing—

> *Tew Eakrs in the first cast*
> *Three Eakrs in the second cast*
> *Three Eakrs in the therd cast*
> *Tew Eakrs in the forth cast.*
>
> *July, 1710—*
>
> *we had tew Eakrs in the first cast*
> *and tew Eakrs in the second cast*
> *and the Eaker in the Aldor in the second cast*
> *and tew Eakers in the therd cast*
> *and the Eaker in the fearm in the therd cast*
> *and tew Eakers in the forth cast*
> *and the nex year it goes into first cast.*

But, in the middle of the eighteenth century, Richard Nash of Upton Court was a person of substance, and his son William increased it. William who followed him was well-to-do and inherited enough money to purchase the Langley acres and the tithes. He lived at Langley House. He was a stern, uncompromising character who turned King George III off his fields when the King and his friends tried to take a short cut with the harriers.

From the end of the century the family seems to have begun to expand in many ways. William Nash, out of a family of nine, produced four rather remarkable sons, William, Zachary, John and Henry. The two first were oddly contrasted. Zachary became vicar of Christchurch Minster and a Canon of Winchester, but William seems to have been entirely a sporting character in the best eighteenth century tradition. He lost an arm in a shooting accident, but he would still set his horse at a five-barred gate. He appears in the well-known picture of the Royal Hunt by Sir Francis Grant and is identified in the 'key'. Besides such activities as coursing and hunting, however, William did nothing except lose money in rather a

grand way quite beyond the resources of the family. Zachary, on the other hand, restored Christchurch Priory and rescued Langley Rectory when it was slipping through William's fingers.

The two other brothers kept steadily in the family tradition and proceeded to improve it. Each became established on a farm with wide lands and raised up a large family, John at Langley, Henry at Upton Lea. Henry had eleven children, John, the elder, had ten. The two groups of cousins grew up within a mile or so of each other. All were lively, attractive young people and apparently very good friends. Not far away, at Slough, another large family was growing up – the Hawtreys, whose ancient home was Chequers. These three groups were, no doubt, a formidable social force in the neighbourhood, especially in sport and the kind of intense amateur theatricals of those days. The Hawtreys ran a private pack of beagles, the tennis tournaments at Langley Rectory were famous for miles around and were reported in *The Field*. Years later there was a yield from all this fun and games to which each family contributed. The Upton Lea Nashes produced Edward, who played football for England and was the first President of the English Hockey Club. From Langley came the tall Rowland, who won the hurdles for Oxford and was judged one of the finest natural athletes of his year. And was not Charles Hawtrey one of the greatest comedy actors of all time?

But all this had changed before I came on the scene as a small boy. Few of the original family groups remained. The Hawtreys had long since left Slough, save one who married the eldest of the Langley Nashes. Henry Nash was dead and his children dispersed. Only at Langley something of the old state lingered. Guests came and went, tea-parties gathered in the shade of the mulberry-tree, shooting luncheons were devoured in the paddock under the chestnuts, and Christmas was still a family festival. Christmas at Langley Rectory! That is something to remember from another age.

When my father used to read the *Pickwick Papers* aloud to us, I always pictured Dingley Dell as Langley and Mr Wardle as my grandfather. Indeed, there was a considerable likeness in character between these places and people. Like old Mr Wardle, my grandfather was a true yeoman with the authority of a squire. He, also, was extremely autocratic, outspoken and kind, while both were somewhat choleric and given to comical outbursts of temper, though I do not remember seeing my grandfather lose control of himself. But you did not trifle with John Nash nor contradict

him lightly – at least not twice, for the force of his personality was such that he compelled immediate respect. He was too, a very pious man and a strict Sabbatarian.

Langley Church, which you see from the Great Western Railway, was at the extreme end of the parish from the old rectory, a long walk for the aged. So a chapel of ease was built by my great grandfather in the big meadow beyond the walled kitchen garden and here an evening service was regularly held. Sometimes Mr Scoones, the vicar, would come there to preach, more often one of the curates. In either case they took supper at the Rectory afterwards, and although Mr Scoones was exempt, no curate ever escaped an expression of my grandfather's opinion upon the sermon we had just listened to. It followed immediately on the 'blessing' and took one of two forms. Either, 'Thank you, Mr Jones, for your sermon, calculated, I should imagine, to do a great deal of good.' Or, if the unlucky gentleman had been trying out any personal flights of fancy, 'Oh, I say' (said not in a conversational tone, but with emphatic distress), '*Oh, I say*, Mr Jones, *do pray* preach the gospel!'

I enjoyed Sunday at Langley more than at any other place. I liked driving to church in the family brougham and seeing the villagers smile and touch their hats or curtsey. The inside of the church was so enthralling that it was difficult to keep up an appearance of interest in the service. From the family pew in the choir I had a view of the congregation beyond the screen and of the exquisite little chain library on the far wall. More constantly my eyes strayed to the clear glass east window where the branches of trees showed through, or to the lovely painted vault above, pale, clear blue painted with golden stars and bunches of corn. After the service I would escape by our special little postern into the sunny churchyard.

But I have been anticipating. The dogcart is now bowling past the field gate to Upton Lea, and the Rectory is coming into sight on the opposite side, not the house, for that is hidden as yet, but all the beloved features of the farm and the lands. Now we have come to the path across the big field, known as the daisy hale, which runs past the honeysuckle arbour along by the quick set hedge above the close orchard. In the summer it divides the tall corn stalks threaded with poppies and marguerites. Now it traverses the plough where the green shoots are already pricking through. Soon we have clattered past the George Inn and round by Mr Ives' cottage, through the village and into the straight drive by the little round lodge and over the narrow stream which flows across the meadow. There is the great barn

and the old elm! There are the good ricks and there is the red mellowed brick face of the old Rectory and the large round bed out in front, bright with spring flowers.

My grandfather and I were great friends. He liked children, but he had an odd phobia about dogs. If he patted a dog he would go at once and wash his hands. This must have been an inherited distaste, for his father could not tolerate the presence of dogs and was driven frantic by great-uncle William's greyhounds who, perversely, would follow him about round the farm. 'William,' he would shout, 'you know I can't bear these damned dogs. You must do something about them.' 'Very well, sir,' William would reply with dignity, 'they shall all be hanged to-morrow morning.' But this presented too awful a picture. 'No, no, William, I wouldn't like that.' So everything went on as before. My own father was distinctly nervous of dogs, regarding them as applicable only to sport, and beyond that as a powerful nuisance and a good deal of a menace. Hence, there was far too much cautioning us children, 'mind the dog', 'don't touch the horse', and so on, which did us no good and prevented us from learning what Langley had to teach. I should then have learnt to ride a pony, to shoot rabbits and to become acquainted with other manly sports, I suppose, but somehow I never did, in spite of the sporting presence of Uncle Hubert.

Hubert was our favourite uncle. Rowland, who was living at home then, had our affectionate regard, but he was a strange, rather uneasy being, difficult to get to know. Hubert's gay personality radiated happiness and fun. He had a voice more vibrant than any I ever heard. It was like a huntsman's horn. He must have inherited most of Uncle William's nature, but he had a reserve of sound sense and conscience. His ruling passion was betting. He would bet you a shilling the chicken wouldn't cross the road or the cat turn round once more in her basket. He ran what we knew as the Vicarage Stakes for years, taking odds on which spinster in the parish would marry the curate. With him I learnt country law, the habits of birds and wild animals. From him, too, I learnt to make a catapult, to fish in the stream and, above all, to find nests. Before I left I knew where the garden warbler built in the hedge at the top of the daisy hale. I had found a moorhen's nest in the orchard ditch, a fly-catcher's in a tree on the lawn, a wagtail's in the old brick wall and a tree sparrow's in a hollow branch of the apple tree. A walk with Hubert was one of the chief joys of Langley visits.

The other principal figure of the Rectory was Aunt Edie, affectionately known as Aunt Dot. She it was who 'ran' the house and looked after

everyone's wants. She also found time, it seemed, to run and care for the entire village. Aunt Dot was a cosy, lovable person with a deep sweet voice. She had a pleasantly rounded form and round smiling eyes. But the roundest thing about her was her mouth when she sang and from which poured out the roundest fullest notes conceivable. One day when she and I were walking home across the orchard at Upton Lea, I made some remark upon the cow grazing by the hedge. There must have been a slight narrowness about my pronunciation, despite a country nurse and careful upbringing in London, a certain tinge of cockney tone, I suppose. 'You must not say cauow,' said Aunt Dot gently but firmly. 'Say cooow,' emitting such a resonant 'ow' that the cow stopped eating to look at us.

Thus I profited by my visits to Langley. But memories centre mostly round my grandfather. In the morning after I had had my talk with Venus, Uncle Hubert's emotional Irish setter, the pony chaise with Pither, the coachman, on the box would drive round to the front door and I then set off seated by my grandfather on a round of the farm, ending at the office. For some years the Langley fields had yielded a valuable brick earth which had been profitably worked. The office, on the borders of Slough, was the centre of operations presided over by Uncle Hubert.

Grandfather wore his tall silk hat which always covered his massive head summer and winter on his walks or drives or when he rode a horse. Under its rim his thick arching eyebrows, which are a family characteristic, followed its odd twist above his steady eye. His rather short, strong nose jutted out of his bearded cheeks, his strong kind mouth was a little parted, I could see. On the side I could not see I knew his eye was blind. He was now eighty-three, tremendously strong, alive in every faculty. As we went our round I was able to watch his incisive dealing with the problems that arose. The farm was in perfect condition, everyone seemed to be working happily, the labourers gave us a true smile as we stopped to talk to them.

When we reached home again a quaint treat, which I looked forward to, was in store for me. Opposite to the dining-room from the flagged hall was a small room which served as my grandfather's study. Here were collected various specimens of the farm's yield. Specimens of corn, heads of wheat or barley, samples of field roots. Alongside these might be found freak objects, disconcerting potatoes, twisted parsnips, even a dead mole which was going to be skinned. But for me the most enthralling of all objects, natural or perverse, was a clutch of hen's eggs collected from different

localities of the farm, ranging in shape from almost round to long ovoid and in colour from purest white to deep warm brown.

Ever since I can remember sensation I have been delighted by the sight and feel of birds' eggs. They represent for me a kind of beauty which to this day nothing supplants. To take an egg from the larder and hold it in my hand gives me the same pleasure as touching and contemplating a piece of perfect sculpture or the most exquisite faience. Indeed for me it seems to combine the qualities of sculpture and pottery, with its supreme glaze covering the lovely solid form. The fact that it is potentially alive I do not think ever interested me. I experience only an aesthetic emotion. As a child in my grandfather's study I had some such instinctive experience, I know, but it was slightly obscured by the excitement of a game my grandfather had invented, which consisted of drawing pigs on the eggs. I think it also involved shutting our eyes and then putting in the eye of the pig. In any case it became a pretty absorbing and hilarious game which dispersed for the time all other considerations.

There were all sorts of treasures in that little study. The most rare of all was our family copy of Bunyan's *Pilgrim's Progress,* a unique specimen, as it turned out, and even thought by some to have been Bunyan's personal copy. Not many people had seen this little book, but very special visitors were shown it. All degrees of people came to the Old Rectory in the course of its history. I imagine the tide of the hunt sweeping over the Langley fields was often responsible for stranding some distinguished piece of jetsam – someone staying at Windsor Castle who was glad of a draught of ale and a home-made sandwich after a morning with the harriers. I cannot recall anyone more distinguished in this way than Disraeli,[2] who walked in one morning. The record of the conversation is confined to my grandfather's utterance, but this was typical. 'You will find a very good cut of cold beef on the sideboard, Mr Disraeli.'

My day has come to an end. Now I am in my small bed at the head of the stairs. But I have not been able to get to sleep and I can hear my grandfather's heavy tread upon the stairs and the sound of his stick. At the top of the stairs he stops and thumps three times with his stick. I hear the talking and laughter downstairs subside. Suddenly, almost in my ear, it seems, grandfather's voice rings out like the challenge of a sentry. 'Are all the windows barred and all the doors fastened?' From below a confused chorus of 'Yes, father, yes, sir, everything is done, sir.' Then, still in a ringing voice, 'Goodnight, everybody', and from below in every male and

female voice of the household, 'Goodnight, sir, goodnight, father, good-night'. And then the crash of his door which shook me in my bed.

2

One day, not very long after my visit to Langley, I walked out from Ghuznee Lodge and down the steps into the street, a still small, but quite new individual. I had on a new dark suit and wore a dark cap emblazoned with the outline of a silver Maltese cross. I carried a satchel of books. I was going to school.

The reason why I was taking this rather long walk across the wilder parts of Kensington to reach a centre of learning on the borders of Hammersmith was, I suppose, fairly obvious. My father and mother wanted to keep me near them – I was only eight – and Westminster would have involved a more difficult journey daily. So I was sent to Colet Court, the preparatory school for St Paul's.[3]

Why I was so certain that this step had changed my nature is not easy to tell, but I did feel changed, or rather, perhaps, the circumstances of life were now so altered that it was impossible to be still myself. I recognised quickly enough what had happened to me. My liberty had been taken from me. In all the years that followed, until I left school at seventeen, I was never free. Nor was I particularly happy during those years. In fact I think it is fair to say that in those years I suffered greater misery, humiliation and fear than in all the rest of my life.

It is for that reason, perhaps, that I do not wish to dwell upon this period. But I know that there were certain events in its course which moulded and directed me.

As I have explained already, a profession had been chosen for me. I was to go into the Navy. At that time the preliminary training was not at Osborn, but in H.M.S. *Britannia,* and the age for entrance much later, fourteen, I think. I knew I had four or five years in front of me before I need take the entrance examination.

Colet Court was a preparatory school on an unusually large scale. It embraced all classes, speaking socially, but the more indeterminate strata of society predominated, both there and at St. Paul's. There were at least three hundred boys and the biggest looked very formidable to the smallest, of whom I was one. I might not have noticed this fact particularly, if it

had not been impressed on me very soon after my first encounter with this new, alarming community. I then realised that outside the classroom or the actual playing field, an organised system of bullying went on from which there was no escape. I cannot remember it having any purpose beyond terrorising for the fun of torture, but it was carried on without the knowledge of the masters and in defiance of the prefects and was run by a small group dominated by a tall heavy boy with a fattish white face and a quiet voice. I have always remembered his name, and I can still see the look on his face.

I got through my dose of bullying fairly well after the first sheer fright of it. But the realisation of this state of things sank into my mind. I hated it and I determined, if ever I could, I would prevent it. I knew then that cruelty was what I could not stand.

Soon I began to find out other things about myself. Although not a coward, I was hardly physically courageous. I got along with a certain amount of bluff and pluck. I could give as good as I got in the ordinary way. Then one day I discovered that I lacked some nerve which should have been there to meet the emergency, but being absent betrayed me to disaster. The experience was salutary. I never forgot the incident which humiliated me, but to a certain extent I was always subject to this nervous failure, which generally took the form of acute apprehension. If I had to face an ordeal of any sort I suffered an agony of suspense beforehand, although, quite often, when the moment came, I could become master of the situation.

My weakness affected me in odd ways, but particularly in games. Thus I was no good at cricket, which, above all, is a waiting game. Although I could run fast I never won in the Sports, because I never got off the mark with enough confidence. But at football, where I had time to get going and keep going, I soon showed enough skill to be singled out and it was not long before I was selected to play for the second eleven. My parents (especially my mother) were eager for me to show a certain proficiency in games. There were family traditions and it was tiresome, no doubt, to hear constantly of the prowess of my more athletic cousins. I remember a ludicrous but poignant incident.

It was Sports Day. For some reason neither my father nor my mother were present. As usual, I had belied the promise of my running in the heats and lost both my races by starting badly, owing to 'anxiety' nerves. Disconsolately I wandered round the playground, when suddenly I realised that a race was about to be run between three or four oddly assorted

boys, while a prefect was ringing a bell and shouting 'Any more for the Consolation Race?' Nearly everyone was drifting across the field towards the prize-giving. No one seemed to be watching this race. Here was my chance. Pulling off my blazer I toed the line just in time and won easily. At the prize-giving I was awarded a huge cup, not silver and certainly hideous, but a cup. I bore this home to Ghuznee Lodge. My poor mother, seeing me coming, rushed to the door, her face happy with pride. 'Oh you have won a cup! What was it for, dear boy?' The Consolation Race,' I sang out. 'Oh . . . oh! . . .' all the joy went out of her face. 'Well, never mind, come and tell me all about it . . .'

In school I was even less successful, by reason of another far more serious handicap. Again it was for the lack of some faculty that I was prevented from making progress. After a year's trial of my natural abilities one fact was clear. Although I appeared to possess a good average intelligence I was extremely deficient in mathematical calculation. Every examination showed the same result; my total suffered by the scores of marks lost in arithmetic, algebra and geometry. Actually, I was capable of quite complicated methods of computation to prove my sums. But the answers were fantastically wrong. It was as if, instinctively, I argued that two and two make five, or, on other occasions, no more than three. My unfortunate masters were in despair. The masters at Colet Court were patient and kindly men and among them no one was kinder or more patient than James Bewsher, our Head. But I think almost from the first, all those who attempted to teach me mathematics were baffled, and how I was able to progress at all I do not know. I think, sometimes, I must have been given marks for sheer perverse ingenuity. I have seen mathematical teachers reduced to a sort of awe by my imbecility.

For some time nothing drastic was done about this. My reports admitted that in other respects I had brains and could use them when I chose. In the holidays my poor father tried by every persuasion in his power to instil the knowledge that I lacked. My mother's eyes were anxious. What was I to do? Why was I such a fool?

In 1900 my grandfather died. For some while my mother had not been her normal self. Without being told anything definite I realised that some trouble was haunting our home. Often mother seemed disinclined to eat. I heard arguments about this between my parents. My father seemed annoyed, my mother irritated. My mother began to look thin and strained. Evidently something was wrong. Then one day we learned of a great new

plan, which caused immense excitement among us children. We were going to build a house in the country. We were leaving London to live in the country! Where was it going to be, everyone asked. It seemed most likely we should find a place not far from Langley. It must be somewhere rather near London, as my father would have to travel to and from the Temple every day. In the end he and I took a train one very sunny day and walked out from Langley station to a place called Iver Heath. At the top of a long, gradual incline, beneath the most beautiful trees, we came to the gates of a fairly large house almost hidden by its massive shrubberies. We rang the bell and were admitted into the presence of a venerable gentleman and two middle-aged ladies. This was the family of the Lovedays. The purpose of our visit was to persuade them to sell my father a piece of their land on which to build our house.

The Lovedays were by far the most cultured and talented family in the neighbourhood. They were closely connected with the stage, the brother of our landlord (as he came to be) was stage-manager to Henry Irving for many years and both the younger Miss Loveday and her brother, whom we met later, were extremely musical. All the family were well-read; all could speak two or three languages easily and all were devoted passionately to the arts.

After much discussion, which revealed the fact that our new acquaintances were people of fine sensibility and rather strong emotions, we were allowed to purchase an acre and a half of a field at the furthest possible distance from the house. We reviewed it from the terrace. It looked a pleasant spot and later, as we passed it on our walk back to the station, we tried to imagine our home there. A line of pollarded elms ran at right-angles to the road forming our eastern boundary; beyond that was a stretch of arable land belonging to the distant farmhouse. The road-hedge was thickly grown with holly, elm, hawthorn and briar. The dog-roses were just opening. In the ditch the red berries of the arums had thrust through their sheaths. There were birds everywhere. It was the real country, only fifteen miles from London.

The first effect of our going to live in the country was that I became a boarder at Colet Court. Both St Paul's and its preparatory school were primarily day schools; only a very small proportion of boys were resident. I was fortunate enough during my two periods in 'Houses', to live in the care of two human and kindly men, the genial Sam Bewsher and later the unique, beloved Cholmondeley of the High House.

The parting from home was less agonising now than it had been that autumn, only last year, when my family had prolonged their stay at Swanage and I was sent to stay with my aunt and uncle at Primrose Hill. Here, for the first time I knew the misery of homesickness. My aunt was a very pious lady and in those days rather severe. She had beautiful smooth, nut-brown hair. She was also my godmother in no uncertain sense, for on every one of my birthdays I was given either a Bible, a hymn-book or the Book of Common Prayer. When we went to live at Iver Heath and had our own pew in church, in virtue of my father having become the Rector's churchwarden, I was able to stock the entire length of book-rail from my holy library and to lend hymn-books lavishly to the neighbours as well.

My uncle was a tremendous specimen of a man, tall and powerfully built, with a handsome head hewn-out in Gladstonian lineaments. During the day he was at the Stock Exchange, but sometimes in the evening he would unhook from the wall of his little workshop where he loved to 'tinker', a huge banjo with a brown parchment face and a very deep tone. Then the family, which included an uncommunicative parrot named Cocky and a weak-minded spaniel, would be regaled with darky tunes – Swanee River and Poor Old Jo. This practice deepened my gloom. Aunt Maggie sang in a nice though nasal voice, but the rest of us showed little enthusiasm – the spaniel inattentive, the parrot seemingly critical but silent, myself dreaming of that sweet far-away mystery which I knew as 'home'.

On the third day I spilt the ink on an important carpet and was cast into disgrace. The crushing severity of the reprimand broke up my last defences, and I ran away to my room to cry. This lack of manliness made matters rather worse. I was not supposed to be sensitive. All that sort of thing was vested in my brother Jack, who was delicate and had silky auburn hair and very wide-open eyes. I was apparently robust and had no picturesque attributes. On the contrary, my hair was so black and thick and stubborn as to be called the blacking brush, and I had rabbits' teeth and an odd-shaped head.

My sole consolation during this unhappy visit was a strange supernumerary to the household, known as Old Charlie, a half-wit who lived by running errands. He seemed inseparable from that dreary neighbourhood by the Regent's Canal. He was very tall and loose-limbed, rather incoherent and progressed about his business with a queer raking shuffle in immense, broken and bandaged boots. One of his duties now was to take me safely to the 'bus which carried me every day to Hammersmith.

One morning we were hurrying along hand-in-hand down the hill, when on the broad pavement outside the public-house we found something horrible was happening. There was a man and woman and a little crowd beginning to edge up to them. The man was shouting in a violent voice, the woman was deathly pale. Suddenly, he hit her in the face; some blood splashed on to the pavement. 'You bloody cow', he shouted. I saw her begin to cry. I felt Charlie's hand trembling against my trembling hand. He tugged at me and we rushed along, Charlie muttering crazily. As I looked back the crowd had grown bigger and had shut in that dreadful sight, but it haunted me for a long time. Even now I can clearly see it and remember what I felt.

But all that happened two years ago. Since then I had almost become hardened to fights and minor brutalities. Bullying still put me in a cold fury, but after a year at Bewsher's the tables were beginning to be turned on the bullies, and at last I turned one on our oriental prince from whom I had suffered petty tortures as a new boy. His popularity as a freak had waned, so his protection had gone. I had to jump to reach his face. His pendulous, princely nose bled richly, then two great tears rolled down, mingling with the dark blood. I watched fascinated, feeling rather ashamed.

For the most part our recreations were pacific. Like all boarding schools without the benefit of country pursuits, we were turned in on ourselves. We had to get the utmost out of games which could be played in the playground or in the house itself. Naturally, we tired of the more orthodox and sought diversion in something imaginative. My terms at Bewsher's coincided with the reappearance of Sherlock Holmes in the pages of the *Strand Magazine*, as the principal figure in the new Conan Doyle thriller *The Hound of the Baskervilles*. It happened also that our House-master at that time bore an extraordinary likeness to the famous detective, and, to complete the setting, the under House-master possessed so many characteristics, both physical and mental, of Dr Watson that identification was inevitable.

The serial of the terrifying hound was followed by everyone and when it rushed by flaming into the fog, leaving us in an agony of suspense until next Wednesday, no one could talk of anything else. I distinctly recall the expression of scorn and disappointment which broke out as we snatched the new number. 'Sulphur! Oh I say, how feeble!' What we expected I can't imagine.

But the result of all this was an extraordinary infection which sprang up among us. We all became criminal investigators. A small group of us

persuaded ourselves that an attempt was being made to break into the house. Evidence accumulated every day. Scratches on window-sills, chisel-marks on doors, suspicious sounds and flashes of light – we worked up an atmosphere which not only got on the nerves of our house-master, Dr Watson, but in the end involved so much tapping and whispering that we ourselves became frightened and turned to a new preoccupation with some relief.

This was really a new aspect of an old pastime. Among our varied assortment of boys of all sizes, natures and degrees, we had one of obvious talent, a good-looking, quick-witted creature called Calthrop.[4] For a boy he had extraordinary histrionic power. He could make you laugh and cry. I have seen him entertain half the school with no other properties than a cricket-bat and an old hat. His influence on the house was paramount towards the end of his time, so we inevitably became absorbed and involved in anything theatrical we could manage among ourselves. This had been limited more or less to getting up revues and plays and generally forming backgrounds and audiences for Calthrop's individual 'numbers'. But lately we had been experimenting with a model theatre and now this became the rage. Everything to do with the theatre was now the fashion. Detection, mystery and horror were a yawning bore and utterly out of date.

As a member of the detective squad with rather more imagination than some, I had got a small reputation, enough to distinguish me from the herd. But now I became almost conspicuous. I had had a passion for theatricals ever since I could remember. I adored pantomime and scenes of phantasy and transformation. Once, Judge Darling's sisters had taken us to Drury Lane, which, incidentally, gave me my first insight into artificial beauty, but I laughed so much at Dan Leno that I wetted my knickerbockers and remained in misery for the rest of the party. Yet I remember nothing equal to seeing my first Punch and Judy on the pavement outside Kensington Gardens. That startling voice! I stood entranced, studying every movement of the dolls, and trembling with excitement as the ghost rose from the shadows of the box. I determined to have my own Punch and Judy show and plagued everyone's life until I had it. The box was rather an amateur affair, but we found a shop in Church Street, Kensington, where the real puppets could be bought, while Barbara had a conveniently flat, bored-looking dog which did for Toby. The curious part in all this is that I cannot remember getting a 'squeaker'. I somehow screeched naturally in imitation of Punch's queer voice, for which I believe I had a special faculty. I wonder?

Now, at Bewsher's, my early exercises in drama equipped me for dealing with the model theatre. I found, too, that even such feeble powers of design as I possessed were unique in the House. I invented, coloured and illuminated all the scenes, and was especially good at caves and rocky coasts. Later, it was discovered that I could act in a small way and give amusing improvisations – just enough to show how very much better Calthrop could do them. Not that he was jealous. He gave me every encouragement and when the time came for him to leave, with a final gesture, he cast his mantle upon me.

I now found myself virtually head of the House. Recently, I had been given the coveted rose-cap of the first football eleven; I was well up in the school and had been selected to cox Bewsher's Four on the river. I began to take a strange new pleasure in power. I found I could make people do things even against their inclination by sheer personal insistence. This went rather to my head. I became exalted and tyrannical. From being a decent small boy I became an insufferable prig. But even then events had started to move which prepared a pitfall for my pride. It began with the sudden discovery that St Paul's lacked the necessary 'machinery' for getting me into the Navy. I have never been able to understand this; nor shall I ever forget the occasion of its announcement.

I had just been promoted to the big school and had gone 'across the way'. Here I was in an entirely new world in scale and quantity. Everything was twice as big and there were double the number of boys. We seemed always to be moving about in dozens, scores or hundreds; going up and down flights of shallow steps, settling with a ceaseless humming sound upon long tables of food, or swarming over the green playground like ants—always rather like ants. The Principal of the termite community, however, was not at all ant-like.

On the third day of my occupation of a seat in the Great Hall my attention wandered for the twentieth time to settle idly on the immense images that overwhelmed the walls. There were monster representations in mosaic by Sir William Richmond of the more famous old Paulines, from Milton to Marlborough. Suddenly, a voice so huge in volume that for the moment it seemed to me to be identified with the great Duke broke on the stillness of the afternoon. I came to my senses to see, a few paces away in the aisle, a terrifying personage in a voluminous silk gown, whose angry gaze focused on me. 'You're doing no good here', bellowed the voice, with such a burst of sound that the hall echoed 'here', 'here', in a supporting

chorus. Everyone seemed to stop working to look at me. The next second a formidable stomach had overtaken the voice and was trained on me like a gun. Behind this I could see an enormous uncared-for beard leading up to a great God-like head, out of which blood-shot eyes were glaring and from which the voice was raising again in a deafening crescendo.

It was the first and the last time I saw Dr Walker.[5] Within a few hours my fate was decided and within a week it was arranged that I should be sent without delay to a Naval crammer, the one selected being the famous Planes, at Greenwich.

*

The Planes was an attractive residence perched high up on the side of the steep hill which led to Greenwich Park and the Observatory. The trees from which it took its name were two oriental planes which grew just inside the grounds and shaded the side-walk beyond. The entrance was through a gate in the high wall, and so, by way of a shrubbery, to an open garden and lawns, around which stood the private house, the school buildings and a gymnasium detached on the left. The Planes was run by a retired Naval Commander and he, in turn, was run by his wife, an American lady of more than human personality.

The system of education at the Planes was simple. You were there to be got into the Navy. The place was a crammer's, a place where they stuffed you with knowledge against time. If you didn't absorb the mental food quickly enough, they beat it into your head. There was no caning. That was too elaborate. Punishment was swift and direct. If you were slow or stupid you were cuffed till your head sang.

Each master had a different style. The Latin and History masters, both cultured men, preferred a deliberate slanting slap across the side of the cheek. It could sting damnably, yet somehow it was a fair blow. But upstairs was a class taken by a tall half-caste, who obviously enjoyed himself. He hit cruelly and viciously, his dark lips writhing back from his little pointed teeth. Once a week his place was taken by a drawing master. He was one of the few who had no terrors for me or anyone. But in moments of extreme exasperation he had an alarming habit of hissing through his thick, carefully-combed moustache. Everyone expected him to bite, but the wrath of this sheep was never terrible. The Commander hit with his clenched fist, generally in a blind, growling rage.

I should not like to live over again the first three weeks I spent at the Planes. As a new boy I endured not only the terrors of the class-room, but out of school, an ordeal of bullying far worse than anything I had known at Colet Court. Here you were hit with the blackboard compass for choice. It had a metal stud and you were lucky if it hit only your bottom.

By the beginning of the second week I was desperate. It did not take long to find me out. Fright and constant cuffing only made me more stupid. I became the butt of the class and even the other boys looked on me as a kind of moron. A crisis came one cold Monday morning when the Commander was taking us in arithmetic. Monday was his bad morning, when he was invariably in a state of hardly suppressed irritation, ready to explode at any minute. We were all cold, most of us had chilblains on our fingers. We stole uneasy glances at the Commander, who was going round almost in silence, but breathing too heavily to be safe. We knew that ominous quiet and we saw that he was gripping his ivory ruler. Suddenly there was a sharp tap and a yelp of pain somewhere behind me. I did not need to look round, even had I dared. The Commander had found a mistake and had rapped some wretched boy across his chilblains with the ivory ruler, a well-known trick of his winter term technique. I could hear him swearing and stabbing at the sum with his bit of pencil. He was coming nearer and he was in a black temper. I couldn't get my sum to come out. I knew there was an obvious fault, but I was par-alysed with fear, as in a bad dream. I heard the Commander's heavy hurried breathing by my ear and smelt his breath. The next moment I was knocked sideways out of my desk. With a roar of fury he began to shout questions at me, cuffing my head with heavy blows on the ears. I remained dumb and impotent. He yelled at me to sit down and correct my sum. A few minutes later there was a kind of half-strangled screech followed by a resounding slap, and the Commander's voice, hoarse and nearly inarticulate with passion. Two boys were whimpering and someone was crying rather wildly and blowing his nose in a noisy way. Everyone was now in a state of nerves. Even the clever boys began to make mistakes and get hit and cursed at. In the next class-room which was visible through the glass partition, I could see the History master dealing out his cool, judicious slaps. Then the far door burst open and a small fair boy from the half-caste's form hurried across to the lavatory, blubbering. I still sat looking at my sum. I couldn't think. I knew the Commander was coming back, but I was dazed and becoming desperate. In a moment he was on me again. Half-way through the morning he always went into his private house for ten minutes, presumably for a drink of some sort. He had just come

back, straight to my desk, by now quite beside himself with rage, bellowing or almost whispering, choked, literally with fury, and his first blow was such a wild swing that all his rings flew off and rolled over the floor. Immediately, there was a wild, sycophantic scramble to restore them. I was past caring what happened and I think this exasperated him even more. He fell on me without mercy. When he had done I escaped to the lavatory. My ears were bleeding and I could not stop crying. I wrote to my father, imploring him to take me away. I described what we had to go through. I don't know whether he took any action, but it was quite clear to me in his letter that I had to go on.

How long I *could* have gone on in these conditions I cannot imagine. I remember the longing for night to come and the terror of each new day. Now this sounds quite exaggerated, but then it was very real. Suddenly, however, everything was changed, and, as if by magic, I was lifted out of my tribulation.

It was a chance word that gave me a place in the first football game of the season. Our opponents were regarded as formidable and usually defeated the Planes XI. But I soon found the standard of play was below my average and it happened to be one of my good days. We won triumphantly after a tussle. I scored the winning goal and was chiefly responsible for our victory. At once from being the most despised creature in the community I rocketed to the state of a popular hero. But the most important feature of this extravagance was the behaviour of the Commander. To commemorate my generalship of this game he named me Julius Caesar. Henceforth I became Julius. Apparently, to be given a nickname by the Commander was immensely lucky. At the same time the Latin master changed my Christian name to Publius, a peculiar compliment, but more than all that, the power behind the Commander, familiarly known as the Mistress, called me her little-old-general-who-looks-at-me-with-one-eye-and-cheats-with-the-other. This had a curious significance.

Life at the Planes was ordered with one end in view – the making of a perfect midshipman who, in time, should grow into a perfect lieutenant and so on. We were trained hard physically. Besides games we were made to do long distance runs over the neighbourhood, generally involving the interminable Shooters Hill. No side of our development was overlooked. We had to learn to walk as well as to run, to sing a song after dinner, to dance with each other in a confined space without bumping into the Commander and to eat anything that was put before us. This last was my greatest trial.

We took meals in a long narrow room. Each wall was a mirror and there were narrow mirrors in the angles and up along the cornice to ensure complete reflection. From her place the Mistress could have a glimpse of everybody and every boy knew it. On the whole the food was good, but on Sunday we had to eat a joint that was unlike any meat I knew. Its grain was unusually coarse, it had a strong smell and its fat was sickening. After a few disasters I determined to avoid bolting it. By infinitely slow degrees, looking innocently at the Mistress the while, I would work the loathsome fat into an envelope and the envelope into the pocket of my Eton jacket. I think the Mistress knew all about this manoeuvre but mercifully condoned it, and so I became her little-old-general-etc.

In many ways she was a remarkable woman. Aside from the very efficient organising and running of the Planes machine, she took a personal and quite kindly interest in us all. She was a small lady with a good figure and an imperial carriage. Her wardrobe was obviously expensive to keep up with her jewels. On party occasions she seemed to radiate a faint blue light from her diamond encirclements. Her principal act was on Sunday when she inspected for Church Parade before we marched tophatted in columns of four down the hill to Greenwich Church. Each boy had to present for her scrutiny first his right ear, then his left, after which, at arms' length, his hymn-book held to show a clean nail on a thumb pressing down on a penny for the collection. Each in turn was summed up and dismissed according to his deserts, either with a playful buffet which carried him through the cross door into the next class-room, or a swinging backhander which sent him reeling back where he came from. It was better to have earned a buffet. Most of us would rather rouse the Commander's displeasure than his wife's. A backhander from the Mistress on Sunday, when she had all her rings on, was like being hit with a knuckle-duster.

But when we went up to London for the Annual Examination all these trials were forgotten. A completely different atmosphere was created. Oddly enough the examinations were held in one of the lecture theatres of the Royal Academy. Afterwards we were given luncheon in one of the smaller banqueting rooms of the Café Royal. Then, all formalities and restrictions evaporated under the genial charm of the Commander and the Mistress's gay raillery. We were given the best possible food always leading up to the delicious crisis of an ice pudding. After lunch the Commander tended to become lost in the human traffic of the Quadrant. On the return journey a few privileged seniors travelled home first-class with the Mistress, when

it was customary to take turns, two at a time, in scratching her back with ivory sticks, until the train drew into Greenwich station.

*

With my final failure to pass the Naval examination all intelligent effort to continue my education temporarily broke down. I was returned ignominiously to St Paul's. But before I left I had gained a curious position of leadership at the Planes, rather similar to that which I had held at Bewsher's and, again, it was partly through my ability to draw that it came about. As a caricaturist and an inventor of lampoons I led a campaign of persecution against an unfortunate bully left stranded by his gang going out on the tide. I had my full vengeance on bullies, but it left me only with a distaste for vengeance.

Since I had left St Paul's the great Dr Walker had died[6] and the authority who reigned in his stead regarded me with a dubious eye. I could hardly expect a very cordial welcome or very sympathetic consideration. The last thing I expected, however, was to be put on the science side of the school. With the burden of laboratory calculations – an alarming responsibility – added to geometry, algebra and arithmetic, I began to lose heart. As an awkward case I was relegated to the notorious Upper Transitus, where no one pretended to work and which had a reputation to keep up as the form which could not be disciplined. Here, ragging was a fine art, the greatest exponent of which was Boulanger whose buffoonery amounted to genius. The Transitus was never quiet or still. People were always walking about or falling over in false faints. Minor panics were frequent and conversation, interrupted by subversive noises, never ceased. Much of the din was made by the poor ineffectual little master shouting and beating his desk to instil order. Most of the books were piled on the floor or built into screens on top of the desks. Inside the desks might be found anything from toy pistols and motor-horns to a clutch of white mice. In this atmosphere I became rather demoralised. Most of the non-mathematical subjects were taken by a small sour man with a club-foot, who appeared to find it more amusing to exercise his very real talent for sarcasm than to teach. After a time I gave up work and took to ragging and other diversions.

My transference from Bewsher's to Cholmondeley's House, however, gave me a new lease of life and the only friend I was destined to make, the gay debonair Payne Gallway, who so soon afterwards went into exile.

At Cholmondeley's I enjoyed many things, but I cannot look back on this period of my life without distaste and disappointment. At home the spectre of my mother's illness had come nearer. All our resources were being pitted against it without avail. And now I looked like being another embarrassment to my unfortunate father when he most needed support.

One day, bored with the pandemonium of the Transitus, I availed myself of the usual pretext in order to take an airing in the corridor. Wandering up to the first floor I found it pleasantly flooded with the afternoon sun in which the modelling of the various busts and statues of the antique showed up well. In the middle of the corridor, perched on a stool, was a fair-sized swarthy boy drawing at an easel. I recognised in this phenomenon one, Kennington,[7] who lived not as other men, but like a bird, rather, on a perch, knocking off likenesses of the plaster casts and whistling tunelessly the while.

The highest forms at St Paul's were different sorts of eighths – the History 8th, the Science 8th and so on, among which it was said that Kennington comprised the Drawing 8th. What a life – to be free! No mathematics! Did the idea then and there enter my mind that such a life might be mine? I do not think so. No drawing I had ever done could be said to justify such a hope. I watched Kennington's skilful pen running and pausing, cross-hatching and dotting as the spit-image of Caesar grew upon the page. Caesar, Julius . . . I wandered away, lost in the strange thoughts and memories that arose . . .

III Openings

I

I was seventeen when the long and complicated purgatory of my school life came to an end. I emerged from it impaired in body and spirit, more or less ignorant and equipped for nothing. It took at least three years to build up my self-respect, and my education only began when I was at liberty to learn for myself.

Before I left St Paul's one more attempt had been made to enlist me in a respectable profession – that of an architect. But once more my disability where mathematical calculations were involved had been my undoing and I now had to face the fact that so far I had been a failure. I found, too, that in the opinion of a good many people, I was practically doomed to continue a failure. In those days the doctrine of 'getting on' was regarded very seriously, particularly in the families of the 'professional classes', and, of course, if anyone asked my parents how I was getting on, the report was discouraging. My father was warmly advised by friends and relatives alike to cut his losses and place me in a bank. A bank! I began to feel I was the victim of a ridiculous conspiracy which, because I was bad at figures, maliciously committed me to any calling wherein figures played an essential part. But my father remained unshaken, even by the advice of the oracle at Elm Park Gardens. Perhaps he remembered his own youth and how, of all people concerned, his father had been almost alone in supporting him in his rash resolve to read for the Bar, thereby throwing up the sure prospect of a comfortable partnership with his uncle, Sir Henry Darvil, an eminent Windsor solicitor. So when I proposed earning my living as a black and white artist or

illustrator of some kind, no objection was raised. In fact, everything was done to launch me on this precarious career.

Certain connections suggested a line of attack. Two early friends, or at least acquaintances of my father's, were focused upon, both of whom had left the law and become conspicuous in other fields, Stanley Weyman,[1] the historical novelist, and Reginald Smith of Smith, Elder & Co., the well-known publishers.[2] A third figure was also indicated as a possible ally, Mr Paxton, the newspaper draughtsman and illustrator, who had once or twice drawn my father in court. Thus, it came about that I began to illustrate the dramatic situations of Mr Weyman's romances by way of practice, and some time later took my drawings for the sympathetic consideration of Mr Reginald Smith, Mr Paxton having proved kindly but unable to help very much. Mr Smith, also, was friendly and extremely courteous, but when he eventually returned my drawing he expressed regret that he was unable to commission me, as he would have liked to do something to encourage 'your father's son'.

This phrase so fascinated me that it helped to break the fall, as it were, of my first disappointment. Nevertheless, one disappointment followed another for a long time. Eventually my first earnings were half a guinea as a landscape prize in the Holiday Competition of the Chelsea Polytechnic where I had become an art student – not much towards a living, as my Elm Park Gardens uncle remarked, with a sardonic intake of his moustache.

Stories of early struggles are rather like amateur theatricals, full of flattery, perhaps, for the actor, but pretty tedious for the audience. I have nothing romantic to offer. I was never near starving; I had always a home to come back to. At the same time, we were by then in difficult circumstances owing to the expenses of my mother's illness which began its inveterate course not long after we had settled at Iver Heath. Soon we were obliged to let our house, first for the summer months, then for longer periods. In such emergencies my father and I would retire to some cottage or rooms in the neighbourhood. Later, when the children came back from school and my mother was sufficiently recovered to leave the nursing home, we would flock back once more, only to be scattered again in a few weeks' time. I relate such details with reluctance. They are meant to explain the urgency I felt for making money so early in my career as an artist. Had I been able to begin studying at a proper age I might have made another thing of life, but to begin at eighteen with no apparent *natural* talent beyond an ability to compose out of my imagination was not encouraging, especially as I

realised that, somehow, within the next few years a living must be quarried from this dubious field. Such prospects might well have depressed me, had I not been of a rather careless and sanguine temperament. As it was, however, I felt stimulated rather than cast down. To be my own master, free to make my own way as I chose seemed everything. How I should have felt had my father's support weakened or had he shown signs of losing faith in me I do not know. But he never wavered, nor, apparently, did he worry. Without offering either criticism or advice he waited with a confidence which I now realise was the greatest encouragement I received during those early years.

I soon found that the Chelsea Polytechnic was of no use to me. At that period its instruction was not practical enough for my needs and I began to feel I was wasting my time. A fortunate chance brought me, however, into contact with a teacher there who knew the value of the commercial training to be found at some of the L.C.C. schools and accordingly suggested that I should try the one at Bolt Court in Fleet Street, where a cousin of his was secretary.

The school at Bolt Court turned out to be situated in the old house in which Doctor Johnson had lived and supported his human menagerie.[3] It was now given over to easels, 'donkeys', naked models and eager students. In the upper rooms were lithographic and etching presses. The whole place had an atmosphere of liveliness and work. Here were no amateurs or dabblers and no women except the models. The students were young men who worked at various commercial jobs during the day, coming here in the evening to improve their drawing, to practise design or to learn lithography and etching. The whole purpose of the school was avowedly practical. You were there to equip yourself for making a living. It suited me.

Soon after I had begun work at Bolt Court my mother died. My father and I were alone. At first the release from the strain of constant anxiety and the reaction of sheer grief which followed numbed us both. My father, I fear, suffered far more than I, being less absorbed and less occupied than I was at that time. But as the winter ebbed and the spring asserted itself, he slowly drew in the breath of life. Together we began to face a different world which gradually brought us the consolation of peace of mind and, in course of time, something like happiness. My chief regret was that by signing on as a student at Bolt Court I had, unthinkingly, committed a selfish act. The whole course of my day was now altered and I was obliged to leave my father with hours of solitude before him. His day was spent

in chambers or the courts, while I worked at home. But in the evening, almost at the same time as he returned, I had to set out for my night classes. Fortunately, he did not like going to bed early, so we were together for an hour when I reached home each night at about eleven.

What a strange existence that became for me as the year increased! I was fortunate in having so much of the day to myself. It provided then what I most needed, time for thinking and reading. My education was only now beginning. I was literally starting my schooling at nineteen. But now an unlooked-for influence began to shape my way. Instead of profiting by the commercial art training of Bolt Court and becoming a slick and steady machine for producing posters, show cards, lay-outs and other more or less remunerative designs, I fell under the disintegrating charm of Pre-Raphaelitism, or, rather, of Dante Gabriel Rossetti.[4] For some time previous to this, romance as a guiding force had gradually taken hold of me. The historical romances of my early author Stanley Weyman soon gave place to something more deep and potent – *The Morte d'Arthur* and, thence, to poetical romance and its less remote practitioners, Tennyson, William Morris and so, head over heels, into poetical adventures of all sorts, but with no very clear direction. Each discovery of a new writer was a fresh, disturbing shock. Keats, Whitman, Blake and Coleridge shook me in turn. My friends the Lovedays were passionate admirers of Robert Louis Stevenson, so, inevitably, I was enrolled among them and continued to absorb most of that writer's prose until I discovered Carlyle and Borrow and began to rejoice in the extravagant gestures of *The French Revolution* and the eccentric, robust personality of Lavengro. The latter fascinated me. The vivid pictures of England and the imaginative projection of her inhabitants, as conceived by Borrow – I had found nothing like it. This was poetry of a new kind. But still the personality of Rossetti dominated. I read every word relating to him and knew almost every poem and picture. Owing to his example I began to practise his dual expression and it was one of the first fruits of this experiment which earned me the recognition of an undoubted authority. But I must first describe certain circumstances which led up to that important occasion.

Three influences were responsible for my beginning to write poetry. As a poet-painter Rossetti was, to a certain extent, supplanted by Blake, although the former exerted a stronger hold on my imagination by his personal life, as rather unfairly depicted by the biographers of that period. In later times Rossetti's portrait has become less attractive, the moth and

rust of realism and the insistent gnawing of candid friends having cor-
rupted it. But when I was nineteen I wished to be another Rossetti. So I
began to write verse. The second factor was one of time. Each day I spent,
in all, an hour bicycling and two hours in a train in my journeys to and
from London. But it was rather the character of these journeys than the
length of time on my hands which affected me. My road from home to
Uxbridge station was varied and delightful. At the end of our own lane
where slight evidences of the ancient heath showed in the tufts of heather
and furze on the grass marge, were five cross roads and a belt of firs, a gift
to highwaymen of the last century who must have lurked there, if they
were not stationed at the Crooked Billet at the mouth of the forest tunnel
of Black Park, half a mile to the west. Turning to the east I rode across
the open plateau to the farthest end of the scattered village of Iver Heath
where the road suddenly dips into a switch-back across the Iver road and
so to the top of its steep hill and on again until, rounding a corner, it faces
an almost precipitous fall into the valley of the Colne. This was Chandlers'
Hill, a notable feature of the neighbourhood and the clearest demonstra-
tion of the sudden change of altitude between the plain and the heath. It
was a formidable hill whichever way you looked at it. You needed to be
sure of your brakes in descent and most cyclists had to dismount half-way
up. On the right ran the wooden palisade of Earl Howe's territory, while
to the left, over the hedge with its graceful ash trees, lay rich grass fields
and small farms. At the bottom the hill took a sudden twist, in which
lay its danger, and ran over a little bridge into the Uxbridge Road. This
spot was known as Alderbourne Bottom, which took its name from the
Alderbourne, a narrow tributary of the Colne, which flowed at the foot of
the hill. This bridge, with its low-talking stream, became a place of great
meaning for me in those days, or, rather, I should say, in those nights, for
it was at night on my return from London that I found enchantment as I
dismounted before climbing Chandlers' Hill.

In order to catch the fast ten o'clock train from Paddington, I had to
leave Bolt Court before the classes broke up for the evening. I had to
hurry down Fleet Street into the wilderness of Farringdon Road, at that
hour in the process of purification by all sorts of sweepers, human and
mechanical, most of which seemed to raise more dust than they laid. This
sordid thoroughfare had a stale fetid smell which was unrelieved in its
whole length, except where the fried fish or tripe shops belched their
overwhelming stench across the pavement, so that I arrived at the station

thankfully. Thus, what is called by journalists 'the breath of the streets' had an early and special significance for me. Imagine, then, with what relief, after a tedious journey involving two changes, I reached at last the sweet Alderbourne talking in its limpid tones in the still night. For talk it did, most convincingly, nor was its voice the only one I could hear, as I leaned on the parapet.

These journeys through the night, this halt by the stream, and this voice, made up the influences which compelled me to write poetry. For now I needed an outlet for a new thing which had begun to stir in me and growing, gradually to absorb my whole mind and body, the strange torture of being in love. Henceforth, my world became inhabited by images of a face encircled with blue-black hair, with eyes wide-set and luminous, and a mouth, like an immature flower, about to unfold. But the whole countenance, as I saw it so often in my dreams, seemed remote, untouched by human warmth, lit only by some other radiance which poured out of the eyes in their steady gaze – unaware of the mundane world; certainly unaware of me.

With all the ardour of a passionate disciple of Dante Gabriel I began, inevitably, to set this face in my drawings, the new Beata Beatrix. Nevertheless, at about this time my mediaeval phase was already waning. The illustration of poetic episodes in romances no longer absorbed my invention. Instead, I began to turn to Nature for my scene, whilst the personages of that scene began to derive from my own imagination.

The reason for this was largely the decline of my god Rossetti, and the gradual establishment of other gods who, through my worship, served me better. To live in those little close rooms of Rossetti's, so charged with the intense atmosphere of romantic love, produced in me a tingling sensation in sympathy with his mood. I felt the anguish of those imprisoned lovers. . . . I, too, counted the heart-beats in the silence—

> '. . . when in the dusk hours (we two alone)
> Close-kissed and eloquent of still replies . . .'

But I began to realise that my fixed attention was wandering, that with the succession of Lancelot and Guinevere, Hamlet and Ophelia, Paolo and Francesca, a feeling of constriction was invading me and that my tingle was the exquisite but crippling sensation of pins and needles. Very slowly, as one must in that predicament, I began to stretch my cramped limbs and then, very softly, for I felt a renegade, I crept from the room. I might have

spared my caution. No one and no thing noticed either my presence or its departure. The lovers stayed locked in their anguished embrace, the chained monkey continued to pick the rose to pieces, the boarhound of unsure anatomy still slept by the side of the lance and the shield. On the window-sill the dove lay dead. Outside the door I passed the frenzied eavesdropper among the shadows.

I emerged into open spaces. Led by the voice of Lavengro I followed on to the heath.

In those days I knew nothing of the sea or the magical implication of aerial perspective across miles of shore where waves alternately devour and restore the land. But among the poems of Blake I found one which arrested my thought. Its message for me seemed in accord with that call to the heath, an exhortation to open my eyes and look about me, above all, to look up, to search the skies.

'To my friend Butts I write
My first vision of light
On the yellow sands sitting.
The sun was emitting
His glorious beams
From Heaven's high streams.
Over sea, over land,
My eyes did expand
Into regions of air,
Away from all care;
Into regions of fire,
Remote from desire;
The light of the morning
Heaven's mountains adorning;
In particles bright
The jewels of light
Distinct shone and clear.
Amazed and in fear
I each particle gazéd
Astonished, amazéd;
For each was a man
Human formed. Swift I ran,
For they beckoned to me,

Remote by the sea,
Saying: Each grain of sand,
Every stone on the land,
Each rock and each hill,
Each fountain and rill,
Each herb and each tree,
Mountain, hill, earth, and sea,
Cloud, meteor, and star,
Are men seen afar.'

The strange import of this poem, which has even more meaning for me to-day, penetrated my consciousness insidiously. I began to form a habit of visual expansion 'into regions of air'. I believed that by a process of what I can only describe as inward dilation of the eyes I could increase my actual vision. I seemed to develop a power of interpenetration which disclosed strange phenomena. I persuaded myself I was seeing visions.

These generally took the form of faces and figures in the night sky. The first occurred to me in the western sky one night as I turned into Wood Lane from the junction of the five cross roads on the heath. When I reached home I drew an immense figure of a woman whose head and body were partly articulated by stars, but whose feet were composed of the reflection of stars in a pool, so that the effect was of a being established in three elements, water, earth and air. After that I began to imagine or to see all my drawings. For the first time I was realising things for myself. I imagined a wide, slow-moving river flowing between fields of poppies and orchard trees. The surface of the stream was covered with human heads upturned in sleep and carried gently along by the tide. The fields were being scythed by winged reapers and above the distant hills a huge dolorous face appeared with hair streaming across the sky and threaded with the feathers of its flat outstretched wings. Underneath this design I wrote 'a poem' of sentimental symbolism which later I regretted and destroyed. Nevertheless, the drawing was to have far-reaching effects.*

The monthly sketch-club exhibition at Bolt Court was something of an event. On these occasions a well-known artist or a technical expert was

* A better drawing and a better poem was about an angel fighting a devil on the top of a hill. It is reproduced in this chapter because it is, in my view, the best of its kind. — P.N. [The work Nash refers to is *The Combat, or Angel and Devil*, 1910.]

invited to judge the entries, and it seems that we were able to command, or rather, I suppose, to persuade judges of high calibre to give us their time. The exhibition of one of my first contributions, a pen drawing designed to illustrate Rossetti's poem *Staff and Script*, happened to coincide with the visit of about the only contemporary artist likely to notice it, namely Selwyn Image, who was shortly afterwards appointed Slade Professor at Oxford.

'Contemporary' is not an accurate description of Selwyn Image at that date. He was the last conspicuous pre-Raphaelite before the second advent in the person of Stanley Spencer. A small man, rather like a wise and genial abbé in appearance, he seemed to be inseparable from a cigar, which he alternately drew at and regarded with an absent eye, while speaking in very precise and mellifluous language. Incidentally, he was an inexorable entomologist and is known to have once caught a rare moth (the Convolvulus Hawk) in Sturge Moore's back hair. But of this I knew nothing at the time of our meeting which was effected through the secretary who, somewhat impressed by the honour done me, conveyed an invitation to take tea with Mr Image in Fitzroy Square the following week.

I shall always feel grateful for that invitation. It marked the first occasion of my entry into another world. As a family we had no social-artistic connections, except that as children we used to play with Constable's grand-children, whose mother's brother Richard Holder married our aunt. But we had no 'contacts' of a contemporary kind, and I suppose Selwyn Image was the first artist of any distinction whom I met and whose house I visited. Here he and his wife made me welcome and showed me the collection of moths and butterflies. Here, too, I got to know and respect the austere craftsman-like designs of this robust inheritor of the Morris tradition.

To have attracted such attention by one of my first exhibited drawings was naturally very encouraging, so on the next occasion I sent in my river composition with its accompanying 'poem'.

When I arrived at the classes on the evening of the exhibition there seemed to be an air of excitement among the students. But before I had time to investigate, the door opened and a remarkable-looking small figure entered abruptly. Close behind followed a magnificent being, somewhat obscured by a wide hat and a high collared cloak. The head of the first was very dark and round, with round dark eyes and questioning eyebrows behind round spectacles. The expression of this head was one of acute

intelligence and the carriage almost imperious, as of a person accustomed to command. The second possessed a countenance rather than a face, the profile of an actor, but in no sense empty. It was a beautiful countenance, yet its expression was baffling. The countenance of a dreamer, of a genius perhaps, with its mane of light hair. Who were these? I asked eagerly. The little man, Will Rothenstein, the other Gordon Craig.[5] Both these names were familiar to me, of course, but I had seen little then of their work. It was enough that their visit was an unusual honour and their judgments far beyond ordinary professional worth.

It soon appeared that Gordon Craig was not to participate beyond taking a somewhat amused interest, at times swooping and scrutinising intensely, like a falcon from the upper air. But Will Rothenstein talked on and on. I was amazed at his fluency; from the moment that wide, judicial mouth opened a stream of easy, persuasive and ingenious talk flowed out, full of shrewdness and wit. As I listened and heard the judgments and award of marks, my whole heart became heavy. The unerring gaze had swept the room, nor was my picture missed – merely unmarked. Perhaps it might get four out of the possible ten. I groaned with disappointment and was beginning to make my way out when I was aware of a sudden pause in the speaker's talk. He seemed to have asked a question and no one seemed ready to reply. Suddenly I realised the question concerned my drawing. Was it, I was asked, when located and pushed forward – was it a personal expression? I gathered he referred to the poem as inspiring the design. I admitted both were my own. There was a moment's pause, like that moment's time when the clerk comes behind the judge and places a small black handkerchief on top of his wig. With a slight sound as of the passage of huge wings, Craig pounced from the skies, peering myopically at my drawing, with an increasing smile. Then Rothenstein passed sentence in a few memorable words that I have forgotten, except for the last five which sounded almost defiant: 'I shall give it ten.'

Several months were to pass before I saw Will Rothenstein again, when, portfolio under arm, I climbed steeply to Frognal. I remember I carried with me not only my latest drawings, but a letter – a letter of which I was extravagantly proud, the words of which had exhilarated me to an almost absurd degree.

It had reached me in a curious way. The Iver Heathans, as they were sometimes called, among whom I lived, were not, on the whole, a very cultured people in an intellectual sense. But here and there were ladies

who 'read a great deal' and into whose nets, as it were, strange fish would sometimes come. One of these ladies described to me a fish of this sort. It had come from a poet in the North who was known to her family. It was a thin, square book with an ominous title, *The Crier by Night* by Gordon Bottomley. I had lately been reading Yeats' early poems, *The Wind Among the Reeds*, which had made a strong appeal to me. When I began to read *The Crier* I soon realised by whom it was inspired. But its voice was distinctive, a harsher, even stranger voice and more compelling. Throughout the ghostly drama a dark mood prevailed, impregnating the scene and giving its puppet characters a superreal life. This mood, the nocturnal scene, the mysterious, horrific nature of the Crier and the extravagant poetic language seemed to accord with my own imaginative experience – my familiar world of darkness, the voice by the Alderbourne and the giantesses of the night skies.

Without considering the sanctity of property I began to illustrate the book, drawing in pen and ink a vignette of the marsh sucking under the herdsman, and a full-page design of the crisis when Blaned opens the door on to the marsh and stands swaying with eyes shut against what she dare not see to be even now crossing the threshold.

I returned the book thus decorated, with some misgiving. But my impertinent enthusiasm was taken in good part and was, without my knowing it, described to the poet who wrote asking to see what I had done to his play. My kind friend saw in this an opportunity to introduce my work generally and to obtain, perhaps, some valuable criticism. So a packet was made up consisting of the kind of drawings we imagined were most creditable to me and most likely to appeal to Gordon Bottomley.

I waited the return of my packet with apprehension. The opinion of such a poet must weigh with me considerably. Supposing he found nothing in my work? It was crude, I knew, and my powers of drawing showed their limitation in all directions. At length the parcel arrived, containing besides the drawings, a letter, the sight of which made me pause before reading it, so individual and beautiful was its calligraphy. It was the first of many to be written to me, yet I do not think I have ever received a letter from Gordon Bottomley without experiencing a slight thrill at its appearance. But if its form was moving, the content surpassed the bounds of anything I could have anticipated. It expressed in the most generous terms an admiration for my drawings which I could hardly understand, but which I was forced to believe in by the obvious sincerity and intelligence of the

appreciation. The effect was to send my self-esteem rocketing to a giddy height, while it increased my confidence and stimulated my production. I wrote back eagerly, pouring out my hopes and doubts, my troubles and ambitions, and received in reply an even longer letter closely, miraculously written from which I quote in part. 'I do think you have true imagination in a degree which you can develop to a very fine insight and vision if you will,' he wrote. 'Art needs steadfastness and endurance just as much as tropical exploration or football do. Many weaklings can be brilliant at a spurt; but it needs much concentration of nature to do even as much steady glowing as a glow-worm does. And I don't think you are a weakling, or your drawings would not contain so many rugged and (if you will forgive me for saying so) sincerely uncouth places. Perhaps you have more natural ability than you think; but if you have not it does not greatly matter. If you *live* your idea ardently enough it will help you to its own proper utterance. . . . The ordinary art-school . . . is of little use to you; that kind of school teaches people to draw with a smooth steady sweet nerveless line which enables them to avoid making a positive and personal statement about anything . . .'

At this time Bottomley was a complete invalid, propped up with pillows and almost unable to move – the victim of a defective lung. If he travelled, it was with the greatest difficulty, so we did not meet for a long time. For three years I knew him only through his letters, but in the early spring of 1913 he was able to come South on a visit to his old friend Robert Trevelyan at The Shiffolds, where I, too, was invited to stay.[6]

2

Some time after my preliminary encounter with Will Rothenstein, my participation in a poster competition at Bolt Court brought me again to his notice, and later, he wrote inviting me to come to see him some day at Hampstead and to bring my drawings. I did not immediately comply, but one day a casual acquaintance and admirer of the painter urged me so strongly not to miss such an opportunity that I hastened to construe what had seemed only a vague invitation into something more definite.

The house in Hampstead was at the top of Frognal and had a sweeping view over London from the large windows in the back rooms. Ushered into one of these I became aware of a new visual experience. For the first

time I realised I was in the presence of taste. I was kindly welcomed and introduced to my hostess who at once encompassed me with a gracious yet enigmatic smile. But my attention was constantly diverted from the occupants of the room to the room itself. The austere beauty of its lines and intelligently considered spaces, its colours in a low key, set off with perfect effect the many lovely pictures and objects, which had been selected with subtle discrimination to enhance the simple forms of the furniture, most of which was very plainly upholstered. All this was so new and interesting to me that after a while I begged to be allowed to examine it in detail. Will Rothenstein cordially agreed and I began to make the acquaintance of Indian drawings, Cotswold furniture and the dignified compositions of the New English Art Club. Then I was shown some particular treasures – a drawing of his landlady's child by Rossetti and the sketch for his unfinished painting, *Found*, both acutely beautiful, the painted fans of Conder, some John drawings and a landscape by Steer[7] which I have never forgotten.

After tea the drawings I had brought were examined and Gordon Bottomley's letter was read, Rothenstein exclaiming with pleasure at Bottomley's description of his northern garden, 'Spring touches tentatively here'. After a little consideration he gave his opinion. 'You should go to the Slade,' he pronounced, 'and learn to draw.' I accepted the suggestion as a sound one, but pointed out that I could not expect my father to find the fees just at that time. 'Well, then, why not make them for yourself?' replied Rothenstein, without hesitation. I must confess I hardly felt equal to the task as I stood there looking down at my raw efforts – the efforts of a hand which had yet to learn to draw – while surrounded by the evidence of so much accomplishment and finished achievement. But I could not show doubt to someone who, in some unexplained way, seemed to believe in me – or so I imagined. Then there came into my mind the words of Blake—

'If the sun and moon should doubt
They would immediately go out.'

Doubt was no use. I left Frognal determined to make the fees for the Slade, bearing away, as I did, many encouraging and stimulating thoughts which the conversation of Will Rothenstein had aroused.

My resources for earning were by now slightly increased. For some time they consisted only of small fees for designing bookplates. I began by

providing a zinc block and fifty prints for half a guinea. The designs were made in pen and ink and printed by a local commercial printer. They were generally extremely complicated, as they set out to interpret the personal qualities of the owner. I was soon able to raise my fee to a guinea and eventually to three, but most of my designs brought me only a little more or a little less than a guinea clear profit.

I now turned again to the idea of book illustration. This time, however, I thought I might invoke a commission on the strength of my imaginative drawings and with this end in view I secured an appointment with Elkin Matthews.[8] But we did not get very far. He was a little sallow man with tortoise-like eyes. When I showed him the giantess in the night sky he remarked with condescension, 'Ah, a very pretty conceit!' Conceit!' I echoed indignantly, 'it is a vision.'[9]

I then made a more direct attack. My greatest ambition was to illustrate a book of Yeats's poems and I therefore sought the advice of Rothenstein. 'Send him a letter and a drawing,' I was told. 'That is the right thing to do, for a young man. To [Augustus] John a poem, to Yeats a drawing.' I cannot remember whether I followed this advice literally, but in course of time I was invited to a strange house in Woburn Place, where in a shadowy room upstairs I found Yeats sitting over a small dying fire. He was less condescending than Elkin Matthews, but inclined to be suspicious, and, as a specialist in such matters, probed me with a few languid questions, peering at the drawings the while and smiling at me with an amused air which I found disconcerting. 'Did you really see these things?' he asked. Before the master of visions seated in his own ghostly room which was growing darker every minute, it seemed necessary to be uncompromising. But I did not feel he was convinced, or, if he was, that he was interested enough. I was rather glad to get into the narrow street again, and later, when a letter came to say that his publishers were not favourable to the proposition I had made, I was less downcast than I had expected.

But now a quite unlooked-for thing happened. Without seeking or anticipation of any kind I suddenly acquired a patron. A house at the end of our road had been sold to some people from London, a widower, his daughter and two sisters. He was a well-to-do banker in Smithfield, but his nature was pantheistic and his spirit lived upon poetry. Soon after we had exchanged visits he saw the drawing of the giant figure in the night sky and, with a slight preamble, offered to buy it. Five guineas was agreed

upon as the price. This was indeed encouragement; it was positive success. My joy and astonishment were shared by my father, who that evening sat down to write a letter to my sceptical uncle on some matter of trustee business. I could imagine the postscript. 'You will be glad to hear that Paul has sold a picture to our new neighbour ...' I watched the firm characteristic letters forming under the J pen, as he addressed the envelope – 60 Elm Park Gardens, London, S.W. Our flag flew in the breeze.

It was to this new friend that I now appealed. I had recently designed him a bookplate which had been a failure. I made a new design which he accepted, and hearing of my plans for studying at the Slade, commissioned a copy of *The River of Life*, if I could see my way to eliminating 'the terrible flotsam borne by the river' – meaning the floating heads. So I made a new version and earned something substantial towards my fees. Thus, in one way and another, a title page for a Cheltenham guide-publisher, various bookplates – I do not remember what else – the amount necessary for a year's training at the Slade School was at last collected, and one morning at the beginning of term I approached that inscrutable building along the curving asphalt path which flows like a grey stream between the bright green lawns.

The dominating personality at that time and, indeed, until the day he retired many years later, was Henry Tonks,[10] or Tonks, for no one ever referred to him otherwise. In my period, the Principal was Professor Fred Brown, while Wilson Steer encouraged painting, but Tonks was the Slade and the Slade was Tonks. As a new student I sought an interview and confidently displayed my drawings, secure in the good opinion of at least two authorities and already beginning to be collected. But Tonks cared nothing for other authorities and he disliked self-satisfied young men, perhaps even more than self-satisfied young women, if any such could be found in his vicinity. His surgical eye raked my immature designs. With hooded stare and sardonic mouth, he hung in the air above me, like a tall question mark, backwards and bent over from the neck, a question mark, moreover, of a derisive, rather than an inquisitive order. In cold discouraging tones he welcomed me to the Slade. It was evident he considered that neither the Slade, nor I, was likely to derive much benefit.

But if the head priest showed little cordiality, the young acolytes were hardly more warm. Not that the Slade resembled a temple in the least, not even a temple of art. It was more like a typical English Public School seen in a nightmare, with several irrational characters mingled with the

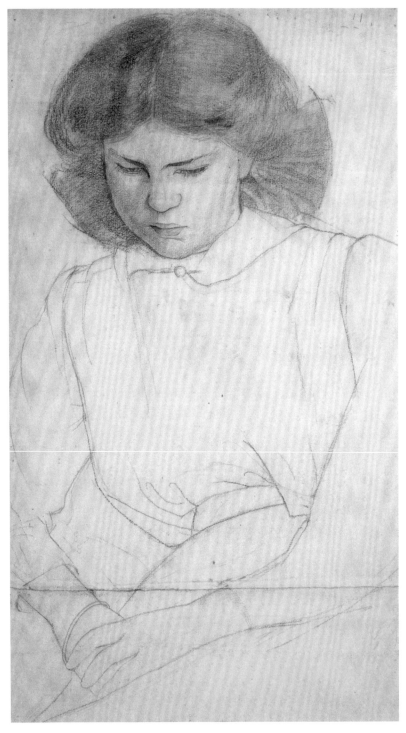

Paul Nash, *Barbara Nash*, c.1910, pencil, charcoal and ink wash on paper, private collection

conventional specimens. Certainly, in atmosphere, it differed very little from St. Paul's at its chilliest. I think I associated groups of art students vaguely with camaraderie or some such romantic stuff. It required all my so-called public school training to take my place at the Slade, and I will confess it began in the Antique Room among the casts. Only in the late afternoon was I admitted to the life class for a session of short poses.

The Slade at that date, about 1910, was in one of its periodical triumphal flows, when from the unknown deeps arise a few gifted ones. And now, upon the crest of the wave, were riding nearly half a dozen – Stanley Spencer, Mark Gertler, William Roberts, Edward Wadsworth, Charles [sic] Nevinson, to recall a few at random. Nevinson, ex-Uppingham, was the school bully, in a playful sort of way, on a mental, rather than a physical, plane—I do not remember any scenes of violence. He invented the tortures for self-conscious new boys. There was a tall one, with very curly hair, called Wheeler. When he came into the life class everyone uttered baa-a-a like sheep. But I don't think the subsequent professor of archaeology was really aware of this: certainly no curl of his hair uncurled. Then there was a very nice man who arrived every morning in a taxi, wearing dancing pumps. He was called The Duke. I came in for Nevinson's sarcasm because of my rather neat appearance. In those days I wore stiff collars, conventional suits, a hard hat and spats. Nevinson asked me publicly whether I was an engineer. It got a laugh and I felt a pariah. It meant that I did not 'belong' and, looking around from Gertler with his Swinburne locks and blue shirt to Roberts and Spencer with their uncompromising disregard for appearance, or Nevinson himself with his Quartier Latin tie and naive hat, I was forced to accept the implication. The butt of the school, however, was a delightful person called Have-a-smoke, from his ingratiating habit of offering everyone a cigarette on every occasion. He was impervious to ridicule and seemed to live in a world of his own. Even Tonks could not, or perhaps would not, snub him and was forced to listen to endless theories on painting from this strange bore who contended that vermilion was the proper ground for painting a head because blood was just beneath the skin. Have-a-smoke once commissioned Gertler to paint his wife, watching him the while. At every successful touch of the brush, Have-a-smoke called out 'Good stroke, Gertler, oh, good stroke!' Gertler told us he felt as if he were playing cricket. . . .

I soon found my conventional appearance was not wholly against me. Other creatures of like habit, once their natural reserve began to thaw, seemed inclined to make friends. The most conspicuous of these was one

Brooks, whose other names were Ivan Wilkinson, which committed him to being generally known as Wilkie. He was good-looking, a dandy and a kind of wit, not so much by virtue of the things he said as by an irresistibly amusing method of talking, which made him the most charming companion. It was this quality, I think, which attracted another newcomer to the Slade, whom at first I could not place, so greatly did he seem to differ from the other students. In appearance he was rather short but very strongly built, with a physical poise which suggested he was in some way athletic. His face was remarkable and vaguely familiar to me. I felt sure I had seen someone like him recently. 'Tell me, my dear,' remarked a lady to her companion at some Private View, 'who is that young man with the three-cornered head?' It was not altogether an impertinent description. As we three were sitting on the grass in the interval, Mark Gertler approached and in his imitation Oxford accent, one of the best of his clever repertoire, said, 'Oh, Nicholson, how does your father paint those *marvellous* black backgrounds?' At once I remembered. So this was the son of the famous William Nicholson whose portrait by John had been recently exhibited and whose photograph I had seen in the *Tatler* the other day, showing him in his latest spotted dressing gown. William Nicholson was then particularly conspicuous as an artistic personality, no other painter being quite so brilliant an executant. All his work had an air of easy mastery and good quality, like something hall-marked and immaculate. This air of quality distinguished all that concerned him from his children (each of whom seemed to be talented) to his schemes for decorating his house and his person. This 'person', I learnt from his son, never appeared without a black stock, whether in evening dress or on the tennis court.

Ben Nicholson and I soon became friends, and I was taken to his home in Mecklenburgh Square to meet his people and see the blue ceilings. I seem to remember a good many effects in the Nicholson home which ecstatic interior decorators have 'invented' twenty years later. In fact the Nicholson aesthetic was comfortably ahead of its times. Or was it really absolutely of its times? . . . Blue ceilings, black mirrors, maps on the walls.

In the early part of the new year, snow lay on the Downs and yet we were close to spring, when Ben and I went to spend a week at Rottingdean where the Nicholsons had a charming house. Here again was evidence of the amusing family taste applied with a slightly different flavour to adjust it to country life. Everything was bright and gay and calendered. The family was away, so we had the place to ourselves. We lived very simply.

Ben, who already showed a fanatical partiality for anyone or anything that absorbed him at the time, was then being fanatical about cornflour blancmange which likewise had a calendered look. We devoured it incessantly with bright coloured jams. Our diversion from Rottingdean consisted of visits to Brighton, where my so-called 'cousin', Nell Bethell, lived with her mother.[11] We both enjoyed Nell's company for she was intelligent and pretty and had a fascinating stammer. The only slight drawback was that, after our visits, Ben and I stuttered helplessly all the way back to Rottingdean and often far into the evening.

When we returned to the Slade, we both began to establish our rather unsure positions and to make new friends. The Slade was then seething under the influence of Post-Impressionism. Roger Fry had brought about the second exhibition of modern continental art in London, and now all the cats were out of the bag.[12] The first demonstration had caused quite enough disturbance one might think. But it was nothing to what followed the second opening. It seemed, literally, to bring about a national upheaval. Probably it was the relentless distortion of the human figure which was responsible for this – in a sense, 'the rage of Caliban at not seeing himself in the glass'. It is true that every canon of art, as understood, was virtually shattered, but this, I think, only acutely affected Royal Academicians and art critics. Sir Claude Phillips of the *Telegraph*, for instance, the most honest and uncompromising of them all, threw down his catalogue upon the threshold of the Grafton Galleries and stamped on it.

All this had a disturbing effect at the Slade. The professors did not like it at all. The students were by no means a docile crowd and the virus of the new art was working in them uncomfortably. Suppose they all began to draw like Matisse? Eventually, Tonks made one of his speeches and appealed, in so many words, to our sporting instincts. He could not, he pointed out, prevent our visiting the Grafton Galleries; he could only warn us and say how very much better pleased he would be if we did not risk contamination but stayed away. What effect, if any, this appeal had I do not remember, but as far as I was concerned it made no difference either way. I was left untouched by the second Post-Impressionist exhibition, as by the first. I remained at the point I had reached and continued to make my monochrome drawings of 'visions', some of which were supplemented by 'poems'.

Among the few people at the Slade who seemed in the least interested in what I was doing was a slight dark man with a strange voice. It was rather high-pitched and curiously uneven in tone, yet in its uneven,

Paul Nash, *The Three*, 1912, ink, chalk and watercolour on paper, private collection

slightly sing-song progression oddly attractive. He had profound magnetic eyes capable of laughing, a nose of which it occurred to me George Borrow must have had the fellow, and hair that was dark and thick above a high bony forehead. Claughton Pellew-Harvey was about my age. A cadet of the Essex family he had a romantic inheritance. Certainly, he was the first creature of a truly poetic cast of mind that I had met. We had much in sympathy, although I had more to learn than I could possibly give. His own work was remarkable for a searching intensity both in thought and technique. It was full of suggestion to my unformed mind, a valuable corrective to my too hasty methods and impatient effects. I began to appreciate the virtue of finish, the fullest possible statement of the mental conception.

These things we often discussed, or, as often, poetry, love, women and, of course, our own love affairs, in which, again, we found much in common and I again learnt something from my new friend. An exchange of visits to our homes followed. Pellew-Harvey lived with his people in a large, comfortable house at Blackheath. On this visit I returned to that neighbourhood for the first time after the unholy interlude of the Naval crammer five years before. I saw again the hated walks, the tyrannous roads we had to run on, and the bleak, cold heath, and had to try to undo the evil lesions of memory and to see anew the character of this place which contained so much natural and artificial beauty.

But it was on my own 'heath', for me at least, that we spent such memorable days when Pellew came to stay at Iver Heath that autumn. Hitherto I had attended chiefly to his ideas upon painting the human figure, more particularly heads. My own attempts to draw from the life were still incompetent. Tonks, not unsympathetic now, deplored my lack of science gloomily, but without sarcasm. Painfully I drew on. But the human figure as represented by the models at the Slade did not interest me, I could make nothing of it. But now, as we walked in the fields, Pellew began to interest me much more in what he talked about. I found he had a deep love for the country, particularly for certain of its features, such as ricks and stooks of corn. At first I was unable to understand an almost devotional approach to a hay stack and listened doubtfully to a rhapsody on the beauty of its form. Such objects, and, indeed, the whole organic life of the countryside were still, for me, only the properties and scenes of my 'visions'. Slowly, however, the individual beauty of certain things, trees particularly, began to dawn upon me.

Our house stood at the end of a gradual ascent on a level plateau at about the highest point of the 'heath'. The road uphill was well planted with all kinds of trees. At the top, where it contracted slightly into a winding lane, only elms grew up, clipped and pollarded. The hedges on the left were thick and deep, but to the right, between the narrow trunks of the elms, the strange procession of our boundary trees could be seen crossing the upland at right angles to Wood Lane. These also were elms but of such an eccentric growth that they looked like some new species. In effect they resembled palms, their stems being close-cropped and only the top branches left to spread. But few had grown erect so that they appeared to be hurrying along stooping and undulating like a queue of urgent females with fantastic hats or a file of plumed serpents, reared on their tails. About the centre of this elm-row stood three trees which in spite, or perhaps because, of their rigorous cropping had emerged into a singular grace. Their feathered bodies mingled together as they thrust upwards and their three heads fused in cascades of dense leaves spreading out like the crown of a vast fountain. I knew these three intimately but not very consciously. I now began to look at them with a fresh interest. They were indeed beautiful. I wanted to express something about them. But at present I had no real contact. They stood outside my scheme of things. After a while Pellew talked in vain as far as I was concerned. The new world which his words had begun to conjure up eluded me. Yet I was shaken within; a new vibration had been set up. It was not long before the true response came.

3

Meanwhile my mode of life changed. The influence which brought this about was sudden and unexpected. During the summer vacation a somewhat unusual visitor appeared in the village. Apart from being distinguished by a personal beauty, she was remarkable among the natives as a smart woman from London in contrast to the country ladies who, while they seemed to live too near London to wear country clothes with ease, could not quite convincingly be labelled 'fashionable', even on party occasions.

Mrs Harry Taylor had come on a visit to her sister-in-law, the Hon. Mrs Hancock,[13] a friend of ours and a well-known resident, who, since the death of Major Hancock, had lived in a charming house at the farthest

inhabited part of the Heath before it merged into the wild fields and woods of the Fulmer country.

At that time my father and I frequently visited Heath House, where we met Mrs Taylor, who had, it transpired, positive connections with the artistic, as well as with the fashionable, world. At a slightly earlier period she had been painted by Poynter and by Richmond and I think also by Burne-Jones, but of this I am not certain. Towards me she showed an immediate kindly interest, which I naturally found flattering. But it soon appeared that she considered my present mode of living a hindrance to progress. I should, it seemed, go to London and live there. I was far too out of touch. I ought to meet 'all sorts of people' and particularly Sir William Richmond. Immense discussion followed, my poor father being attacked by both ladies. He was in no position to raise objections before Mrs Taylor, who frightened him by her fashionableness. He wished to do the best by me and the most that was possible to please Mrs Hancock. Soon, however, all was arranged amicably and in the early autumn I settled myself into a bed-sittingroom in Paultons Square, Chelsea, a few minutes walk from the Embankment.

First of all something had to be done about the room, which was bright enough, but restless with rosebuds. I had it papered in light grey and hung with dark-blue curtains. The bed was ingeniously curtained off and there was just enough room to work. My landlady and her daughter were the kindest people possible; my landlord I seldom saw. He was a small inveterate football 'fan' and spent every Saturday afternoon desperately watching and shouting. Sometimes when Chelsea had done something spectacular he would not be able to keep it to himself, but 'respectfully intruded' to give me an account. Thus I continued my work at the Slade, while living simply but comfortably at a reasonable cost.

But now the first of my Sunday visits to Sir William Richmond at Belvoir Lodge, Hammersmith, was approaching. When the day came I was ushered, on my arrival, into a large room of the spacious house set in its walled garden. As I walked down this room a figure appeared from a recess at the far end, which was hidden from view; I stood in the presence of the god-son of William Blake. He was rather convincing as such. Certainly, Blake might have had, as it were, a spiritual hand in his making. He was not unlike the ancient, vigorous old men of the designs. He was in a bad temper that morning. Probably he did not want to be bothered with me, and he had cut his finger, which prevented him playing Bach, a

Sunday morning recreation. He looked at my drawings and I was studying
him while he did so, when suddenly some cartoons on the wall behind
caught my attention. At once all thoughts of Blake vanished: I almost
recoiled as, before my mind's eye, there rose up a series of gigantic human
images – Colet, Milton, Pepys, Marlborough, the monstrous mosaic char-
acters of my haunted boyhood. I just had time to wonder wildly whether
G. K. Chesterton, another old Pauline, was being added to the sequence,
when Sir William raised his head and began to speak. I was quite igno-
rant of his artistic achievement, beyond recalling the mosaic murals of
the Great Hall at St Paul's. At that time I had not set eyes on those other
mosaics of that other St Paul's, which, regarded as an onus to posterity, are,
I suppose, such a very different affair.

As a mentor, Sir William was wise and kind. He had a booming Blake-
like voice, but inadequate control of the letter R. Nearly all our interviews
ended the same way, 'Wemember my boy, drwawing, drwawing, drwawing,
always drwawing.'

I soon began to enjoy my independent life in London. Hitherto my social
world had been restricted almost entirely to the country. But now, thanks to
my new friends, particularly Ben Nicholson and Wilkie Brooks, I began to
meet a variety of people and to move in a society that amused me.

As a personality Wilkie Brooks differed considerably from both Ben
and Claughton Pellew. He had a great appetite for life and cut at it as
into a cake, from odd angles, hoping to find more plums. He was prodigal,
generous and adventurous. His dandyism led him into some charming
extravagances, but as an artist, his chief gift was for caricature, in spite of
his conviction that in his case this should be regarded as a sideline. His
delight in certain characters of humorous fiction was extreme and imag-
inative. He positively lived these characters and embodied their natures.
Through him I came upon a whole new field of reading which began to
work considerable changes in my outlook. Humour, in our home circle,
had always been kept warm and active up to a certain point. My father
brought us up on the *Pickwick Papers,* which he read with immense relish.
Personally, I was a lazy, incurious reader, inclined always to feed my mind
rather than to seek adventure. I had a smattering of all kinds of writing,
but certainly my knowledge of romance and poetry far exceeded what I
knew of humour. Now, under Wilkie's guidance, I began to discover a vein
rich in a peculiar ore; a substance rarer in essence and far more stimu-
lating than any humour I had known – the subtle fantasies of Peacock, the

Paul Nash, *The Garden at Wood Lane House*, 1912, watercolour and pencil on paper,
private collection

exquisite ironies of De Quincey. I read these eagerly and with relish, while for poetry I turned to Coleridge and Wordsworth. Years before my Uncle Arthur had said, 'do not forget your Wordsworth' when on one occasion I had run on for some time about other poets. At that time I knew only the *Ode on the Intimations of Immortality,* but Aunt Gussie gave me her precious copy of Wordsworth poems, in which was fastened a letter from Edward Lear thanking her for the book and describing his life at San Remo and the odd behaviour of his pigeons. The book was recovered after his death and so came eventually into my possession.

My own attempts at verse had by now produced a considerable number of short poems nearly all of which reflected, in one way or another, the romantic obsession which had begun in the nights when I listened to the Alderbourne. During these years I had been faithful to the ideal and to the ambition which then were born. But to the human subject of my inspiration I had never spoken, except through the poems and although she read them all, after three years she had made no sign. We met now at longer intervals, which only made such meetings more difficult to face. To each one I went with a new desperate hope. Each one yielded me nothing. Yet before we met again my hope had revived.

Not long after I had settled in Chelsea I chanced to hear that she was staying with some friends who lived in one of the Squares lying between Baker Street and Marylebone. Suddenly I decided I must see her and force an encounter for which she would be unprepared. Perhaps in such circumstances I might surprise – I knew not what – but something which would surely prove decisive. For I had now reached a point when I did not want to go on with only doubts and hopes.

It was a fine autumn afternoon when I set out to walk to Marylebone. By a strange coincidence, within two years, I was to traverse that distance once more on foot from a place only a few hundred yards away in that Marylebone square to a street adjoining the very spot whence I now started. But in what different mood did I walk then! How inconceivably changed was my whole world!

I had no plan for this encounter ahead of me. I did not know the number of the house; I felt only a strange certainty that we should meet. As I came into the street the sunshine was still warm on the pavements. When I entered the third square I saw her walking towards me. We met with the most obvious pleasurable surprise on her part; but I looked in vain for the slightest hint of any deeper emotion. Her lovely eyes expanded

like butterflies sunning their wings on a cool flower, her slightly crooked mouth parted invitingly. I begged her to have tea with me, but, of course, she was hurrying to a music lesson or a musical seance of some kind with her musical friend. How well I knew those musical seances with their rather sentimental preference for Brahms' waltzes and the sea-songs of Macdowell! How often had I cause to hate them for depriving me of her company! Now, I felt—this will be the last time. We talked a little uneasily after that, and parted. But a resolve grew in me from that moment, a resolve which a few weeks later I carried out; for although I was now sure of her sentiments towards me I had finally to break what had become a morbid spell. Only spoken words could do that, hard or gentle as might be. . . . When they came at last they were of neither kind – 'With huddled, unintelligible phrase And frighten'd eye' – we stared at each other in the firelight of the hall.[14] Miserable and baffled I stood up. As I did so I felt something slip from my shoulders and recede into the darkness behind me. The face in the night sky, the voice by the bridge of the Alderbourne had, as I feared, been only a dream.

The reaction which followed my renunciation had one inevitable effect. My poetic faith was shaken and I soon found that what I believed to be a natural outpouring of a poet's expression, however slight, was, in reality, an emotional outlet of my desire and despair. As these forces waned my spring ran dry. The impulse gone, I no longer wanted to write, and, with the realisation of this, I made no more attempts to combine poems and pictures. The last link with Rossetti was broken.

But I was not yet free of pre-Raphaelitism and I now tried to put its teaching into practice on a new theme. The character of Lavengro still fascinated me; more than ever the adventures of the heath and the open road became my romantic food. About this time I met a gypsy-like girl who shared my sympathies. Our friendship was one of comrades, but inclined to become tender at moments which suggested that it might develop sentimentally if we chose. In the meantime I took her as a model for one of the two figures in my new picture, although by pre-Raphaelite standards, this was heresy, she being dark-complexioned with almost black eyes and short dusky hair, whereas my character taken from literature, was described as flaxen and fair. My subject, however, was well in the tradition, *Lavengro teaching Isopel Armenian in the Dingle*. It was a situation that had often appealed to me. The lonely cup in the open fields encompassing in its depths the forge, the little horse and cart and

those strange beings, the roving scholar and that attractive enigma, Isopel
Berners of Long Melford. The tentative relationship of these two, so dra-
matically met, thrown together and abandoned like shipwrecked survivors
on a deserted island, stirred my imagination. How would it end? I knew it
never should, for it had that mysterious quality of all beginnings; the slow
advance of dawn, the almost invisible movements of an opening flower.
But it had no purpose, no destiny. Borrow, for I did not doubt that it rep-
resented himself, would never allow nature to take its course, as it were.
Isopel might sigh and he might want her, but it was obvious he was tied
up in one of his perverse knots and could only fall back on his usual habit
of teaching or preaching something for which his audience had no ear.
This had a certain virtue in my eyes. It fixed the figures of this drama; they
resembled those on the Grecian Urn described by Keats, they could not
move, or, alternatively, they could not stop moving. As I saw them they
sat immobile, except for Lavengro's dictatorial finger endlessly declining.
Between them, the wood fire of green ash lit up their forms and faces and
gave a vague design to the surrounding trees of the dingle. This dingle was,
perhaps, the most interesting of any feature in the whole scene. I found it
difficult to visualise. I was not well acquainted with dingles and I felt par-
ticularly uncertain of their usual dimensions. The Lavengro dingle seemed
curiously large, yet if its mouth opened too wide it would lose its character
as a dingle. I am sure Ruskin would have condemned the place I eventually
evolved, as being against nature and against pre-Raphaelitism, and more
particularly had he known that it was composed from sketches made in
Richmond Park where, so far as I could discover, there are no dingles.
Also mine was a nocturnal scene illumined only by starlight and a fitful
camp fire which might easily exaggerate proportions of form and distance.
Beyond the radius of the firelight the ground mounted into the uncertain
darkness of shrubs and trees until the rim of the cup showed against the
sky. This steeply receding wall took on a vaguely pyramidal design under
the influence of obscurity, and this was repeated in the two figures, each of
which had the suggestion of a pyramid form. But now I had to discover a
model for the second of these two figures. Whom could I find to fulfil the
character of Lavengro?

Reviewing my friends I could think of no one quite suitable for the
part. True, Claughton had a Borrovian nose and Romany inclinations, but
he was far from representing Lavengro. It must be a stranger, then. I had
the whole population of London University to choose from, apart from

casual acquaintances. But it was a very special creature I was instinctively tracking down; how curiously special and how important to my future I little knew.

A conspicuous figure at the Slade at this time was a personage known as the Man from Mexico, so-called from his habit of arriving each morning in Gower Street riding an elderly bicycle and wearing some sort of equestrian leggings and a wide-brimmed hat. He was not, however, a person to stand for ridicule as the Slade wits soon found out. He had a power of caustic reprisal and was capable of aggression. His usual companion was an immense blond Irishman. After a while the Slade left them alone. But I had become interested in the Man from Mexico and was beginning to study him. His name, I discovered, was Lee, perhaps of the gypsy family?[15] Certainly, he had in those days a gypsy look about him. At the same time his face had an intellectual structure and his finely modelled features a serious, half-sarcastic expression. He was largely built with a big head for his wide hat. Suddenly, I felt convinced that here was my model. We did not know each other, but a few days later we happened to be washing our hands side by side. Without preamble I said, 'Will you sit to me for a figure in a composition I am doing?' He turned his head to give me a long searching look. Then said, 'Yes, if you like, what is it about?' I explained as well as I could the significance of my conception of the scene from *Lavengro*. He seemed interested and, finding we were neighbours in Chelsea, invited me to have tea with him a few days later.

Lee had two small top-floor rooms in a little row of houses close to the Fulham Road. I climbed up the narrow flights of dim stairs and obeyed a voice which shouted 'Come in!' Opening the door, I was momentarily surprised to find nothing upright in the room, except an easel, and that was the leaning kind. On the floor, however, which was bare, two figures were stretched out in rather awkward luxury at opposite corners, my host and a very spotty man with long legs. Both were smoking hookahs. I listened to the conversation while I had my tea. The hubble-bubble seemed to induce philosophic speculation, obscured by cynicism, but when the spotty man left, Lee abandoned his pipe and metaphorically came off his exalted perch to show me his work, which consisted mostly of sound scholarly studies for the Prix de Rome competition. Some of the figures were in tempera and these, as well as his experiments with layers of gold leaf, were for me interesting novelties. I discovered that his ruling passion was music and that he was, in fact, a musician by nature, but that he

had no training and no means to develop his gift. As a draughtsman and designer he might hope to make a beginning and, if he got an award, the Prix de Rome would at least keep him afloat for a while. Lee and I soon became friends. I must have seemed very raw in his eyes. He was far more intellectually mature than any of my other friends and he possessed, or very successfully assumed, a philosophic detachment by which he carried off his crippling circumstances with an air. But he was sensitive under his mask, though to me frank and warm-hearted.

The study for Lavengro proved successful enough and accorded well with the figure of Isopel. These two, set in the cup of the dingle, became a design which had some elements of structure, but which I began by ruining with an over-elaboration of detailed pen-and-ink work. I showed it to William Nicholson who looked at it with obvious misgiving; but I had come prepared and quickly produced one of Wilkie's caricatures of Wilkie, Ben and me engaged in judging one of Wilkie's pictures. Ben's father at once cheered up and said it was brilliant, so exactly what Ben was sure he did *not* look like. . . .

Lavengro was taken home and submitted to a scrubbing with a nail-brush and warm water, by which it got rid of its pre-Raphaelitism and emerged with a broken surface pleasant to work over with a pencil and on which to emphasise those virtues of drawing which had been obscured by the pen-and-ink.

At the end of the year I had to leave the Slade. I had enjoyed my time there and it had been fruitful in many ways, chiefly in giving me friends of various kinds. Beside Wilkie, Ben and Claughton and, more recently, Rupert Lee, Claude Miller, a student distinguished among us for having lived and studied in Paris and being able (a little hazily) to expound Cubism, had become a fairly constant companion. We shared certain enthusiasms and interests. Originally, I think we shared an admiration for one of the Slade girls who was both clever and good-looking to an unusual degree. This was Dora Carrington who belonged to a small group of students, governed in a vague, gentle way by Dorothy Brett, Lord Esher's daughter. Carrington, however, was the dominating personality, and when she cut her thick gold hair into a heavy golden bell, this, her fine blue eyes, her stutter, her turned-in toes and other rather quaint but attractive attributes combined to make her a conspicuous and popular figure. But I had noticed her long before this was achieved, when, as a bored sufferer in the Antique Class, my wandering attention had been suddenly fixed by the

sight of this amusing person with such very blue eyes and such incredibly thick pig-tails of red-gold hair. I got an introduction to her and eventually won her regard by lending her my braces for a fancy dress dance. We were riding on the top of a 'bus and she wanted them then and there.

A friend of my later days at the Slade was Bluett-Duncan, whose beautiful wife, Adela, turned out to be connected with my patron who bought the drawing of the giantess in the night sky. They lived at Prestwood in Buckinghamshire, and I was invited down to spend the day. By an odd coincidence I made then the last of my 'vision' drawings of which Assheton Leaver of Iver Heath owned the first. But the thread of chance did not finish there. In the background I painted in, with chalk and water-colour, the thickening spring woods in the evening light. On my next visit to Belvoir Lodge it was among the drawings I showed to Sir William Richmond. He studied it intently and suddenly said, 'My boy you should go in for Nature.' I had only a vague comprehension of his meaning, but out of curiosity I began to consider what Nature offered, as it were, in raw material. How would a picture of, say, three trees in a field look, with no supernatural inhabitants of the earth or sky, with no human figures, with no story? I wandered over the stubble. The air was filled with the delicate agonies of the peewits who were wheeling and curvetting about the sky in eccentric flights. A few were walking or running in the furrows, where the shadows of the elms were lengthening in the afternoon sun. In the blue vault above vast cumulus clouds mounted up with slowly changing shape. A full level radiance illumined the scene, articulating all its forms with magical precision. This peculiar clarity had in its essence a sort of mystery. A phrase of Gordon Bottomley's came into my mind. 'The greatest mystery comes of the greatest definiteness.' I had been looking at the 'mystery' lately, it had for me an increasing significance. There were certain places where it seemed to be concentrated. I now realised that I had been unconsciously studying some of these places which lay near-by, within the distance of an ordinary walk. But it was close at hand that this magic was enshrined and it emanated from here with a potent force.

My father and I, when we were alone in the house, lived all our waking hours in the morning-room. It is impossible to describe my memory of this room. It had an unfailing changeless warmth, and comfort not for the body merely, but for the spirit. It was one of those rooms, so rarely known and scarcely ever planned, which seem inseparable from the scene outside. It had a wide corner window and a door leading on to a verandah

with the garden beyond. This was the southern aspect; the western angle of the window looked down the drive. The view which conveniently filled the eye from inside the room was a space of the virgin field from which the garden had been made. This was planted with a few flowering shrubs and trees, some clusters of daffodils and pheasant eyes, but was otherwise uncultivated. Each year the grass grew up and flowered and was cut down and made into hay-cocks. Thereafter it was an open space of meadow invaded to the sight only by the birds, by other small creatures, and by the shadows cast by the laburnum, the chestnut, the tall acacia and the little conical silver fir. These, with a few others and the boundary hedge of beech behind, made up a group that had a curious beauty of related forms, whether seen on a dull day or transfigured by the sunlight or the moon. We called this the Bird Garden, because birds were always there. Eventually I cut out a winding walk which led from the drive inwards and round between the shrubs and trees alongside the beech hedge on to the croquet lawn. But this walk was invisible from the window. I had already made a drawing of the Bird Garden, which I exhibited at the Slade sketch club and subsequently gave to Claude Miller. It was undoubtedly the first place which expressed for me something more than its natural features seemed to contain, something which the ancients spoke of as *genius loci* – *the* spirit of a place, but something which did not suggest that the place was haunted or inhabited by a genie in a psychic sense. Like the territory in Kensington Gardens which I found as a child, its magic lay within itself, implicated in its own design and its relationship to its surroundings. In addition, it seemed to respond in a dramatic way to the influence of light. There were moments when, through this agency, the place took on a startling beauty, a beauty to my eyes wholly unreal. It was this 'unreality', or rather this reality of another aspect of the accepted world, this mystery of clarity which was at once so elusive and so positive, that I now began to pursue and which from that moment drew me into itself and absorbed my life.

IV Beginnings

I

When next I took my drawings to Sir William Richmond he was obviously interested in what I showed him. Bending over them he emitted an astonished grunt and then in a gentle roar he exclaimed – 'These are something new!'

I was surprised at so much enthusiasm. I could not make out just what quality excited the old man. But he was not inclined to be expansive and urged me to go away and do some more. So I returned to my woods and fields where it was now full spring. The buds were just breaking in the oaks and green was overwhelming the hedges.

There was a place on the way to Fulmer which had always been our familiar haunt. It was known to us as Hawk's Wood, from the fact that nearly always there would be a sparrow hawk or a kestrel hanging in the sky overhead, or, nailed to a tree in the Keeper's Larder, a dead hawk hanging among the dead jays in the dark aisles of the wood.

This wood was the peak of our discoveries when, as children, we came originally to Iver Heath. It represented then our most daring adventures into unknown country. Its curious solitude was one of its charms, for we very seldom met anyone on the road outside and, in spite of its precincts being sacred to pheasants, we had no awkward encounters with keepers as far as I can remember. The fear of such made us alert and sensitive to every sound as we crawled through the hedge into the undergrowth, and added to the thrill of our explorations. Once we penetrated the farthest limit of the woods and out beyond into a little narrow field through which there ran a quick stream between steep banks. There we found a kingfisher's nest and took one of the white round fragile eggs. Now, as

I came up to the wood, I remembered the joy of that day. The shells of the eggs were so thin that they appeared delicately rosy from the colour of the yolk within. We saw the bird speed like a beam of light down the shady ditch.

The approach to the Hawk's Wood was another of its attractions which began to be felt perhaps a mile away as we left Mrs Hancock's house behind and traversed the upper plain of the Heath with its scents of broom, gorse and heather. All this was good birds-nesting country which delayed our advance considerably until we came to the cross-roads, Harefield to the right, Farnham Royal to the left, and turned into the narrow winding lane which descends to the Fulmer Valley. From this point we three, my brother and I with my sister on my back step, holding my shoulders, used to coast down hill at an ever-increasing speed. As we flew the high banks gave place to openings and low hedges, beyond which appeared fair meadows and copses of the vale, with brownish pink fields of earth where the bright green blades of corn were pricking through. Near the bottom the road widened and turned rather abruptly, disclosing a farther more gradual incline and the objective of our full momentum – the water-splash, a shallow stretch of water five feet wide across the road. The splash was not always shallow and it could double its width according to the season. But we seldom hesitated to make a lunge at it and generally staggered through, damp but exalted. Immediately beyond, the road began to climb steeply up again, overshadowed on the left by the primrose banks of Hawk's Wood.

My mind cast back to these scenes as I meditated, as I sat by the roadside looking down to the water-splash with the angle of the wood jutting out on my right hand and somewhat overhanging the bank. I renewed in memory the emotion that the country had stirred in me then – the almost unbearable beauty of certain scenes; the intoxication of sunshine and rain, the shock of deep cold. I remembered the intense excitement of hunting for nests, the breathless moment when the hand torn with thorns reaches out just one more inch to the rim of the nest and how the thrusting, twisting fingers must then become delicate and sensitive as a moth's antennae as they feel for the eggs. Was this more thrilling than that pause in the chase across the Heath when the Red Admiral settles on a patch of sunny earth to rest its unbelievable wings, when again all the haste and pressure of pursuit must be checked and changed into the coolest caution to take the quick, unhurried aim with the lifted net? I remembered, too,

those exquisite moments of first discovery of a rare flower or animal. The first sight of a snake gliding from the path and leaving you with that involuntary sick terror at your heart. The first time even, that you surprised a hare in his form, or came suddenly face to face with a fox in the grass ride of the forest.

But now a new emotional experience was beginning which, while it involved those simple reactions of heart and mind, called upon sensibilities hardly touched before and demanding powers of expression that were as yet undeveloped. 'You are like a man trying to talk who has not learnt the language', Tonks had said to me only a year before. I had left the Slade without having learnt to draw in the accepted sense. But I had seen enough of students who, after a full course of instruction, were considered 'to have learnt to draw'. They had learnt nothing else in all those years and it would be only a matter of time before they themselves would be doing nothing else but teaching another generation to draw.

Now, however, I would draw this tree in front of me as I felt it. It was exciting drawing this tree thrusting up out of the hedge. It was an oak about to break into leaf. Here and there the yellow green had evolved, but mostly its branches bore the red swollen buds typical of its strength. The spring sunlight struck across the wide shoulders of the oak, glancing down its great limbs which reflected the beams in a pale glow; the round trunk in the sunlight was as white as paper. I did not find it difficult to draw this tree, as I had found the models at the Slade difficult to draw. An instinctive knowledge seemed to serve me as I drew, enabling my hand to convey my understanding. I could make these branches grow as I could never make the legs and arms of the models move and live.

There stole through me a peculiar thrill as I realised the forms taking life under my hand. I tried a further experiment. Hitherto I had made my new drawings from Nature entirely in monochrome with tints of one other colour, usually blue. To-day the scene and its exhilarating influence suggested a bolder attack in full colour. With nervous strokes I painted in the washes of pale colour, trying to convey the sense I had of the landscape's bodily structure, suffused by its delicate greens and rosy browns. At the same time I aimed to keep the whole scene within a mould which I deliberately imposed on its natural irregularities of silhouette and complexity of detail. I sought deliberately to simplify.

Within an hour I had said something for better or worse about the oak, the hedge and the road. The blue sky *did* seem to show through the

branches. There *was* a feeling of light striking the bole of the oak. I knew
I should soon deplore the faults of my design, I could see them growing as
a cloud grows, eclipsing the blue. I looked again into the sky. An unusual
movement was taking place across the serene plane, a thin shadow swept
over the sunny earth. A moment later I detected its cause – a hawk was
hovering above the wood. Quickly I set his image in my paper sky.

After a month's work I presented myself once more at Belvoir Lodge
and spread out my drawings for Sir William's verdict, which I felt would
this time be decisive, so far as I was concerned. He gave it immediately. 'I
knew it,' he exclaimed in a rousing bellow and, striking his thigh with a
sharp report, 'I thought I was right, but I feared it might be some phan-
tasmagorrwia of the brrwain!'

Whatever 'it' was, and I was by no means clear about that, I could not
help feeling greatly elated by 'Billy's' enthusiasm, and determined to take
advantage of this warm expression, if I were given an opportunity. I heard
him muttering – 'not a bit like those damned Post-Impressionists,' he said.

Presently he asked me what were my plans, and I explained my posi-
tion, telling him that I had left the Slade because I felt that I ought not to
depend on my father for another year's fees and because it was absolutely
necessary for me to begin earning. I was over twenty-one, and could not
spend any more time on my education, which had now taken up more
than twelve years of my life, though only a quarter of it had been directed
to equipping me for my profession. Henceforth I must get my training
as I went. I knew already the wise implication of those words, drawing,
drawing, drawing, always drawing. It was possible to learn to draw and to
paint by drawing and painting, so I believed. Something of this I managed
to say to Sir William, who looked grave, but slightly nodded his head. 'I
will do what I can for you,' he assured me, 'meanwhile go on with your
drawing and come to see me again.'

I went home feeling a new man. I could see my father was impressed by
what I told him. In the afternoon we took a walk round Black Park and
called on Mrs Hancock.

My time in London was running out. Now that I had left the Slade
there was no purpose in continuing to live in Chelsea, more particularly
as my field of operation seemed likely to develop in the country altogether
henceforth. Also, I looked forward to living again with my father. In the
tortured years of my mother's illness and after her death he and I had
grown to be very close companions, not so much as father and son, more

as brothers. Now it was pleasant to be going home again to enjoy that sweet-tempered society. I therefore said goodbye to my perfect landlady, Mrs Rice, and her daughter Rose who had served me devotedly.

Before I parted from Sir William I had extracted a vague promise that he would see a Director of one of the London galleries on my behalf. But when I applied to him again, after working for another month, I found to my dismay that he had gone abroad and was not expected back until the autumn. There was nothing for it but to go on amassing drawings, hoping he would arrange an exhibition for me on his return. I had made up my mind to hold this exhibition, although it did not seem a thing likely to happen at the time. But I began to feel about, now that I was going to be successful – in some degree, at least – the period of failures being past, now that I had nothing whatever to do with mathematics!

True, I had problems to solve still, but I could solve them in my own way – not according to some preordained formula. Even the laws of Nature, I discovered, did not hold against the needs of art. I remember a fellow student being shocked because I disregarded the natural evidence of the sun's influence in the matter of certain cast shadows and reflections. 'But they can't go that way,' he said. 'Yes,' I replied, 'in a picture they go the way you want them.' Only the Pre-Raphaelites allowed themselves to be imposed upon by Nature without selection, and even then it was not so much Nature's imposition as Ruskin's. But what came of it? No great art, I fear, though certainly a number of records of man's incapacity to ape the appearance of Nature consistently. The Death's Head Hawk Moth held in the palm of Hunt's Hireling Shepherd is a kind of miracle, so far as verisimilitude is concerned, but the painting entire is surely a sort of bore.[1]

The summer advanced. I began to plan a few visits with a view to getting as much variety of scene as possible for the material for my drawings. Of these I had perhaps half a dozen, the yield of the neighbouring country and a night piece painted in London while staying with Wilkie at his home in Kensington. My thoughts turned to Essex where I could stay with my godmother and Uncle Dick, the Constable[2] connection who now lived actually in the Constable country, only three or four miles from Dedham. It was a quiet, rather dull household, but that would be all the better for work. My aunt had grown into a sweet friendly creature from the rather severe relative with whom I stayed in misery at Howley Place as a small boy. Uncle Dick still played his immense banjo in the evenings

and still kept up his absurd pretence of bullying my aunt and threatening her with the policeman, or was it the constable?

There was the usual weak-minded spaniel and, of course, Cocky, the parrot. I reviewed this quaint household in imagination and decided I would stay there for a while. My father had to stay with friends elsewhere, so I was soon travelling towards Colchester which is the nearest station for Great Hawkesley.

As the journey drew out, names began to flash by which I recalled with varied emotions, Chelmsford, Hatfield Peveril, Whitham. Two years before I had been drawn into a strange adventure in these parts, which began with my designing a bookplate for someone quite unknown to me, and ended by my being involved as a performer in the county pageant. I remembered how I had been doomed to dance a Pavane with a stout girl who sulked all the time for some strange female reason I could never discover. But there had been many compensations, such as the visits to Rivenhall, most romantic of country houses, the home of the unique Bradhursts and of the child poetess, Heaven, with her face of alabaster, green eyes and dark red hair, who wrote the lines which others may laugh at, but which I shall always respect and enjoy—

> *'So he is dead, ah! he is dead,*
> *Why must I live now he is gone?*
> *I am the stalk without the bloom,*
> *I am the feather without the swan.'*

I thought, too, of my benefactress, Miss Lance, and of her friend, the astonishing Chatelaine of Gosfield Hall. Certainly, I should not soon forget my first encounter with her, as she sat on the great bed of the Throne Room receiving the members of the miniature pageant she had commanded, most of whom had ridden through the lanes to Gosfield in their costume and armour. She herself wore a very large hat covered with nodding ostrich feathers of pink and blue. About her shoulders and spread over the counterpane was a cloak made entirely of different coloured ribbons, each embroidered by a friend.

When I came into her presence she detained me and I sat on the bed holding her hand. 'There is something strange in your face,' she said. 'What are you going to do in life?'

Perhaps the most memorable incident of my sojourn in Essex was one which occurred before this, while I was staying in Kelvedon. The Sun Inn

was the kind of inn one reads of in Dickens – hospitable and spacious. I was about to sit down to my chop one day when a slight, dark young woman entered and demanded luncheon. She had a train to catch and was in a hurry. There was no food ready, it appeared, so I offered her my chop, explaining I could get some food later. Her appearance interested me. She was almost exactly a Beardsley type, a Morte d'Arthur Beardsley, not a 'fleur du mal'. She expressed her gratitude for my gesture by inviting me to call on her one day at Paycocks, and with that she was gone. Paycocks? What and where was that? I began to enquire. It was a very ancient house in the adjoining village of Coggeshall. Our sudden visitor was a Miss Buxton, who was staying with the owner of Paycocks, a relative of hers, a certain Conrad Noel, no ordinary character by all accounts.[3] The next day I went to explore.

There was no mistaking the house. It was flush with the village street, but its whole facade was carved in the most extravagant manner. I began to study the design, but this was difficult without seeming to stare into the windows. It was beginning to rain. I knocked on the heavy studded door and a man's voice called 'Come in'. A figure which had been crouching over the fire rose up. I was confronted by a tall powerful man with a commanding head. Dark curling hair slightly receded from a finely cast brow, the eyes were deep and visionary, but below the curved nose the humorous mouth had a decided hare-lip. This was the mark of his birth, a hare-lip being a characteristic of the Gainsboroughs, to whose family he belonged. I explained my intrusion. He welcomed me to the fireside, while he struggled on with a book review for some daily paper. He was in the grip of a cold and cursed and sneezed alternately.

Presently, my acquaintance of the inn came in from a walk with another, smaller lady, Mrs Noel. Very quickly we all seemed to get on well together. They were amused at my accounts of the rehearsals for the pageant; and I soon found that I had struck a set of people with interests new to my limited experience. Of politics I knew little and cared little, but my new friends were passionately political and I began to be fired by their enthusiasm.

Conrad Noel, who was a priest without a benefice at that time, was the leader of a group known as Christian Socialists and it appeared that an important Labour demonstration, including a procession, was imminent. But a banner was lacking, about which an excited discussion took place. They seemed really to be in desperate need. I felt a wild resolve forming within me. 'Let me paint you a banner,' I said suddenly. Their eager expressions focused on me. *Would I* do that for them? My Beardsley

lady looked her gratitude as only a living illustration to the Morte d'Arthur could look. It seemed to say, 'How heroic! First your chop and now a banner . . .' I painted a banner full of symbolism. Perhaps it is carried in Thaxted to this day! I came back to spend an exhilarating week-end with them later on. We talked and talked. We dressed up in fantastic clothes. Conrad Noel read poetry aloud – The Ballad of Reading Gaol. I heard one name frequently – Masterman, yes, Masterman will be Prime Minister one day.[4]

Conrad was a lovable man. But for his crippling health he surely had a great career before him. He behaved always in a kingly sort of way. He used to answer his huge mail in the train on the way up to London, throwing all correspondence dealt with out of the window. A constant stream of papers flashed past the gaze of passengers behind – rather like these stations flashing by, Kelvedon, Marks Tey . . . Colchester.

Soon I was installed at Great Hawkesley where a Judas tree grew under my bedroom window and the nightingales sang without reserve most of the night. I explored the Constable country. It held no terrors for me; I did not want to paint landscape like Constable. But in any case I did not notice Constable pictures everywhere here as one notices Cézannes in Provence. I saw a rich arable country heavy with the green of midsummer and the ripening corn. I painted a water-colour of the side of a field where a path ran under the shadow of hedgerow trees, and another at evening where a path wound uphill between the corn whereon a figure was about to disappear over the hill between the dark silhouettes of huge trees. I painted the Dedham Vale in moonlight with its clotted elms. None of these pictures looked very much like the places, but in some degree they expressed perhaps the mood of the landscape.

I tried to introduce a sleeping woman into the cornfield design, but the elements would not agree. It was really a cast back to D.G.R. but my nostalgia let me in for such complicated and dangerous processes of elimination in getting rid of the body that I learned a lesson then and there. Figures cannot easily be introduced into landscape. From the first conception they must be an integral part of the structure of the composition.

After about ten days I returned to Iver Heath. I had not attempted to renew any of my old acquaintanceships with the inhabitants of Essex, although I would gladly have seen some of my old friends again. But all that, I felt, must be left for another time.

On my arrival home I found everyone preparing for the annual expedition to Wallingford.[5] My father was oiling his gun, straps and buckles were being polished and tennis rackets tested.

My brother and sister were now beginning to emerge from the chrysalis stage of school careers into an equality of companionship with the elder members of the family. We seemed to take each other for granted in a slightly different way. Barbara was still very young and undeveloped, but Jack was within a year of leaving Wellington and seemed suddenly to have matured. No one knew what he would do. The wildest schemes had been suggested for his future, the Church, a diplomatic career, journalism, but at present we were content to say he would probably go to Oxford. He showed already one quality, the mentality of a scholar, but as yet it was no more than an attitude.

I have spoken before of our Wallingford holiday and described my cousins elsewhere. But this visit has a special significance for me in retrospect. For the first time the disparity in our ages seemed far less important. In the same way that my brother had overtaken me, we had caught up with them. This brought about mild surprise generally among us, so that we reviewed each other with a new interest and sympathy On their side they were charmed by Barbara's ready adaptability and attractive appearance; they admired Jack's dark, fine profile, while his scholarly, slightly elaborate manner of talking intrigued them. Me they already knew well and, I believe, on the whole liked but found baffling now and then. I was capable both of irritating them and amusing them to excess. In either case they would explode in a manner I found irresistible. When the Welles were annoyed their very blue eyes became protuberant and they snorted. Their voices, too, rose in proportion to the astonishment they felt in being contradicted, and mounted in registers of outraged infallibility. But their sense of humour was equally inflammable and they would go off into enormous gusts and salvos of laughter which echoed and detonated in the airy rooms or burst out in the hall, making the organ vibrate on the stairs. In the case of Uncle Alfred, one often got the lightning with the thunder, as a slanting sunbeam caught his many gold-crowned teeth.

All the Sinodun Welles were musical, particularly vocally, all were proficient at games and field sports and it was Father's keenness and reliability as a 'gun' or a 'rod' which made him doubly welcome at this time of year. He was indeed a very good shot, so far as I could judge in my humble capacity as beater. Why I had no ambitions beyond this humble rôle I am not quite sure.

I suspect it was a matter of pride. I had tried most games and found that, with the possible exception of football, I had no ability for playing them. Also I had neither a good eye nor a quick enough hand. But more than these I realised that I lacked enthusiasm. I remember when I was at school trying very hard to play cricket, for which I had no aptitude whatever, and a kindly senior saying 'I'm playing you because although you're pretty bloody you *are* keen'. That sort of thing was all right at school, but now mere displays of keenness were not necessary and almost invariably led to one being imposed upon. The only things worth doing now were those one enjoyed. After all I had not much talent for drawing, but it absorbed me, and once I was free of the Art Schools I could do it alone. Competition of any kind I detested and I was rather afraid of ridicule.

But although I did not enjoy shooting, it was not entirely because I was not good at it. Nor could I say it was for humanitarian reasons. I did not actually shrink from killing. Part of my job as a beater, which is a rather low form of life, somewhere between a mute and an executioner, was to 'despatch' the 'winged' bird or the wounded hare and I had learned to break his neck with a swift guillotine stroke of the edge of the hand. I had hardened myself to watch the film glazing the partridge's little round eye after I had dealt him his death blow against my boot. I always felt slightly inferior to the setter or retriever who, with such skill, pursued and captured the game desperately trying to escape among the roots, yet did not kill, but miraculously carried the terrified bird in a soft mouth to deliver aloofly up with a look which seemed to say '*You* do the dirty work'. I loved these creatures, as I loved all wild Nature. Yet at the same time I took part in their slaughter without a qualm. I had never let my imagination loose on that track. I had no idea what blind alleys it would encounter. Partridges, hares, pheasants and other game played certain parts in my experience. They appeared in quite separate acts. First as the wild things of the field to be watched and cherished, then as game to be pursued and killed, finally, as delicious food, of which one never had too much. But these functions were separate and evoked different sorts of behaviour. One would hardly, for instance, catch oneself watching a partridge during the autumn with a wholly cherishing eye. He was then game and potentially delicious food.

As the line of guns and keepers, dogs and beaters slowly advanced over the hill I reflected on the strange pleasures of rough shooting, apart from its sport.

The sweet September sunlight poured out of the sky making us sweat for our pains. The dogs panted noisily, their tongues hanging out, and the

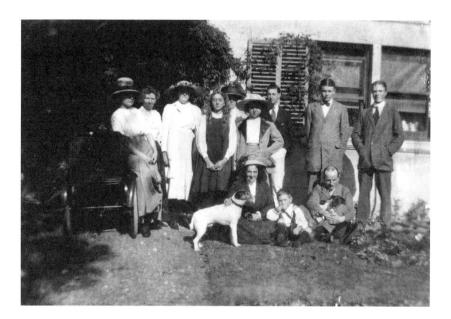

Paul Nash with relatives at Sinodun House, near Wallingford, *c.*1912. Nash stands at the left of the group of three men, with his brother John at the right; the man standing between them may be the Australian artist and Slade teaching assistant Derwent Lees. Nash's great-uncle, Alfred Wells, sits in front holding a dog, photograph, private collection

keepers mopped their brows with startling handkerchiefs. It was extraordinarily beautiful out here in the open fields in the middle of the afternoon. I realised, suddenly that only a pursuit of some sort would normally get us out here. Unless we had been chasing something, tracking it down to kill, we should not be plodding across these wide lonely fields, mile after mile in the hot sun. The ploughman and the sower no doubt shared these joys of the solitary with us. They knew the pleasures, if they were so reckoned, of communion with Nature on a plane with the wild creatures inhabiting hereabouts. But it was doubtful whether even the labourer on the land normally encountered certain aspects of Nature, or experienced such sensuous delights as came our way. What did they know of the exquisite relief I was feeling now when, after miles of hot, hard, dusty earth and stubble, we entered a field of swedes drenched by a recent shower and still retaining the fresh cold rain on their heavy leaves, so that walking through them was like paddling on the edge of a lake. As our tired feet soaked up this cool bliss, a smell of clover was blown over the roots from an adjacent

crop. The sun, standing at the turn of the day, now gave out a more lulling warmth. On either hand, the rich acres lay quiet and empty of any visible life. Our world stood still.

We stopped walking at a signal. The dogs were pointing: and in that pause a scene came back to me from years ago. Then, as now, I had paused in the midst of pursuit. But it was a wild chase across fields of lucerne and I was a boy grasping a butterfly net, poising it to strike at a quick-moving exquisite yellow creature which was about to settle on the purple bloom. I struck and missed. With almost a sob I watched my quarry wheeling away over the field on his strong flight. He was a Clouded Yellow – a comparative rarity for me. Suddenly I saw that my long chase had brought me to a happy hunting ground. The field was alive with Clouded Yellows, both the deep and pale variety. Soon I had captured several specimens. In deep happiness at my good fortune I gazed about me. I had come far afield. Beyond the boundary hedges the downs, threaded with juniper and other scrub, mounted to the spine of the great headland that arched up against the blue sky. From the summit a precipitous chalk cliff fell sheer to the sea. The still afternoon was disturbed only by the thin cries of the gulls. I was in Dorset, where we now came every year for our summer holidays. The cliff before me was Ballard Head rising up in majesty over Swanage Bay ... I remembered the curious sense of being alone in the wide fields, the spacious scene beyond emphasising a sense of the power I felt in this isolation. No one and no thing was aware of my presence. True, I had intruded direly into the lives of certain Clouded Yellows, but it had set up no sort of panic among the rest, who probably regarded me, if they ever saw me out of the corner of their eye, as some rather clumsy bird easy to elude.

Cramm! Cramm! I was shaken from my reverie by a series of deep reports on either side. Apparently we were intruding among the partridges. I saw Father slip in another cartridge to take a long shot at the rest of the covey as it planed sharply away, just skimming the hedgerow. Cramm! Even as it disappeared a bird toppled out of the flight. 'Well done, Harry!' cried out the Welles.

The following day I set out on an expedition alone. I had abandoned the shooters. Barbara had gone out to play tennis. Jack was withdrawn to the river for an afternoon's fishing with Ted. My objective was the Clumps.

Wittenham Clumps was a landmark famous for miles around. An ancient British Camp, it stood up with extraordinary prominence above the river at Shillingford. There were two hills, both dome-like and each

planted with a thick clump of trees whose mass had a curiously symmet-rical sculptured form. At the foot of these hills grew the dense wood of Wittenham, part of the early forest where the polecat still yelled in the night hours. Ever since I remember them the Clumps had meant some-thing to me. I felt their importance long before I knew their history. They eclipsed the impression of all the early landscapes I knew. This, I am cer-tain, was due almost entirely to their formal features rather than to any associative force. For although in my mind they stood apart from other symbolism – for Sinodun and all the pleasures that implied – it was the look of them that told most, whether on sight or in memory. They were the Pyramids of my small world.

I approached them now across the ridge of down linking Wittenham with the hill which the Welles had annexed for their habitation. In between was a small hill capped by a lonely clump, known as Castle Hill. It had a vague reputation as a Folly of some sort. As I came nearer to the Clumps, the land fell away in a gradual decline and the two great mounds, crowned with their domes of beeches, began to rise higher and higher above the sight.

I had come out to get a drawing of the Clumps. I wanted an image of them which would express what they meant to me. I realised that I might well make a dozen drawings and still find new aspects to portray. But I did not wish to worry the subject. There was one aspect which, had I the wit to perceive it, would convey the strange character of the place, one image which, in its form, would contain the individual spirit. It was this I sought and was bent on tracking down.

For some time I roamed over the hills, watching the changing scene. Yet at no time could I say, honestly, 'This is the view'. At last, feeling tired and hungry, I stretched myself on the turf to eat my lunch. Instantly, I saw that not far from where I lay was the point at which to make my drawing. An unsought, unsuspected aspect of the hills was suddenly disclosed. I sprang up and began slowly walking backwards up the slope until I had reached the perfect elevation. Twenty yards to the right brought me to the position of my attack.

I did not begin at once to draw. My landscape studies since I left the Slade had taught me already one thing. It was better to think or to absorb first, before beginning to interpret. There was also the Sinodun lunch to absorb. . . .

My thoughts wandered to the shooters over the hill and to Jack and Ted by the river. At this moment, there was probably little to choose

Paul Nash, *View from Wittenham Clumps*, 1912, watercolour, ink and chalk on paper,
Tullie House Museum and Art Gallery, Carlisle

between us. Each had paused in his particular pursuit to consume the good Sinodun lunch. Indeed, we had certain foods in common to eat, the same yellow farm butter and white home-made bread. I had no doubt we shared the Berkshire ham, but the guns would be devouring a steak and kidney pie along with it. The Sinodun cooks had the right idea of a man's picnic—no sandwiches fortunately. How good the sweet apples were, and the cook's plum cake! There was our bond – the food cut and packed up, to be eaten out of doors by the shooters in the barn, by the fishers on the river bank, and by me on the hill. I was as good as they. I hunted my quarry, I watched and waited, I had to know where and when to strike. And what was there to choose between a bird, a fish and a sketch, except that my drawing would last longest.

As I began to draw, I warmed to my task. For the first time, perhaps, I was tasting fully the savour of my own pursuit. The life of a landscape painter. What better life could there be—to work in the open air, to go hunting far afield over the wild country, to get my living out of the land as much as my ancestors ever had done.

2

It was the end of October before Sir William Richmond returned from Italy. By that time I had about twenty drawings which I considered presentable, and as soon as it could be arranged I took them to Hammersmith for his inspection. He received me warmly and was generous in his praise. When we came down to matters of practical procedure he seemed uncertain, but promised to do something on my behalf. He would write to tell me the result and what, if anything, I was to do.

In a short while a letter came telling me that the manager of the Carfax Gallery would see my work if I would take it to Bury Street one afternoon.

I knew this was an opportunity in a million. The Carfax was probably the most distinguished and exclusive gallery in London at that time. It had a record of exhibitions which included rare collections of Old Masters and the very latest work from Paris. It was sponsored in some mysterious way by both William Rothenstein and Robert Ross, but its recent success was largely due to its manager, Arthur Clifton, who originally acted merely as legal adviser.

The gallery was situated in one of those expensive, rather secret streets running between Piccadilly and St. James's. It consisted of one exhibition

room only, which was at the back. There was a spacious shop-window and a narrow passage leading into the gallery proper. On the left side of this annexe was the opening of a spiral staircase down to the basement, storeroom and office. Beyond this aperture the room had the benefit of its full width, but was hampered by an immense 'Old Master', of impressive but dubious design, which hung on the opposite wall. Between this and the street door was what remained of the right-hand wall, an open space interrupted here and there by odd drawings and small paintings. It was this space that my eye fell upon, covetously, as I waited one afternoon while my name was announced below to the manager of the Carfax.

I was absorbed in a vision of my own drawings hanging next to the Johns and Steers when I became aware of a faint metallic footfall and the gradual appearance of a large melancholy head, in slow helical progression from below the floor level. The manager was ascending the spiral stairs.

A. B. Clifton was a big man rather inclined to be stout. He was eminently flatfooted, but always conveyed a dignified presence crowned by a rather distinguished head. As a personal friend of such personalities as Robbie Ross, Charles Conder and Oscar Wilde he had acquired a very special standing in the art world. He was well known for his shrewd and even generous treatment of artists, but could seem on occasion more discouraging and cold than any man I have ever met. Certainly, he seemed so then, as he turned his hopeless gaze upon me. I gave him my name and said that I had brought my drawings. This announcement produced on him no shadow of an impression, except perhaps a deepening or settling in of his mood of gloom. 'Has not Sir William Richmond recommended my work to you?' I asked anxiously. 'No,' replied Mr Clifton and added, in a fainter but more human tone, 'I should not have encouraged you to bring your work here if he had.' I stared at him in amazement and dismay. But Clifton always kept his sense of humour just on the other side of his pose of melancholy, like the sun round the corner of a cloud. His joke about Sir William tickled him slightly when he saw my stupefaction and his expression changed. His heavy-lidded eyes rolled slightly and a wholly charming smile slowly traversed his face. Instantly I took a new hold on this awkward situation. 'Will you look at my drawings?' I asked, as I opened my parcel.

Clifton had probably found things of interest in unlikely places too often not to take a chance. He assented with a slight nod and a thin whistling sort of sigh. I put my drawings one by one on a chair in front of him as he sat down. Rather foolishly, I explained, 'Sir William thinks these

are something new.' I hardly expected a reply, but Clifton seemed to have become interested in a comatose way, and, as in his sleep, murmured, 'Yes, they are something new.'

My hopes began to revive. No other words passed between us, as I went on putting up the drawings. Occasionally Mr Clifton repeated the word Yes with a sibilant breath, like the last expression of a creature gradually losing hold on life. When I had shown him all the drawings there was a pause. Then he asked in a voice utterly devoid of animation, 'What do you want me to do about these?' I replied at once, 'I want to have an exhibition.' This almost shocked him into life. He looked quite sternly at me over the top of his pincenez, which he had put on rather crookedly to look at the pictures, and said with alarming vitality, 'Quite impossible. This gallery is booked weeks and months ahead, besides—' and he slid a sidelong glance under his pincenez at the last drawing on the chair, which I had taken care should be one that I considered to be among the best. He hesitated, glowering tangentially. I felt my wonderful chance slipping away. Desperately I watched the shade of failure creeping up again, but I was too well armed this time to be defeated. I believed in my work, crude and immature as it was, and was determined it should be seen and tested. 'Why can't I have an exhibition on this wall?' I asked, suddenly pointing to the space I had already noticed. Clifton pivoted slowly. 'But we never have exhibitions there,' he cried, waking up completely and looking positively horrified. 'Well, why not?' I asked in a rising tone. 'There are pictures hanging on this wall. You could begin right at the end and just get one row under the—the—er—Old Master and then this space to the door would take the rest of my drawings, with perhaps some of the 'visions' in a portfolio.'

For a moment I thought Clifton might be going to have a fit. But he was only deliberating. Apparently he saw the force of my suggestion and was turning it over in his very shrewd mind. Suddenly he withdrew his opposition and even consented to having the Old Master hoisted up a foot or two. We went over the drawings and measured the spaces. Jack, the factotum of the gallery, a friendly smiling creature who was invaluable to Clifton, was summoned from below. He regarded the situation with amusement and me, I thought, with a certain awe. Before I left it was decided to hold an exhibition of my drawings in November. I journeyed home to Iver Heath in a state of dream.

The news of my approaching one-man show in a London gallery by invitation (it had not occurred to me, I must confess, that it could have

Paul Nash, *Falling Stars*, 1911–12, ink on paper, private collection

been obtained otherwise) caused a small stir, not only among the Iver Heathens, but also among 'the family'. There was a certain amount of sceptical clucking from the aunts, whilst some uncles sucked in their moustaches sharply. It was generally admitted, however, that I had 'made good', or nearly so, and those who had prophesied my early eclipse were, very naturally, disappointed. My father and I, breakfasting cosily by the morning-room fire, listened with amusement to the reverberations on the distant family shores.

I remember only one moment of the Private View beyond the general impression of peering, bewildered relatives, and that was the first as I opened the door of the Carfax and saw utter amazement break over Clifton's face. I think he was already considerably surprised to find himself holding an exhibition in his front hall, but for an artist to attend it wearing a top-hat and carrying a malacca cane shook him to his foundations. I had sought advice on the etiquette of private views and had been assured by a new rather modish friend, either through malice or personal conviction, I don't know which, that a silk hat was essential. I had, unthinkingly, obeyed, adding what I considered to be the proper accompaniments, a silver-headed cane borrowed from Rupert Lee, snuff-coloured trousers, a black jacket and white spats.

On the whole the exhibition was a modest success. There were a few encouraging notices written in a serious tone, but I was disappointed at not selling more drawings and sent a report to my old friend Sir William Richmond, who replied that I must not be discouraged and that when he was a young man he had held an exhibition and had sold nothing.

One evening a few days before the show closed, I was just leaving the gallery when Will Rothenstein walked in. As he examined the work his expression became as grave as that of a doctor who has found deep-seated trouble. Turning to me he informed me very earnestly that my exhibition was most interesting. What could he do about it—he had put off coming – he had not realised – could he write something for me. I was overcome; I explained that the exhibition was just ending. Clifton appeared. Rothenstein told him how serious my case as an artist was. Clifton put on his pincenez awry and followed him round, murmuring sibilantly. I tried to keep out of earshot. All at once Rothenstein said 'I should like to buy No. 5.' I had a wild impulse to clap him on the back and shake his hand, but he still looked very grave, on the point of tears almost. Suddenly I felt my eyes pricking. I thought we should both burst into tears and frighten

Clifton. I told Rothenstein as well as I could how much I appreciated his gesture. Indeed, it was a charming, generous thing to have done. For me at that point in my career it seemed, as if by magic, to change the aspect of my first real venture from something accorded a hesitating acceptance into a distinguished triumph and one that had been recognised by the highest award.

A few days later the show came to an end. With one or two exceptions I had sold only to friends, as Clifton pointed out. One of these exceptions, however, was slightly remarkable. I had exhibited a water-colour of a scene on the Berkshire Downs, showing a hill cut into lynchets, those mysterious flights of shallow steps belonging to whom or to what age I did not know. I called the drawing 'Their Hill'. One afternoon when I was in the gallery, a tall rather rigid individual of very distinguished mien, after making a searching review of the exhibition, spoke in an aside to Clifton who proceeded to introduce me. 'Why do you call that place "Their Hill"?' enquired Lord Henry Bentinck, for it was he. 'I don't know,' I answered, 'I felt it was the sort of hill which could not belong to anyone in particular, but to an ancient people perhaps or to fairies even.' He laughed and added with some decision, 'Well, as a matter of fact, it belongs to me.' Apparently the hill was part of his Berkshire estate. Later he bought one of the tree groups. It was our dear friend Mrs Hancock who acquired 'Their Hill'.

On the day my pictures were taken down and the hallowed walls of Carfax appeared once more, I looked in to see Clifton by appointment late in the afternoon. His melancholy was more whimsical now and he produced his rare smile as a greeting. 'I am afraid your show has not brought you in much money,' he said, 'but it has created a good deal of interest for a first exhibition of only a small collection of drawings.' I expressed my satisfaction and thanked him for all he had done. He seemed pleased and continued, 'After deducting commission and a few expenses, the Gallery owes you just thirty pounds. How will you take it? Shall I write you a cheque?' No,' I said, 'I should like it in gold, if that is possible.' Clifton regarded me over his glasses with widening eyes but a slowly increasing smile. 'Jack', he called out, 'bring up thirty sovereigns.' We parted pleasantly and I carried away my gold in a thick cartridge paper envelope. I was due at a studio tea Carrington was giving in Bloomsbury to a few friends. The check table-cloth was spread on the floor and the check cups and mugs set out when I arrived. Carrington's gold head shone in the candlelight as she sat cross-legged on the floor. I poured out my sovereigns amongst the teacups.

With the closing of the exhibition I felt a reaction set in. I had been haunting the gallery pretty regularly and by now was thoroughly dissatisfied with every drawing I had made. Also, I had received a long letter of criticism from Pellew who had seen the work before the show opened. He pointed out the grave faults of the majority, but was generous in his appreciation of a few of the best. It was an eight-page letter, genuine, friendly and uncompromising, and I felt most of it to be sound judgment.

A few days later I ran into another Slade friend at the barrier of South Kensington station, as I was on my way to Paddington. He had with him a small blond man with a sharp white face. I knew him for an old friend of his in Royal College of Art days, when they were fellow students. He had a formidable reputation at the College for his powers of sarcasm and aggression. He was famous as a heckler at Common Room meetings and stories of his wit still lived, at least in my friend's memory. He had shown nothing but friendliness towards me so far and he now began to enquire about my exhibition. I was still rather full of it and must have shown my enthusiasm. He listened with apparent sympathy. 'How many did you sell?' he asked. I told him six or seven. Without warning his manner changed. His white face became contorted with rage. 'My Christ!' he broke out. 'Look at this bloody tyro. Last year he was at the Slade, now he gets a one-man show and sells his pictures, isn't that bloody nice?' He seemed to suck over his words and spit them out. I looked at his white face. It was darting at me with protruding eyes. I remember thinking they must be pink like a ferret's, but they blazed with a queer false blue, like little artificial daylight bulbs. It was the first time I had met real hostility in a fellow artist. I was to meet it later in a far more subtle and inveterate form. Although this was the first encounter of its kind, it was not the last time I was to suffer bitterness at the fangs of the little blond man.

It was now the end of November. I felt the need of a change of scene and society. For some time Pellew had been pressing me to join him in his solitude in Norfolk. It offered just what I wanted, so packing a suitcase and a parcel of drawing materials, I started for Mundsley on the Cromer coast.

I have no clear recollection of the details of that visit. But a very positive impression remains. Pellew and I spent all our days walking and talking. Our lodging was not particularly comfortable and the weather was desperately cold. In the crisp sunny air we kept ourselves warm marching along the hard roads or tramping over the fields. We walked in a landscape

entirely new to my eyes, flat and chequered, with all the trees slanting one way, their branches welded together in tortuous forms by the relentless winds. We talked about women mostly, I remember, where they came into the scheme of things, how they might share an artist's life. What was best for him, to marry, take a mistress or live alone? The sum of our amatory experience did not amount to much. Each made the most of his adventures, of course, for the benefit of the other. It helped one to feel warmer than talking about art, and we needed something to keep us warm on those bleak Norfolk plains. Pellew had a way of relating the simplest episodes – a walk in the rain, a kiss in the shrubbery – which invested them with romance unsweetened by sentimentality. It was certainly more amusing than listening to the usual sex conquests.

The question of marriage was the most perplexing. So many artists seemed to prefer it to any other way of living, yet we both mistrusted the relationship. We should be tied up, we should be tied down, fidelity would be impossible, boredom inevitable. So we argued with a wholehearted selfishness, which was very comforting while ignorance lasted. Recently I had had a letter from Wilkie in Paris. He was ecstatic about the reformation of his whole life which was due to his finding the most wonderful creature, a very small sculptress called Pete, who was everything in the world he needed and whom he was going to marry as soon as possible. Such news was unsettling.

In spite of the strange and new beauty of its natural scene, I left Norfolk empty-handed – almost. I brought back no records from the traditional hunting-ground of the English School. This was not because I found it haunted by images of the past, for, incredible as it may seem, I scarcely knew the work of Cotman and Crome at that time; my eye was as impervious to their influence as I gazed across the Norwich plain, as in Essex it had been unaware of that other spirit, the master of Dedham Vale. But if I found nothing by day, I did at least draw a night piece.

The landscape at night particularly excited me at this period. At least six of the drawings shown at Carfax had been nocturnal scenes, including the one bought by Rothenstein. At Mundsley I was chiefly impressed by the coast, the macabre fields of poppies on the yawning bluffs above the cold, bitter sea. The drawing I made showed the dark shadow of a figure approaching but not appearing in the picture. The shadow moved up the incline of the top of the cliff which was vividly cast into light and darkness by the moving beam from a lighthouse lower down the coast. In the

semi-obscurity between, the wavering edge gave a glimpse of the cliff's crumbling face and the gnawing waves.

Soon after I returned from Norfolk I went to see how Rupert Lee was getting on. I found him rather dispirited, struggling to preserve a flagging interest in the Prix de Rome studies and more than ever inclined to play the 'cello. Learning that he had nowhere to go for Christmas, I asked him whether he would care to join our family party at Iver Heath. This suggestion seemed to cheer him up, so it was settled he should come.

This visit was a great success. Everyone liked him, and such hospitality as we could give was rewarded by his own generous entertainment, for once it was realised that he was a musician who did not mind being asked to play, he was practically allowed off the music stool only for meals. As a family we were largely ignorant of music, but genuinely susceptible and appreciative. My father was a competent hymn-player and had been taught by Dr Barnaby. Every Sunday evening there was a long session at the piano in the hall. We were not bound to join in, but you would generally see a figure standing by the piano in the rather shadowy hall as you came downstairs. It might be Barbara singing in a small voice rather 'flat', or Jack humming through some improvised wind instrument. Sometimes all three of us would be there singing in what we believed to be choral parts – a fairly loud outcry! But at other times you might hear only a queer indeterminate noise, which was father singing through his pipe. He had by no means a strong voice, but in certain majestic tunes, like 'For all the saints who from their labours rest' from the Hymnal), he would be accompanied by an eerie bubbling and irregular jets of tobacco smoke, which considerably heightened the effect. Until the advent of Rupert Lee we were dependent for any music of a serious secular nature on our neighbours, the Lovedays. Miss Minna Loveday, who used to give me singing lessons, was a born teacher both of music and acting. Her brother George was a real musician in everything but opportunity. Circumstances had brutally wedged him into commerce of some sort where his life had withered. Every week-end he spent at Iver Heath absorbed at his piano. On rare occasions we were invited to small gatherings of sympathetic friends for whom George Loveday would play, or, rarer still, he might be caught walking with his sister in the fields and enticed in, to be plagued into a short performance. Usually, however, there was a feature in his playing which we found disconcerting. He was a highly-strung emotional being of extreme sensitivity. As he became lost

in his playing he would gradually be carried away and rather alarmingly disturbed, so that his breathing came almost in sobs, as he trembled with agitation. No one liked this very much and in a way I think it prejudiced us against classical compositions. Imagine, then, our relief when Rupert Lee showed a perfectly calm front, or rather back, to our watching eyes. From the sides where his important-looking profile could be observed discreetly, we watched narrowly for any signs of 'lathering', but the calm silhouette did not waver. Even in the highest altitudes of Bach and the most overwhelming deeps of Beethoven the only signs of stress were a slight tightening of the lips and a further jutting-out of the chin.

This literal discovery of music by us all induced various appetites and enthusiasms. Jack proved himself to be the most receptive and the most keen. He began at once to read the lives of the great musicians and later, by some seemingly miraculous and certainly painful method, he learnt to play. During that Christmas week, however, when it was so great a mental and physical luxury to sink into a chair after a Christmas dinner or a long walk through the woods, and listen to our deep-tongued Broadwood being rent into such glorious and unusual sounds, we were all listeners. Yet when Sunday came round our old custom asserted itself – Rupert enthusiastically joining the band and choir that accompanied Father's hymns.

With the end of Christmas came a general dispersal. Jack returned to Wellington for his last term, Barbara returned to school, Rupert went back to his Prix de Rome studies in Chelsea and I received an invitation from the Bradhursts to join a house-party at Rivenhall which was apparently to be devoted to a succession of dances including a Hunt Ball.

3

In the new year I began to spend more time in London. Although my work was now centred in the country and was dependent upon it for inspiration, I could not keep away from the pavements and the Parks.

I realised I loved London. It fascinated me as a place far more than for what I could get out of it. There were certain aspects of it which were so joyous, naive and tender in their beauty of grey, white and blue and that miraculous soot-black on Portland stone; it made one stop in the street to drink it in, to get what Americans call 'a load of it'. It had

such mystery in its winter days when suns were pale red discs floating over the deep blue gulfs of the empty parks and flights of duck went whistling overhead. It seemed as remote and unfamiliar as a Chinese landscape. Yet it was all London, the thousand facets and incalculable moods of which I was only just beginning to discover. At the same time I knew that London held my fortune and my fate. Whatever I should accomplish, whatever I should be, depended somehow upon London. However deeply implicated by inheritance I might be with the soil and with the sea, there would always be this third factor of the town in which I happened to be born.

In those days it was not easy to spend many days consecutively in Town. I had very few friends who could put me up for the night in the casual sort of way which suited me. But there was one 'bed' I could always count upon, which involved no ceremony and, I hope, no embarrassment to my host.

As I came to know Rupert Lee more intimately I found him to be a real friend. He lived alone in two top-floor rooms and seemed genuinely glad of my company from time to time. There was no money to spend on charwomen. He swept the floors himself – I don't remember any carpets – and made his own bed. When I stayed the night I slept in a hammock made draught-proof with coats and rugs. 'Toilet' was easy – a basin and a couple of tin pails, a rather frightening lavatory somewhere downstairs and the Chelsea Public Baths.

South Parade, being the last road turning out of Church Street as one comes up from the river, had a partial view of the Fulham Road. Between us and that thoroughfare was a mysterious piece of ground known as the Jews' Cemetery, and somewhere in the line of vision from the window appeared the suspended image of a huge Wellington boot, the significance of which I never discovered. There were trees among the graves which provided a pleasant vague greenery for the eye.

One day as I climbed the stairs I heard unfamiliar sounds coming from the top floor. I paused and listened. A gentle sweet-toned clanging interrupted by a slight discord of sound and an insistent repeated cling, cling, cling on one note was followed by tapping and then again by a progression of sweet tones. When I pushed open the door I found Rupert bending over an instrument which, in my ignorance, I took to be a spinet, but which was actually an early piano of about 1800. He had picked it up in a shop in the King's Road at the price of a piece of furniture in the least

valuable stage of transition between a musical instrument and an escri-toire. For the time being the piano became the centre of his life. It was in a distressed condition, but the sound-board was intact and Rupert, who possessed a certain mechanical skill as well as a keen ear, spent hours, day and night, coaxing it back to life. He could not leave it alone and when it was restored he spent hours making it play and giving it every exercise within its compass. Meanwhile the dream offered by the Prix de Rome[6] faded to the point of an infinite perspective.

'What about the Prix de Rome?' I asked some weeks later, as I looked musingly at the cemetery wall, beyond which the trees as well as the Jews seemed still to be asleep. 'Y-e-s,' drawled Rupert, 'I know, the little girls were on at me about it yesterday.' This was the first reference to 'the little girls', whom it appeared, he had originally met at the Earl's Court Exhibition where they were helping to raise funds for a National Theatre by selling medals. 'Who are these little girls?' I asked. 'What sort of size are they, they sound too small to be true.' Oh well,' Rupert murmured, 'only one is so small, the other is rather big – not heavy, of course, tall and stately, dignified, you know.' 'What's the other one like?' I enquired. Rupert paused, smiling, 'Oh she's little and dark. She's called Bunty. She's going to sit for me, to help me on with the old Prix. They want to meet you, by the way. I've been telling them all about you and Jack and the grand Christmas at Iver Heath. We must arrange a dinner or something . . .'

About this time I made a new friend. Oddly enough I have no recollec-tion of our first encounter, but I suppose any young artist in my position was bound to meet him sooner or later. This was Eddie Marsh, patron of all the arts and private secretary to Mr Winston Churchill.

'Eddie', for that is how I shall refer to him, because that is how he is thought of and known, also lived on a top floor, but in very different cir-cumstances and at the other end of London. Eddie's apartment was, I sup-pose, really a set of chambers in Gray's Inn. It looked out from the lonely height of Raymond Buildings which always reminded me of a drifting Ark or a black iceberg afloat. It looked down on the uneventful, spacious gardens of the Inns where, so it seemed to me, there are planted more plane trees to the square yard than anywhere else in the world, unless it be in a forest of planes. In the autumn, when they looked more like pythons and boa-constrictors than trees, it was pleasantly shocking to watch them strip-teasing in the pallid sunshine.

It was not usual, however, to spend much time looking out of Eddie's windows; there was too much to be seen on the walls and in the bookcases within. The collection of pictures to be found there at that time was not predominantly modern, but it was exclusively English. Another remarkable characteristic was the absence of Pre-Raphaelites. I do not remember one. But when I saw the drawing by Blake of Har and Heva bathing, the superb Wilson and the Cotman monochrome, I knew here was a collection of personal taste. The evidences of excursions into contemporary art interested me, too. Here, instead of Johns and Steers, I found the work of my Slade colleagues, Gertler and Spencer, and a painting by Duncan Grant. What surprised me most, was the number of examples representing the younger men. Also the question of wall space, which perplexes so many people who live in comparatively small rooms and want to buy pictures, did not arise here. Every available inch of wall space was occupied. Pictures began in the hall, ran up the stairs, along the passage, and were only pulled up short by the bathroom. They were in all the rooms, though not, I think, in the kitchen where Mrs Elgey, Eddie's unique housekeeper, had her personal collection of calendars. Eddie Marsh was the first real collector I had met and I remember thinking to myself, if all collectors collect in this way we shall all live happy ever afterwards.

I turned for a moment from the pictures to their owner. What was it he reminded me of? I decided there was something equine about Eddie in a mettlesome sort of way. Not that he was the least horse-like in features, but he had a certain way of rearing his handsome head, up and across to one side, that was reminiscent. He had very fine eyes crowned by remarkable branching eyebrows, one of which curled round a bright monocle. It was the best combination of eye-brow and eye-glass I had seen. His other most eloquent features were his hands. Unlike the average Englishman he used his hands in conversation.

Eddie, as I soon found, was the most generous and hospitable person. Later I was to know in how unusual a degree he would use his influence not only on behalf of his friends, but of his friends' friends in distress. Where so many men would promise, Eddie would fulfil.

Owing largely to Eddie's hospitality I was now able to come to London more often. Unless already occupied, the little spare room at Raymond Buildings was always available. Except for breakfast, we often met only for a short talk at bedtime, but breakfast was a fairly leisurely meal which

from time to time turned into a breakfast party. It was not unusual to find a poet or two for breakfast.

The first time I stayed the night at Raymond Buildings I felt slightly intimidated by my surroundings. The spare room, being the smallest room in the house, was literally papered with pictures, which, so far as I could see, were arranged with no particular regard to size or medium, though there was a consistency of subject which I found disconcerting. Apparently, there had been a recent phase among the English progressives which might have been called the apotheosis of the dwarf. Groups of dwarfs by Gertler and Spencer seemed to menace me from every wall; while on eye level with the sleeper in bed was a large oil painting by the latter of small men with small heads in the likeness of the Spencer family who were thrusting out their arms in the most realistic manner. With this powerful, but, to me, terrifying picture staring me out of countenance up to the last moment before I put out the light, I sank into an uneasy sleep, which was finally invaded by a strange high-pitched voice. I was back again by the railings of Kensington Gardens watching the Punch and Judy show. How did they produce that voice which I knew I could imitate just as I could imitate Eddie's voice . . . 'Sunny dome . . . caves of ice . . .'. This was becoming unbearable. I struggled awake to hear 'Beware! Beware!' sounded in a high passionate voice which seemed close to my ear. I jumped out of bed and ran on to the landing. Close at hand from the bathroom came the voice declaiming shrilly—

'His flashing eyes, his floating hair!
Weave a circle round him thrice,
And close your eyes with holy dread,
For he on honey-dew hath fed,
And drunk the milk of Paradise.'

There was a terrific splash, followed by more splashing and bumping about . . . and then the prosaic gurgle of the bath waste. It was Eddie's habit to recite poetry in his bath at the top of his voice every morning. It happened to be Kubla Khan that day.

It was some time before any picture of mine was acquired for the Marsh collection, and then it was at the instigation of Mark Gertler whose advice Eddie was inclined to seek on matters of contemporary art. But I cannot remember that I had much work to show just at that time, although I

had in the Carfax a place where I might exhibit. Instead of stimulating me to fresh efforts, my little show seemed to have halted me and left me uncertain. My method of expression was still very limited and consisted almost entirely of drawings made in pencil and tinted with washes of bistre and blue which were reinforced by over-drawing in diluted ink with a steel pen, sometimes with the addition of a little hard chalk. Both subjects and aspects were equally confined. Groups of trees in an 'upright' view seemed to be my sole interest. I very seldom worked on a horizontal plan or attempted landscapes involving receding planes or scenes wherein the forms were not those of trees with some surrounding undergrowth. In short I had got into my first rut.

This was due partly to my surroundings and partly to a pre-occupation in my problem of rendering the peculiar degree of beauty, of mystery – what should I call it? – that I found in the features of trees under the varying influences of light. Now, in March, I turned again to drawing the bare elms in the hedgerows. A year ago, but rather later in the spring, I had drawn the oak tree at Hawk's Wood, tentatively, feeling my way, as it were, with a certain trepidation. The constant practice of drawing even during that short period between had strengthened my hand and eye. The statement I now made was less equivocal, more precise and taut and so I thought, conveyed my interpretation more convincingly. Groups of daffodils showed here and there in the grass and small flocks of birds, not yet broken up for mating, wheeled about the sky. These complements to the scene I drew in deliberately and faithfully, yet making them essential ornaments of the design.

But although I had advanced in technical power, I had broken very little new ground. My pictorial range was lamentably narrow. I wanted some new impetus, some force of inspiration which would precipitate me beyond the limits which seemed to hedge me in.

One day, I received a card from Rupert, asking me to tea the following week and marked *very important*. I wondered vaguely what sort of important occasion this would turn out to be, but the date happening to suit me, I sent word that I should be there. When the day arrived, I became aware, on climbing Rupert's stair, of a strange atmosphere above. A conversation was going on, but with an unusual progression and divided up by long silences. The effect was slightly uncanny to normal ears, but I recognised the situation. Rupert was drawing from a model. The door was wide open, and as I mounted the last flight a very small foot jutted across

my line of vision. Coming into the room I found it belonged to a girl who was seated on a chair placed on the table. Another young woman was standing by the window. Rupert was drawing at his easel. The figure by the window, Miss Pemberton, had her back to the light as I shook hands with her and turned, as the seance was not to be interrupted; to meet the smile of the sitter.

She was small and extremely slender with small feet and hands, but the remarkable feature of her appearance was the head which seemed large in proportion to her slight body. This impression was partly due to a cumulus of dark hair, grape-black in colour, which mounted round her brow. The whole structure of the head was vigorous, from the capable forehead to the firm chin. The eyes were large and wide-spaced and the mouth rather full. So much I took in before the pause ended. So this was Bunty, the little dark-haired girl. She was little and dark all right, but that hardly described her, as Rupert very well knew.

We got on well from the first. Miss Pemberton, who was called Rosalind, seemed reserved and quiet beside the sparkle of her friend Bunty, but it soon became obvious that she was very intelligent and had a rather mordant wit. I realised, also, how handsome she would look, if she took the slightest pains with her appearance, which, for some inexplicable reason, she seemed to neglect.

After tea the pose was resumed for a while, so that I had the opportunity to study both girls, covertly. I then became aware that they were both troubled by some pre-occupation which, when they were off their guard, caused an overcast expression to pass over their faces, like a shadow. In Rosalind's case I decided that this was due to something like an habitual melancholy or pessimism into which her thought relapsed rather than to any immediate trouble which preyed on her, but in Bunty's I felt certain that it was the memory of some recent deeply affecting event that now haunted her eyes.

These eyes absorbed all my attention. They were an attractive brown in colour, but their peculiar distinction was that the iris was not normally white, but white suffused with blue. The effect of these blue-lit brown eyes was singularly lovely, all the more perhaps because it was elusive and unexpected. I have described her mouth as full, yet it was hardly so in the Rossettian form I knew so well, nor was it exactly the mouth of an oriental. Something about the curve of the upper lip gave it a wholly individual character, the origin of which I could not then divine, though it

heightened the beauty of this feature in a subtle degree. I found myself dwelling on Bunty's face with more than an appreciation of its attractions. For me at least, it seemed to hold an instant welcome, without reserve or caution. I felt sure that we should become friends.

'That's enough for to-day,' Rupert's voice broke in. 'Rosalind, how about some music?' But we ought to be going,' they protested. 'Stay and have a sardine supper.' Oh, that would be lovely,' said Bunty, beginning to bustle about and look into cupboards. 'There's no bread and hardly any milk.' 'Well, let's get some things and bring them back.' We walked off; all talking at once, to the German baker who made a uniquely delicious loaf which, buttered, went particularly well with sardines. It did not take long to collect what we wanted or to prepare a supper of bread and butter, sardines and tea, which we all enjoyed. Then Rupert began to play Beethoven and afterwards Rosalind played accompaniments for the 'cello, at which he was not yet very proficient. The few hours went all too soon. Presently, we were beginning to say good-night. The stairs were dark now, so Rupert went first with a candle to light our guests to the street. I came down last, following Bunty. A faint, flickering light showed me her small hand in its neat kid glove running down the banister rail like a little black mouse. I was suddenly tempted to reach out and catch it.

We parted cordially with all kinds of plans and promises to meet again soon. I stood listening to Bunty's gay laugh and still marvelling at her hat which was quite as big as Napoleon's usual headgear and was made of fur. By some ridiculous paradox it suited her.

It was rather too late for me to catch my train to Uxbridge, so I was offered the hammock. We undressed leisurely, discussing Rupert's little girls, their individual charms and very diverse characters. He had met them originally, as I have explained, at the Earl's Court Exhibition, for which he had designed a poster, and where Rosalind was selling medals in aid of the National Theatre Fund. She and Bunty had been at school together at the Ladies' College, Cheltenham. Bunty had gone up to Oxford with a scholarship, where she and Rosalind had met each other again by chance. Bunty's father was a clergyman and had lived and worked in Egypt until his recent retirement. The Odeh household dwelt in the region of Baker Street and Bunty had a secretarial job somewhere or other. Rosalind's father had been a well-known dramatic critic. Her mother and sister lived in a rather county style in Worcestershire. All this I absorbed sleepily

before I climbed into the hammock and writhed myself into a hopeful position for the night.

It was none too warm slung up there between the ceiling and the floor. Also, my mind was wide awake once more, as every detail of what had taken place that day since I first came into the room began to figure again in memory. At last, however, the images were becoming less certain when a curious sensation was induced by the passing of a sound. A distinct scurrying noise had interrupted my falling asleep and was travelling round the room. Instantly, I was fully awake. 'Rupert.' No answer. 'Rupert.' 'What?' grudgingly. 'That damned mouse again.' 'Shut up – listen.' I waited, trying not to make the hammock creak. Suddenly, there was a loud crack. 'Got him!' cried Rupert, jumping out of bed. He lit a candle and I tumbled out of the hammock. It appeared that unknown to me Rupert had set a trap and that now the mouse had been caught.

This mouse had given him a good deal of trouble. He was horribly artful and incredibly swift. Often he had disturbed our sleep, but now we had caught him. We decided to drown him at once before he became pathetic, though we both avoided looking at him till the last moment when the pail was prepared. Then I opened the trap and shook him into the water. I have never seen again anything equal to what happened then. The mouse struck the surface of the water, took off from it instantly, as though he had landed on a springboard, and proceeded to race round the side of the pail like a trick cyclist in the Drum of Death. The next moment he was on the rim and had leaped to freedom. By some miracle I eclipsed him with a blanket and after a wild scramble he was recaptured.

Rupert now had him in his hand. He was a small black mouse with the most charming impudent expression. He did not seem very frightened, merely acutely knowing and alert. 'We can't drown *this* mouse, Rupert.' 'No, we can't, even if we could. What shall we do with him?' I had an inspiration. 'Let's put him in the Jews' Cemetery.'

Very carefully, lest we should wake the landlord, we crept downstairs. I now held the mouse and could feel his little heart throbbing against my hand. I was rather uneasy about marooning him among the Israelites, but I hoped he might work his way back to his family. As we crossed the road two men came walking round the corner from Church Street. We almost collided. The smaller of the two suddenly called out, 'What's that, a mouse? Is it a young 'un? Give it to me, I eats 'em.' With a desperate throw I flung our mouse over the wall into the Jews' Cemetery.

Just before daybreak I had a dream. I was descending the dark stairs; in front of me, down the handrail, ran the little black mouse. I felt excited and my heart was throbbing. The mouse ran out of the door and across the street. In a flash he was up the wall and had disappeared. I climbed the wall into the Jews' Cemetery. Inside it was quiet except for the rustle of the bare branches. Bunty was sitting on a chair placed upon one of the flat tombstones. She was wearing the brown dress with the little bows I had seen her in, and on her head was the wide fur hat. One hand was bare, the other hung down covered by a black kid glove. At a little distance Rupert was drawing at his easel. The noise I heard was not made by the trees, but by the scratching of Rupert's charcoal. I sat down on the tomb and took Bunty's gloved hand in mine. Instantly, it became a black mouse and both figures disappeared. A head looked over the wall and, peering eagerly at what I held, said, 'What's that, a mouse? Give it to me.' I was terrified and tried to release the mouse. He was frightened, too, I could feel his little heart throbbing against my hand, which I could not unclasp. We were both trapped. I awoke, gradually, to look into the eye of the window, where in the grey light, hung the dark silhouette of the gigantic boot.

My friendship with Bunty grew quickly. She had a genuine faculty for taking an interest in other people's troubles. It was very pleasant to tell her about myself and to feel that I had an intelligent, sympathetic listener. But apart from this, her personality fascinated me. It was essentially vivid, both physically and mentally, but it was not free from odd contradictions. It was impossible always to take her seriously. If one tried to do that, one would miss the fun of her. She seemed rather like one of my own sums, based on the rule that two and two make five.

It was the first time I took her out to lunch that I learnt something of her own history. She was born in Jerusalem, opposite the Mount of Olives, her father being at that time Chaplain to the Bishop of Jerusalem. Later the family had gone to live in Cairo where he was responsible for founding an important Mission and eventually for building the Pro-Cathedral. The ambition of his heart was that his daughter, whom he regarded more as a son, should carry on his work. Obviously he had been a very able teacher and organiser, and wanted Bunty to be as well equipped as possible for her predestined task.

We compared notes on our education and discovered that, whereas I had begun mine at a Dame's school, she had attended a boys' school until

she was fifteen. At fifteen she had been sent to England to continue her learning at the famous Ladies' College, Cheltenham. From there she had taken a special scholarship to Oxford where she had spent a completely happy three years at St Hilda's Hall.

But Mr Odeh's plans for his daughter were destined to come to nothing. Her second teaching post had been at Scarborough, where, when the winter term came round, the intense cold of the North Sea winds had affected her throat. For a time she had been unable to use her voice and had been warned that she must give up teaching as a profession. Before this, however, Mrs Odeh's health had broken down in Cairo; the Mission and schools had had to be given up and the family had once more been united under one roof in a house in Oxford. Mr Odeh had a cure of souls at Warkworth and a position in the University where he assisted the Oriental Professor as tutor in Arabic. Now, after four years in Oxford, he had come to settle in London and occupied a house in Upper Gloucester Place, Marylebone.

By this time the restaurant was almost empty and the waiters were looking at us askance. We were due at Rupert's for tea, so we decided to walk across the Park, if the rain held off. On our way through Soho Square we met a shower, but when we got off the 'bus in Bayswater the clouds had parted and shafts of pale sunlight struck down across the sky, making the black trees gleam.

We entered the Gardens by the Serpentine, but found ourselves, I remember, in that wide grass expanse which is actually a drive across to the Round Pond with the equestrian figure of Physical Energy crowning the slope. The scene was momentarily dramatic with the lifting of the cloud curtain to reveal the transformation of a bright airy space traversed by slowly floating bergs of cumulus over the ultimate blue. I made a sketch on the large envelope containing some type copies of my verses which Bunty had made for me. She had a peculiar, quite unshakable mistrust of poets, I discovered, so this had been a very special favour, which, of course, I relished.

I do not remember what we talked of, but I know it was somehow a memorable walk, just as it had already been a memorable lunch and as, no doubt, everything to-day would be memorable, because something had begun to grow in us both – or was it between us? – that quickened every hour. As yet it was as unsubstantial as that floating cloud berg on high. It might even now dissolve as easily, or could it possibly be that its dazzling

brightness might turn flat and grey? I stole a look at Bunty. Her warm skin was flushed to a deep rose in her cheeks and her eyes caught and threw back the sunlight, like brown tarns which reflect the blue sky. She looked as radiant as the wet grass or the glistening trees. Yet, surely, I persuaded myself, it is not only a reflection of the brightness of the day.

Tea was ready by the time we reached South Parade. Rosalind was there and Rupert's Slade friend, the huge blond Irishman, Bob Gibbings.[7] After tea Rupert played Bach to us – mostly from the Forty-eight Preludes and Fugues. As I listened a strange conviction grew upon me. A part of my fate was being decided at that moment in that room. The music distilled some enchantment which wove to encircle me and another being, who surely, I felt, must be aware of what was passing. I looked again at Bunty, but she knew other eyes than mine were upon her and wore her mask of detached abstraction. The last light of the sun filtered into the room, falling across her hair, so that the dark red tinge glowed through the black like the veins of a grape. And still the music wove its exquisite intricacies or soared like the lark, plane upon heavenly plane, or ran like the lonely petrel across the hollow of the wave until no images of earth or sea or sky were left between one's self and the music.

While Rupert and I were still standing in the street after Rosalind, Bunty and Bob had turned the corner, I suddenly said to him, 'What do you make of Bunty?' 'Bunty's a charming little humbug,' said Rupert, smiling to himself. I was rather shocked, but I thought I knew what he meant. 'Do you think she likes me?' I asked. 'I'm sure she does, but you're not the only pebble on the beach, old man.' I was aware of that. Bunty had devotees ranging from a Baron at the Russian Embassy who took her on the river, wearing a red cummerbund and a white piqué suit, to an Irishman who frankly confessed his heart was full of darts on her account. But, somehow, these potential rivals did not worry me any more than the fact that I *should* have waited for years before I held a show at the Carfax had worried me. I had a conviction that I was privileged. But of course, if I was being humbugged, that was another matter. I did not believe it, but I determined to find out.

One evening, a few days later I was saying good-night to Bunty at the corner of her Baker Street square after we had been out to a show together. More than ever I had enjoyed being with her and had been charmed by her gay, expansive mood. 'I think I shall marry you some day,' I said, suddenly catching her hand. 'Yes, I expect you will,' she replied in the same tone.

It was not much to go on, but on an impulse I pulled her into my arms. As we kissed all doubts dissolved and the questions we might have asked ourselves were answered. In the fusion with each other, a third sprang into life, we became one only to become three – each other and ourselves. It was the only sum I ever understood.

I was so elated I lost all sense of time and place. We walked about together in our new-found happiness, until some sense of mundane consciousness returned and we remembered our respective homes.

At last we parted and I set off to walk to Chelsea. All the 'buses had stopped long ago, but whether I had no money left for a cab or whether I really preferred walking, I'm not sure. Certainly, I felt at first that I had to walk, because I was walking on air. When I reached Rupert's door I was not yet tired, but I looked forward to a sleep in the hammock. The house looked very blank and dead. I began to call to Rupert, but no response came. I stepped back into the road and threw small stones at the window. There was nothing for it; I must rouse the people of the house. I rang and rang again; I knocked and knocked. The house might have been a tomb.

Eventually I had to abandon all attempts to get in. What did it matter? I walked down Church Street and wandered along the Embankment. It was rather cold and wintry there, so I climbed into the little enclosed gardens opposite Rossetti's old house, where I tried to sleep on one of the seats, but I soon got tired of that and climbed out again. Near Battersea Bridge I found a coffee stall where workmen of some kind or other and two or three tarts were sipping and munching. The tarts brightened up when they saw a possible client, but they found me inattentive. I talked with one of them for a while, but finding there was no business, she remarked sarcastically, 'Got a headache, dearie?'. I was left with the coffee man.

The night dwindled. I will confess I no longer walked on air. At about five-thirty I found a tram line and a tram filling up with workmen. In this convulsive vehicle I dozed uneasily for as many journeys to and fro as my pennies would allow. At six-thirty I was following in the wake of a milk cart up Church Street. This time I made a noisier attack upon No. 3, which summoned a sleepy, incredulous landlord. A minute later I stood looking down at Rupert's pale sleeping head.

When he woke I was still standing in the doorway. He seemed as disinclined as the landlord to believe in me. 'Rupert, I have told Bunty I love her and I think she loves me.' Rupert propped himself up straighter. 'Oh,

do you really love her?' 'My God, yes,' I said. But I was dropping with sleep, and Rupert, being the good fellow that he was, got up and gave me his couch.

V End of a World

I. PRELUDE

My father took the announcement of my engagement with his usual philosophic front. What went on behind I could guess, perhaps: but he appeared to be happy, at least on my account. A few days later Bunty came down to lunch, and the meeting I had looked forward to so much took place. I don't think I had any doubts about its success beforehand. If I had, they were then dispelled, for a friendship sprang up almost from the first which increased in sympathy and affection as time went on.

There was only one point on which my father took up a stand and remained unshakable against all opinions and wishes. He refused to address his future daughter as 'Bunty'. He said it was a fancy, stage name – as it was – undignified, he implied, and inappropriate. Anyhow, why in the world call the girl Bunty when she had a beautiful name like Margaret. At the time I could not agree, for in spite of the logic of my father's argument the nickname seemed to suit and it was hard to break a habit once it had become natural. But because in the end I too came to regret that fancy stage name and got to thinking of her as Margaret, also she herself preferred her real name, I shall adopt it from now on throughout this history. She had another fantastic, impossible name—Theodosia, but this was kept secret.

I was received into the Odeh family in the warmest manner. My new parents were two unusual people. Both had that singleness of heart which in each was allied to true simplicity of mind. Not that either lacked intellectual qualities. In fact my mother-in-law had once been a blue stocking,

one of the first women to be a member of a university at Alexander College, Dublin. My father-in-law was decidedly less intellectual. But he possessed great force of character combined with shrewd judgment and had achieved a very solid personal triumph in Cairo. He and I got along together very well. He decided I was nearer a worker than a drone and he had a touching respect for the mysteries of art, even as I expounded them in my immaturity. My mother-in-law frankly gave her heart to me almost at once. Nothing could have been more spontaneous and consequently flattering. I, in turn, loved her dearly. She was a delightful old lady who was never old except in a certain fragility which became her aristocratic poise. But she was by no means brittle and never sugary. Her sarcasms were only equalled in my experience by those of my Aunt Gussie, and she had a manner of dismissing a person or a topic by a single sniff which was annihilating.

I now began to learn more about Margaret's work. In the early part of 1913 the Women's Suffrage movement was gathering momentum every day, and the reverberations of its angry tide echoed all around the country. It had become a force which, while it was derided and detested for its methods of expression, increasingly enrolled new members and sympathisers. But the wider and deeper it grew the more it was opposed by its enemies, the Government in general, and certain individuals, Lloyd George in particular. Against their technique of suppression the W.S.P.U. fought back with every ingenious and outrageous method conceived by the feminine brain. Before I met Margaret I do not remember taking much notice of the civil war growing up about me. Certainly, I was ignorant of its rights and wrongs. But now I found myself seriously engaged whether I was interested or not.

Margaret was not a member of the militant side of the movement, although she had walked in the famous procession of Black Friday and seen the police break up the women's ranks with their horses. That sickening sight and the obscene invective of the crowd on the pavements must have strengthened her determination to work for the 'cause'. When we first met she was private secretary to the organiser of the Tax Resistance League, whose business was to fight the cases of women of property who refused to pay Imperial taxes while they had no say in government. When their household goods were sold up, the League held public auctions which they used as occasions for propaganda in favour of women's rights of franchise. Often these meetings roused angry scenes. The speakers stormed

and shouted against the hooting crowd, who were not above throwing mud and stones when available eggs and vegetables gave out. In and out among the crowd the 'Government men' stirred up the trouble.

I was first made aware of the part Margaret played on such occasions when I was staying with the Odehs in Upper Gloucester Place. One morning Margaret, who, I noticed, was dressed in a rather different manner from her usual appearance, announced that there was to be an auction at ten-thirty at the corner of Grafton Street in the Tottenham Court Road. She was going, would I like to accompany her? If so, the cart would be round in about an hour. I had heard vaguely about this cart and I was anxious to see one of these auctions, if only to afford a slight protection in case of a row. But when it was time to start I revised my view on beholding Margaret in her full Tax Resisting equipment. She was now dressed completely in brown. Brown shoes and stockings, brown dress with some kind of knitted coat. On her soft black cloud of hair she wore a hard brown hat of uncompromising but by no means unbecoming form. It was clearly in the nature of a helmet and was firmly held by a brown veil passing under the chin. Her small double-jointed fingers were encased in very neat gauntlets and in her right hand she carried a brown leather dog whip. Her cheeks had a high colour behind the veil and her dark brown eyes had gone almost black with the dark glow of battle. She looked slightly formidable and no less attractive. The cart turned out to be a milk cart, one of those low-lying affairs in which the milkman stood up to drive as in an ancient chariot. In place of the milk cans there were piles of leaflet literature and just room for Margaret and myself. As we jogged along I could see the effect on some of the faces of the passers-by and I imagined what a quaint sight we presented. At that date I dressed very differently from the student at the Slade whom Nevinson had sarcastically taunted. No one could mistake me now for anyone but an 'artist of some sort'. I wore my hair thick and rather long with slight side whiskers. My hat was almost as wide as a 'Stetson', fawn in colour. Over my suit of brown tweed, checked with a red thread, I wore a long light-brown Harris tweed cloak made with a waistcoat attached, which had flapped pockets. My collar was low, turned down with long points, white and starched, a special design, with a very wide red silk knitted tie in conventional sailor knot. I smoked a long-stemmed cherry wood pipe with a red clay bowl and carried a long ebony stick with shepherd's crook handle. On special occasions my tweed suit was changed for a black cloth coat and waistcoat

with wide oatmeal-coloured trousers and black patent shoes with cuban heels – sometimes with white spats. To-day, I was in tweeds and cloak with long pipe and crook. I wondered whether my appearance might not act as an additional provocation to the toughs of the Tottenham Court Road, a not very civilised thoroughfare at any time.

Margaret had described one or two of her encounters. I knew why she carried a dog whip. She bought it after her first brush with medical students, always the worst elements of the bad crowds. 'What you want, sweetheart', said one, grinning into her face, 'is raping'. Margaret hit him across the mouth as hard as she could. He bled all right, but it hurt her fingers which were too soft. So she bought the dog whip. Once the crowd got savage and tried to rush the cart. This was what the milkman, who was not more than a boy whom Margaret had unscrupulously fascinated into enlistment for her and the Cause, really lived for. Whipping up the pony he and she charged through the crowd in a storm of missiles and floating leaflets; the milkman lashing out with his long whip and Margaret using her short one, standing erect in the milk chariot like a new kind of Boadicea, scattering the enemy hordes.

Fortunately, no frightfulness occurred in the Tottenham Court Road that morning. Only a certain amount of indignation vented itself when what was thought to be a new kind of street betting turned out to be only an involved advertisement for Women's Suffrage. We wound up the show pretty early, and as Margaret had to go back to her office for some other work, we agreed to meet for a light lunch at her club.

The club Margaret belonged to was not the usual refined ladies' retreat. Its full title was the International Women's Franchise Club, and it seemed to me only partially and occasionally restful. Most of the time it resembled a hive where people of both sexes, all ages and different countries buzzed in and out all day long and half the night. I suppose it was run by some kind of committee but the obvious moving spirit was an extremely smart good-looking lady secretary. The premises also were attractive, a house whose windows looked down Grafton Street, and from whose superb plate glass bay on the first floor members could watch the high-class traffic of Mayfair moving up and down or disappearing round Hay Hill. Only a few days ago the casual watchers had been brought to their feet by an alarming disturbance. Alarming only to the Mayfair traffic, the Club seethed with enthusiasm, many members ran into the street cheering wildly as crowds of people muttering or booing began to hem in a small group of figures

outside Dover Street post office. The post office window was shattered, apparently by a heavy missile which had not actually exploded. On the pavement stood a tall commanding lady with white hair and rather a long face still transfigured by the light of inspiration. She was loudly calling upon the post office or the police to arrest her.

Here was a poetic action but typical of those days. Living comfortably and happily in the South of France, she had read one day of the brutal police charge in Parliament Square and the horrors of the hunger strikes and 'forcible feeding'. Without hesitation she packed up and travelled to England. At Charing Cross she purchased a hammer and a bunch of daffodils. Concealing the hammer amongst the flowers she proceeded to Dover Street and hurled this strange bouquet through the post office window, at the same time uttering a loud wailing cry, 'Votes for Women. Votes for Women!' She then entered the post office and told a bewildered clerk to fetch her a glass of milk and a constable. The Club was still talking about this with glee and I was recalling the deed rather sympathetically, I confess, as I turned out of the smart streets into the building with its hive of odd eager inhabitants.

The large principal room was beginning to fill up with people meeting before luncheon. This was a warning for a stranger to keep his eyes open and be careful where he trod. The wide floor was covered by a handsome bright green pile carpet and roving over this green expanse might be Mr Josephs' identically green parrot. If you trod on or 'fouled' the parrot in any way it would call out 'A spy, a spy!' in a terrible voice. Sometimes it just bit you out of sheer irritation at not being provoked. Most of its life, however, was spent sitting on its master's shoulder. On this perch it went to meetings, travelled in the tube or in 'buses or scrutinised the assembly in the drawing-room at all large gatherings where floor walking was impracticable or so unnerving to the company that it had to be stopped by the Club officials. But wherever the bird went it did inveterate propaganda for the 'cause'. It respected neither person nor place in this pursuit and had been well coached in subversive slogans. It was also credited with ventriloquial powers. In the tube, hidden behind the screen of the *Times,* a voice would begin to denounce the Government, but when the parrot was revealed it appeared detached vaguely chewing its claws. Once it caused a scene in Hyde Park by flying from tree to tree screaming, 'Down with Lloyd George. Down with the Government. George is a damned liar!' Park keepers and police attempted to arrest it, but it towered into the

blue, later planing down in an unexpected direction where its master was waiting to walk away. Legend naturally grew around this extraordinary fowl, but it was hardly popular in the Club where its eccentric secret service antics were often resented.

Margaret joined me while I was talking to Mr Josephs and trying to impress the parrot in my own favour. His master assured me, however, I was safe from being denounced, provided I was a genuine friend; the parrot never made a mistake. We lunched upstairs in a pleasant, airy room with a balcony where you could take your coffee in the open. Presently, I noticed a group of women in serious and sometimes excited conversation at a table across the room. Most of the time they appeared to listen to a handsome, athletic girl who spoke with quiet emphasis, now and then softly hitting the table with her clenched fist. 'What are they up to?' I asked Margaret. 'Another plot, I expect.' What sort of plot?' 'Well, you see that sporting looking girl, she planned the Lloyd George stunt.' 'Oh, what was that?' 'Well, Miss D. was going to play golf with him. His detectives would be a little way off—then they had a car waiting with an old lady dressed as Lloyd George. D. was going to get him up to the car and somehow change over. Then she was going on playing golf with the dummy while they drove off Lloyd George and tied him up on an island belonging to one of the members here. He was to be dressed in pyjamas and kept tied up till he signed a paper giving us the vote.' 'What went wrong?' I asked, looking with even deeper interest at the athletic girl. 'I don't quite know. They dogged him for days but I think the detectives got suspicious. I expect they'll get him this time,' Margaret added grimly. 'I jolly well hope they do,' I said . . .

A waiter came to our table to say that a Miss Clark was downstairs asking for Miss Odeh. 'I will come down to the drawing-room in a minute,' said Margaret. 'This is Ruth,' she added to me, 'go down and meet her.'

I had heard of Ruth Clark before, of course. Apart from Rosalind, she was Margaret's particular friend. They had trained together for their secretarial course.

I encountered Ruth on the stairs going down. She also was dressed in brown that day, but of a pinkish, russet shade. With this was somehow associated a pleasant apple green. She was a pretty creature in a very subtle undemonstrative way, delicately plump yet eminently bird-like and this was suggested again by her voice and way of talking which began, like a good many other birds, on a high note and trilled down the scale, not in

slow falling cadences but in a precipitate twittering, odd and amusing. She was full, too, of sudden quick gestures not necessarily illustrative of what she was describing but in what seemed to be for her an essential emphasis of her conversation. These little swift darts and jerks only enhanced her bird-like quality but removed her from the quail and partridge family where she might otherwise have belonged and made her one with the woodland species which move rather quickly about in thickets uttering small shrill songs. It must have been very early in our acquaintance that she was called 'Twit', I believe by me, but we all adopted the name and she seemed to accept it happily.

In our first flights in that world which is neither earth nor heaven but an enchanted interspace, Margaret and I were, I think, only acutely conscious of each other. Now that we trod on earth again and mingled with its inhabitants, the individuals of our little group began to draw closer together and to increase slightly in numbers. The first addition, after the acquisition of Twit, were John my brother, and my sister Barbara.

The picture of this group could not be called complete at that time without the inclusion of a strange figure, as attractive as any in personal charm although quite enigmatical. I will call her Mary McM. since her own name in the end suffered such total eclipse. She lived then with the Odehs in London and was a member of Margaret's club. She lived her own mysterious life yet was so often one of our party and had so much natural sympathy for us that I still think of her in those seemingly happy days and can still hear her musical Highland chatter and her quiet laughter.

Having given these few outlines of some of the figures in our own small circle I should like to conjure up from those times an impression of the larger circle we moved in, particularly in London in the year before the Great War. Not that any of us had the smallest social range to afford experience but we touched certain points which had a wide radius and showed an aspect of what is long since a lost age. They were the lights going down over the horizon, the voices dying away, the transformations of the last scene of a drama one might call The End of a World. But since this story, should it begin to digress from its path of events, would soon become out of control, my impressions must come within the outline of my personal history only. A parenthesis of the slightest general interest and importance would, I am convinced, carry me ignominiously out to sea.

2

Soon after her first visit to Iver Heath, when she and Rosalind Pemberton came down to lunch, Margaret came to stay.

It was early spring and the urgent blades of corn thrust up everywhere through the furrow. The spearhead of the crocus parted the thick grass in the Bird Garden, and on the shadowed banks of the lanes the arum unfurled its sheath. Up in the sky the peewits tumbled about in their distracted ecstasies, emitting little agonised cries. How sweet it all seemed. How happy we were! What promise shone in the sunlight, and sounded in the birds' songs, or breathed out of every pore of plant and tree! Would any weather bring again a breeze that smelt so much like Paradise! Thus we argued and wondered.

In my pocket was a letter from Gordon Bottomley which brought a piece of exciting news and his congratulations. 'I was only a year older than you when I became engaged myself. I still walk in the transfigured light of those heavenly days—'

How like him! I cried, it will be good to meet him at last. For that was the great news. Gordon had written to say he was so much better he could travel, and was coming South in three weeks' time to stay with his old friend and fellow poet, Robert Trevelyan, who was inviting me for a week-end while Gordon was at Shiffolds, Holmbury-St Mary.

Goodness! what wonderful-sounding places these Georgian poets lived in, I thought. You couldn't go far wrong if you lived in the North at the Sheiling, Silverdale, and went to stay in the South at the Shiffolds, Holmbury-St Mary. What sort of an address could Rupert Brooke have, for heaven's sake . . . Oh, of course, Grantchester, Grantchester, or would it be the Pink and Lily? . . .

We wandered over the crumbling plough until I found a spot where I wanted to draw, and so we made our first picture. It was the drawing I made that day, together with a slightly earlier one of the elm tree group that the New English Art Club accepted, and so I got my first competitive exhibition in London. But it got no more than this modest triumph as I shall presently show.

At last the day came for my visit to The Shiffolds. I had never stayed in Surrey before and had formed rather a prejudice against it. But this was a fair piece of country that the pony trap was carrying me through, with its

tunnelled lanes alight with primroses and now the woods just beginning to break into leaf on the slopes of Leith Hill.

The Shiffolds was a house you might dream of. My only impression is of a satisfying perfection all pervading – not tiresomely, but in a soothing way; yet not a drug. It was a place, at that time of the year and in that age, where you could be healed, recover your sanity, be brought back to life. Yes, here, I felt, you could *revive*.

It stood at the top of a hill yet was built in a wood. The slender larches and the white-boled oaks grew round its flanks, but its head topped the trees so that from the windows of the bedroom the eye travelled like a kestrel, skimming the crests of the declining forest which descended the farther slopes and spread out far beyond. I thought, how fortunate Gordon can come here! The next minute I was being greeted by my host and hostess.

Both were tall figures, not at all middle-aged. Robert Trevelyan, scholar and poet, known familiarly as Bob, had the characteristic lineaments of the traditional Trevelyan head with just those variations that the head of a poet might be expected to take on. It was rugged and massive and nobly hewn, but the nose seemed wayward and the mouth had a witty, argumentative twist. The eyes looked rather small and deepset behind his old-fashioned steel-rimmed spectacles. But they never ceased to glint and twinkle. On top of his fine brow his hair was agitated into an untidy thicket. He was inclined to be restless; perhaps because he was suffering from chilblains, against which he wore three pairs of thick stockings one over the other and no shoes, a strange effect. He was also apt to start sentences which he never or seldom finished, beginning them urgently in a queer rather creaky voice and abandoning them quite high in the scale to die on the air when he would as urgently begin them again.

All these idiosyncrasies fascinated me, but I had little time to observe them, being naturally impatient to meet Gordon and Emily who were said to be upstairs.

Gordon had once sent me some snapshots of himself, so I had an idea of what he would look like. But no print or picture had quite conveyed that big, benign presence. Otherwise he was pre-eminently Victorian, and with his mane of black hair, fine profile, and great red beard could have taken his place alongside Tennyson, Watts or any other of the bearded giants of the last century. He was a good deal of a giant himself. But for his defective lung he must have been a Viking of a man. As it was, I felt all his potential

physical strength was sublimated and employed as power to strengthen the will that drove him on to write in his long struggle with suffering and discomfort. At a far distance I had seen something of that struggle during the three years we had corresponded, had watched its effects upon that beautiful formal calligraphy, and had anxiously scanned the letters that had had to be written in pencil. How little they ever wavered! That last one he had written to send me his blessing had, I knew, been delayed for the old reason, you might just be able to say the hand was tired, but it had not prevented him from writing the fullest measure as usual; even, as usual, running over round the edges, so that *your affectionate friend, Gordon,* filled the last available space. And that was as typical a sign of Gordon Bottomley as I can find perhaps.

He gave, always without stint. His encouragement, his praise, his sympathy, flowed out in the fullest measure and ran over. Once or twice he had written of an artist or a writer he had no use for, and I had seen the cold stare which saw through them and left them withered. But even to the men he was little interested in he gave, always finding some quality that was worth while and always making the most of it on their behalf.

As I had just met Bob Trevelyan, I could not help noticing the contrast between his head and Gordon Bottomley's. Whereas Bob's features could only have jutted from some cliff or crag, Gordon's seemed moulded like his own undulating hills. His slightly flattened, black crest, roofing his broad sloping brows, together with the longer sweep of his great red beard, all suggested rather the flow of polished, sculptured planes. Since very little could be seen of his mouth, he seemed to have acquired a special power of smiling with his large blue eyes which, otherwise, had an introspective, deeply contemplative look. These smiling eyes were enhanced by a low, soft voice trained of necessity, I imagined, to be easy on the lungs, but which, again, was a great contrast to Bob's sudden jets and spurts of speech, for it flowed smoothly on with amazing continuity of thought and expression, the words always ready to the quiet, deliberate tongue of the poet. It was the sum of these many quiet, restful attributes which accounted for his benign atmosphere, and suggested a kindly unwarlike old Northern God who in happier times might have lived in a grove and dispensed oracles.

Emily, by contrast again, was small and quick and darting; part birdwoman, part fairy of sorts. William Allingham at the top of his form might have invented her, or perhaps Gordon himself. Her head was small

with fine naturally white hair and black eyes. She seemed the most effi-
cient creature imaginable. When you studied her operations and strategies
you saw why Gordon could be benign and continuous, and how it was he
could write at all. At least you wondered how he would be alive to write
were it not for Emily.

We talked and talked. It was a strange feeling to be sitting beside
Gordon whom I had known for three years without meeting. But we soon
found it easy to advance our understanding and sympathy. I had sent some
new drawings for him to see a few days before I came. He was giving his
usual generous criticism of these when Bob joined us and asked whether
Gordon had told me about my drawings at the New English. 'No, Bob,'
he said, 'that is your news and, as I think it is also rather important, I left
it to you.' This of course was the signal for Bob to fire a sentence into the
air like a rocket with a terrific rush. 'Well, I rather thought so but he, I
mean . . .'

At the top of the sky I could hear the rocket gently explode. With a hiss
the stick fell to earth. We all waited. Up went the second rocket or rather
down it came for it seemed to begin far up and fall from the sky. 'Well you
see, *Roger.*' An abysmal pause followed. I felt it was my turn. 'Roger *who?*'
I said, as politely as my impatience would allow.

This actually seemed to help Bob, who gave a small bark of laughter
and continued, 'Oh, Roger Fry, you know, he saw your things at the New
English and liked them more than anything else there.'

It was generally admitted that Roger Fry was without doubt *the* high
priest of art of the day, and could and did make artistic reputations over-
night. To be noticed, and picked out of the walls in Suffolk Street was an
undoubted honour for an unknown artist . . .

Gordon by now becoming rather tired, Bob took me off to see his col-
lection of pictures, and the garden.

It was an interesting small collection, but the inspection of it was
slightly disturbed by my impression that Bob was all the while nursing
a joke of sorts. I was now and then made to guess the author of a variety
of paintings. While I hazarded my not very certain opinion, being gen-
uinely baffled and having no great knowledge anyway, Bob regarded me
with glinting spectacles obviously hugging his nurseling. Presently it was
produced and Bob announced that all these pictures were the work of one
man. 'Impossible,' I cried, 'what is his name?' Bob could no longer hold the
joke which had been struggling to break out. 'Roger Fry,' he exclaimed. He

went on to point out that these pictures were not essays in the manner of John Varley Marchand, Matisse or whoever else, but authentic Roger Frys painted during the periods of the particular influences he was under at the time. 'Now, of course, it is Cézanne,' added Bob. In which case, I thought, what can he find to like about my drawings? I felt a growing desire to meet the high priest of art.

On our return from a review of the garden, I was stepping through the French window into the music room when a small boy rose up from the floor out of a half-built city of bricks, crying, 'Mamma, Mamma, who is the man with red ears?'

'Julian, do not be rude,' said Mrs Trevelyan in her quiet voice for, obviously, this was directed at me. I do not think my ears are peculiar in colour, but they do not lie very close to my head and at that moment the sun was sinking behind my back which accounted for an alarming illumination. Suddenly, I in turn stood transfixed. The talking had stopped for a moment and Bessie Trevelyan with her charming tact, to create a diversion from flaming ears, had opened the lid of a long narrow instrument somewhat like Rupert's piano. Standing in her long gown, her long arms reached down to the keys and now there vibrated on the still air the most magical sounds I thought I had ever heard. I felt shaken as by some subtle physical shock while tears pricked at my eyes. It was the first time I had listened to a musician playing on a clavichord. It was Bach's No. 1 Prelude from the 48.

Afterwards there was more music and talks; an inspection of treasured books, and walks in the woods, until that memorable visit all too soon came to an end. There was a plan for me to return at Easter which, alas, was never realised. And so, feeling I had found new friends who were among his own most cherished ones, I said good-bye to Gordon for another year.

When my train reached Victoria on Monday morning, I left my luggage at Piccadilly Tube Station and walked from there to the place where I had arranged to meet Margaret for lunch. This was the famous haunt of vegetarians, the Eustace Miles Restaurant in Chandos Street. It was not my idea of a good place to feed in, but Margaret used it for several reasons. It was near her office, and she often met her friends there. Also it was not supposed to be expensive. In its rather dim, green salon on the first floor, we had reunited after my sojourn on the Chelsea Embankment the night of our betrothal.

Taking a slightly devious route, I came out into Trafalgar Square. It was a sharp, sweet April day, white and blue. The fountains were playing in the

crystal sunlight. The pigeons were endlessly busy with their alternate occupations. People walking by or standing ankle deep among the pigeons had a leisurely air, aware of the spring. Crossing the Square diagonally, there appeared three unusual figures, man, woman and child completely attired in traditional classical Greek costume. These figures looked well in the surroundings of the cascading water and the vast stone floors. Their sandalled feet threaded prettily through the pigeons. But as they approached I thought they looked rather sad, the child was tired and dragged behind. I noticed the hem of the woman's tunic was stained with mud. The man had a fine proud head. All were silent and looked as if they wanted their luncheon. Following in their wake my guess seemed to be right for they crossed St Martin's Lane and entered Eustace Miles Restaurant just in front of me.

Rather to my surprise I found Margaret had already arrived and was not alone. Her companion, a young man who seemed in some way flustered, rose at my approach and retired to an adjacent table. It then transpired he was a complete stranger who had suddenly intruded and, when abruptly discouraged, protested that Margaret had invited him to the table. 'I suppose it's the spring,' I said. 'I met some people in Trafalgar Square dressed as ancient Greeks. They came in here.' Margaret said she knew about them. They were Raymond Duncan, brother of Isadora the dancer, and his family, and they never dressed in any other way. It wasn't the spring with the young man either. He had come over because she had raised her flag. 'What flag is that?' I enquired. It was a small contrivance like a railway signal. I saw every table had one. Margaret had thought it was for summoning the waitress. She saw the young man put his up and she put hers up. Whereupon the young man came over and opened a bright line of conversation. In this he was within his rights it seemed. The flags were not used for summoning waitresses, but as a method of introduction between London's 'lonely ones'; part of a social campaign by Mrs Eustace Miles.

We read all about this in a magazine called *Healthward Ho!* which formed part of a small library of propaganda with which each table was furnished. Here also I learned about the more mystical side of the vegetarian cult; séances in the green salon, meetings to bring together people with sympathetic auras, and the monthly gatherings of old Baldertonians. But among all this you could very easily get no lunch, so we attracted the attention of a rather beautiful pale girl dressed in a tender shade of mock cutlet brown.

Having ordered a meal for us both from her wider understanding, Margaret gave me her piece of news. Rupert had got a job, a wonderful job, just after his heart! He was to work for Gordon Craig in his School for the Art of the Theatre, but not as an artist. He was to be Director of Music. No news could have pleased me more than this, but I felt a great deal must have happened while I had been away from London for such an event to take me by surprise.

How perceptive of Craig, I thought, to see Rupert's real potential talent and to take him on for what he might be rather than another man for what he had done. (But then, whatever Craig could be said to lack it was never any sort of vision.) For many he was the one really imaginative English artist of his generation. My mind's eye gazed back to those night class rooms of Bolt Court, where once again I was one of the crowd of excited students craning forward to see the distinguished visitors. Once again I saw their faces, the face of intelligence followed by the face of genius. Since that day I had come to know something of the work of Gordon Craig, principally from seeing his exhibition of models for 'Macbeth' and other Shakespearian plays, which was held at the Leicester Galleries and, more recently, from reading his book *The Art of the Theatre*. In both scene and page I had found the same unique vision and rare poetic understanding, the same evidence of inspiration which made me associate the quality of genius with his name.

Although I was then pursuing a course which seemed hardly connected with the main purpose of contemporary painting in my own country and was drawn by none of the strong Continental currents, I was beginning to become critically aware of my surroundings or at least of the principal figures in contemporary art whose influence had so greatly affected, for example, my late fellow students at the Slade.

At that time, that is in the spring of 1913, in spite of the many signs of unrest, in spite of Roger Fry's Post-Impressionist Exhibitions and the publication of Clive Bell's *Art*, the doctrine and practice of the New English Art Club represented all that was most typical of modern art in England, Augustus John's being still the most conspicuous talent produced by the New English Art Club. Up to that moment no murmur of 'Time's winged chariot hurrying near' with Wyndham Lewis at the controls, had yet reached our ears. Of the alarming shadow creeping ahead of this approaching event none seemed to be aware. We were conscious only of three rather more than life-size personalities, individually different in

expression yet having many personal characteristics in common – Augustus John, the painter; Jacob Epstein, the sculptor; and Gordon Craig, son of Ellen Terry, the theatrical designer. All were constantly in the public mind where all were associated with something romantic, daring, scandalous and brilliant. Each was the subject of endless anecdotes and legends, not always connected with art. Each was credited with almost super-human virility.

I do not remember being very much interested in the romantic exploits of John or Epstein any more than I was in their work. I had a deep respect for John's draughtsmanship, especially when it was applied with a paint brush. I had seen Epstein's Exhibition on the Chelsea Embankment, which included the Image for Oscar Wilde's tomb and the ambitious Sun God, though here again, it seemed to me, technical power rather than vision predominated. I came away unmoved. But in the work of Craig I found far finer qualities despite its apparent minor importance as a contribution to what was recognised as contemporary art.

In the first place Craig possessed imagination in a degree far beyond John or Epstein. For although the origin of his inspiration in regard to certain technical vehicles of his art could be traced to various sources, the style evolved was his own and it had a constant distinction. But all method and manner aside, what appealed to me in the work of Craig was the abundant evidence of a poetic insight which enabled him to give an imaginative interpretation to drama, while, allied to this was a vision capable of realising his ideas in the medium of three-dimensional form. Once I had seen his models I could believe unhesitatingly in his drawings. Seen alone, the latter often seemed too stylised, too exquisite to support a credible reality. The translations into three-dimensional buildings changed such a limited view.

These models represented the chief testimony of Craig's reputation outside his own country. For abroad Craig was acknowledged as a revolutionary thinker, and as a name he was far better known internationally than either John or Epstein. Recently he had found a wealthy and generous patron in Lord Howard de Walden and was now trying to realise his ambition of forming a school for the Art of the Theatre in Florence, where he had been living for some years and from where he published his magazine of the theatre *The Mask*, perhaps the best printed and illustrated magazine in the world. And now Craig was in London recruiting his personnel, while London was beginning to take notice of this distinctive

visitor. Only the other day a dinner had been given in his honour at the Café Royal, and Rothenstein had made quite a lyrical speech. 'I want,' he said 'to shout from the housetops – Craig is a wonderful man.'

These facts came into my mind as I listened to Margaret's account of Rupert taking the King of the Theatre's shilling, as it were, as chief bandmaster to the School for the Art of the Theatre. Margaret concluded, 'Rupert has an appointment with him to-night at the Café Royal and wants you to be there to meet him, but first of all we are all having dinner and going to the "Oxford". Tich is on and Willy Solar.' All this was attractive to look forward to and we were anticipating the likely songs and recalling our favourites, when we were hailed by a strange voice. Looking round we saw three men of different heights and ages approaching. 'Cournos,' cried Margaret, jumping up, 'and Slonimbski Fallas.' I was introduced and felt three pairs of eyes quickly or slowly scrutinise me. I regarded them in return as we sat down and ordered coffee. Cournos' was an old friend of Margaret's whom I had often heard of, although at that time I did not know his books. A Russian American, he was a highly sensitive poet of the new Imagist school, whose writings I came to admire later, but in whose company at that time I was always at a disadvantage, being seldom ever certain of what he was saying. I had hardly learnt American in those days. The immense drawl, the flattening and elongating of all short, round vowels, and the arbitrary accenting of familiar words utterly baffled me in any prolonged conversation. Cournos spoke a very personal American in a quiet voice which often laughed quietly at the same time. Here, how-ever, was another link with Craig, for Cournos and his friends had come over from their offices in the Adelphi, which were the headquarters of Craig's conspiracy, to form the school. The arch conspirator himself lived in a private suite at Morley's Hotel. We discussed the great scheme for a while, and I found how deeply Craig had been able to inspire his followers with his dreams. Yet while they talked, there still remained a doubt which made these men uneasy and uncertain of success. Only a history which is unlikely to be written can say exactly why the school for the Art of the Theatre was never realised.

That evening a rally took place at the Oxford Music Hall. First we dined at the Dieppe in Soho. The Dieppe was like no restaurant I can remember. I was beginning to know the London restaurants now, from the Cock Tavern, where Father and I used to sit on stools and eat bread and cheese and drink stout from tankards, to the palatial Café Royal with its mirrors

and caryatids, spruce napery and crimson plush couches. Or there were the restaurants here and there, attractive because of their national atmosphere, truly French like the Escargot, or truly Italian like the Commercio, which had the added attraction of being cheap. Others, the Mont D'or, a little more expensive, where Eddie Marsh was able to give artists of promise their first dinner with a patron, or rather smart Bohemian and fashionable, like Kettner's and the Isola Bella, which were beyond our purses. But the Dieppe was both absurdly cheap and unique in character. The little tables with their bright flowers and coloured shades were not all set frankly in the open, some were ensconced here and there in graceful arbors under wreaths of artificial blooms and leaves. In the roof of these bowers, cages of the brightest colours hung, from which poured a constant trilling and twittering of canaries, finches or simply toy birds which could be wound up by the waiter. In the evening these bowers were illumined by tiny coloured lights concealed in the leaves of these trellis walls, even so, they afforded opportunities for all sorts of dalliance. But the diners at the Dieppe were not hall-marked respectability. Most of them were artists and their models and those whose business made them inhabitants or habitual visitors in Soho. Every sort of creature came there. Theatrical managers, anarchists, pastry cooks and coloured boxers. What the bird books call occasional visitors to these shores, was my father in his top hat and check trousers. Once he had lunched there with us, he couldn't be kept away on any occasion, such as a private view, which seemed to justify his appearance in bohemian company.

One day while we were at lunch there, three or four families of dwarfs came brusquely in, muttering and scowling suspiciously. I suppose they came from the Coliseum and were living in the hotel upstairs. They were obviously late for lunch, but they couldn't get upstairs quickly and kept tumbling down. It was impossible not to laugh. The dwarfs were furious. But that night, as I recalled our embarrassment at being unable to control our laughter at the expense of those unfortunate midgets, I remembered we should soon be helpless with laughter under the spell of the master midget, the incredible Little Tich. We arrived indeed only just in time for his act at the Oxford. As we took our seats, the orchestra struck up one of those brisk and merry tunes which are inseparable from Tich's public personality – a very different personality from his private character which was rather grave and inclined to studiousness. Tich, as we and the world knew him, was an expression of comic genius, and he was, without question, what is so often glibly claimed for such 'artistes', a true

artist. He was able to be funny in so many ways – in appearance – his physical appearance in itself was a considerable creative comic gesture of chance or design. Only four feet high, a face rather like Punch's but more intelligent, agile as a mongoose, but capable of the most absurd and alarming tumbles and gestures, and then a voice of many modulations from shrill girlish piping to guttural innuendoes and sibilant 'doubles entendres'. But his strangest most compelling asset were his feet. These I think were normal in themselves, but were habitually inserted into the most monstrous boots, long, narrow and flat, so long that he could bow from the boots and lean over at almost an acute angle from his heels. At the same time they were so flat and pliable that Tich could flap and slap with them in a kind of tap dancing that was never known before or since. The scene tonight was a familiar one—a street with a background of houses and trees. On the right-hand wing, a corner house with an area and a grating. Tich has on his fantastic boots and his little comic hat and he waves and waggles his little swagger cane. With this equipment he can make you laugh and can fascinate you endlessly with his nimble dancing and twittering songs. Presently he will inadvertently hit his long boot with his cane and his surprise and pain will be unbearably funny. Suddenly he sees the grating. At once the gay, innocent comic becomes a mischievous little monster, all leers and terrible chuckles. Turning his back he leans over his boots – which is funny enough in itself – he peers through the grating and begins to show signs of naughty excitement, his little stick held casually behind his back somehow begins to look like a little dog's tail which begins to wag with pleasure. The audience is not slow to get all these signs and they laugh and hoot and whistle rude whistles. Tich is delighted with his peep show and, as the band begins to play its catching tune again, he begins to sing:—

'Curi-uri-uri-osity, curiosity,
Most of us are curious,
Some of us are furious,
I do think it's most injurious
Curious to be.
What did I get married for,
Curiosity.'

After this Tich makes some patter and when the chorus breaks out again, there is a crescendo of laughter and applause. Tich becomes tremendously animated and does a wonderful little dance, slapping his boots

together in midair. He throws up his hat and in his ecstasy throws away his little stick. This aberration suddenly halts the whole show. The band stops: while Tich tries to move towards recovering his hat but hesitates and turns to the direction of his stick, and then changes his mind again, and so on, until he is demented with worry. However, the band creeps in *sotto voce* and this seems to encourage him to pick up his stick firmly. But as he stoops to gather up his hat, the toe of his long boot pushes the hat ahead, sometimes it goes only just out of reach, sometimes it positively jumps like a frog. Then suddenly Tich either kicks it, or hits it in a miraculous way so that it spins into the air and he catches it on his head. This is the signal for the band to open up again. Tich resumes his dance and amid a storm of applause the turn is over.

We could not have picked a better night for our fancy at the Oxford for the bill contained not only Tich but Marie Lloyd and an exotic newcomer called Willy Solar who was the first singer I had heard of who, so to speak, orchestrated his voice, punctuating the singing word by all sorts of extravagant and subversive noises – whistles, cat calls, cockcrows and comical lip sputterings.

We came out into the crisp, spring night to face a delicious buffet of cold March wind, as we turned up the Strand and made for the Café Royal in the Regent Street Quadrant. Some of the party now broke up and dispersed for home. I was left to keep my appointment in the Brandy Square, where I looked forward to meeting once again that slightly fabulous figure Gordon Craig, creator of the School for the Art of the Theatre.

As I entered the Café I spied him at the far end of the Brandy Square, but safely coupled to the dining part of the Café, with his back to the engine, as it were, with a marble table before him, from which, although he seemed to have finished his meal, the cloth was not yet drawn. This was because Craig was still drawing all over it with a very heavy black pencil. However, the space was now so full of Theatres in the air, not unlike illustrations for De Quincey's dream and other dizzy imaginings, that an impatient waiter who had been watching him for some time, rudely snatched the table cloth almost from under the Master's pencil. Craig took no notice but merely continued his drawing upon the white marble table which from thence became transformed and animated by what looked to be a quite transposed architectural complex which even held the waiters spellbound. Meanwhile he talked. He was flanked on either side by two of our friends, Rupert Lee and Robert Gibbings, who were eagerly listening

and watching. Craig asked us what we were doing or what we were going to do. 'What about you?' he said to G. 'I'm an artist,' said G. who had not yet left the Slade. 'Nonsense,' said Craig at once. 'You're too tall for an artist.' G. protested in a vigorous brogue, we all in fact demurred. But if you thought about it, very few artists worth considering were tall men, in fact who could you think of as a tall artist? I recalled my late comrades at the Slade, where artists were growing up. All the men of undoubted talent such as Gertler, Spencer, Roberts, were of medium height or small. The tall chaps were not among the gifted ones. Yet surely Craig was tall, or was he just something of an illusionist who increased his stature by a special projection of his tremendous personality, and, on the other hand, kept from looking too tall, by wearing a very wide-brimmed hat?

Gordon Craig at that moment of time was at the zenith of his career, enjoying as he did the dual distinction of *cher maître* and a voice crying in the wilderness. For several very good reasons he lived abroad, in Italy, where so many Englishmen of rare gifts have preferred to reside. He was, to a certain extent, in his element in this setting, surrounded albeit on two sides only, for none of us liked to obtrude into his range of vision, a group of eager, slightly spellbound students . . .

PAUL NASH'S NOTES FOR THE CONTINUATION OF HIS AUTOBIOGRAPHY

VI Making a New World

I

War attitude. Enlisting in the Artists' Rifles. Training in London. Meeting Rupert Brooke. I refuse an invitation to Salonika. We go to guard the Tower of London. Life at the Tower. The first air raids. The Zeppelin posts. Strange adventures. I get married at St Martin's-in-the-Fields by Dick Sheppard. Training in Richmond Park. My new friends. Billy Nowell. Kinnaird Bliss and Lance Sieveking. Art still persists. First and Second Exhibition of the London Group. Vindication of Vorticism. First pictures of the war. I become a map instructor at Romford Camp where I meet Edward Thomas. Life at Romford. Study of E. T. Good-bye to the ranks. O.T.C. (1) Denham. (2) Staff College, Camberly. I pass my first exam. Commissioned in the Hampshires, Gosport. False start for France. London leave. Second start for France. The voyage up the Seine.

2

The Bull Ring at Rouen. Introduction to the Battalion. Introduction to the Salient. Life in the Salient and round Ypres. First impressions. First drawings. The rival C.Os. and their insecticides. I am commissioned to do a poster. My horse ride to Popperinghe. We go out to Rest. The great Rehearsal. Return to the trenches. Accident. I am sent to the C.C.S. Vimereux. England. Swedish hospital. I hold an exhibition of war drawings and am sent to see Mr John Buchan at the F.O. Testimonials for an official

artist. Visit to the Cotswolds. The John Drinkwaters and the Rothensteins. Return to duty. Life at Gosport. The F.O. forgets me. I am booked for the East. I remind the F.O. I am seconded for special duty to the F.O. I go to see Masterman. I am appointed official artist on Western Front and return to France.

I am expected to operate from G.H.Q. I am determined to operate around the Front Line trenches. I begin my campaign. Difficulties of an infantry subaltern behaving like a Staff Captain. I evolve a technique. Eventually I get where I want to be.

Impressions of Flanders, October, 1917. I realise no one in England knows what the scene of the war is like. They cannot imagine the daily and nightly background of the fighter. If I can, I will show them. First I must find my brother. He has been through the battle of Passchendaele. I find he has been sent on a bombing course and has missed Passchendaele. We meet somewhere in the back areas. He is a Sergeant in the Artists' Rifles. We go out to tea. . . .

Visit to Brigade H.Q. Zillebecke. The chance I have been waiting for. Sanctuary Wood at dawn. Gheluvelt. The German pill-box. I escape from the Brigadier. Adventures in Passchendaele. I draw the German Front line. The Menin Road. The mule track. Sunrise at Inverness Copse. About noon I get back to H.Q. I have made fourteen drawings. I fall asleep for hours. Apply for extension of leave. I set up house. My chauffeur finds me a batman who can cook. From our base we drive to different areas of the Line. I spend some days working out my rapid sketches. We visit Vimy Ridge. Gradually series of drawings grows. Time is up. I return to England.

3

I show Masterman my drawings fearing I have failed in my duty as an official artist. Masterman's surprising enthusiasm. I am commanded to hold an exhibition. Exhibition arranged for May at the Leicester Galleries. Life in London. We become friends with the Sitwells. I meet Robbie Ross. I begin to paint in oils, and to draw on stone. Nevinson helps me with lithography. New friend at the F.O. I find a new friend and patron. Jim Baird and the parties at Queen's Gate. Osbert Sitwell at Swan Walk. Arnold Bennett. Exhibition at the Leicester Galleries. Success and consequences. I am commissioned to paint a panel 14 feet by 7 feet for the Imperial War Museum.

The F.O. helps me to rescue Jack from the trenches. He is given a panel to paint for I.W.M. We hire a shed in Bucks. Work begins on the panels and other pictures.

Life at Chalfont. 'The Menin Road'. We fly from Chalfont. 'The Menin Road' and the burning van. The Gower Street studio. Life in London again. The bombs on St. Pancras. Did we escape? The end of the war.

VII Old World Revisited

I

Struggles of a war artist without a war. Lance and Jack design a humorous book, and I go to see Max Beerbohm. I am elected a member of the New English Art Club. We let our flat and go to live in Fitzroy Street. Exhibition of war panels at Burlington House. Triumph of 'The Menin Road'. I begin to design for the theatre. The truth about the Russian Dancers. I go to see Barrie. First meeting with Du Maurier. I meet Karsavina. Production at the Coliseum. Edwin Evans. The Leeds Town Hall frescoes scheme. Jack and I visit Leeds and see the Black Country. First sight of Dymchurch-under-the-Wall. Raymonde Collignon. Raymonde holds a concert at my studio. I hold a private show of drawings. A party at New Inn. I meet Lovat Fraser. A seaside party (Athene Seyler, Grace and Lovat Fraser, Sybil Thorndike, Casson and our own friends at Dymchurch). Lovat and I explore the Marsh.

New life in a different world. New kinds of work. Wood engraving. Writing articles, designing textiles. Snares of journalism. The friendship of Sickert. Arnold Bennett proposes a magazine. I escape the trap.

I begin to learn about painting. New inspiration. Modern French art. The Russian ballet. Roger Fry, the Quaker Jesuit. The rise of the Bloomsbury School. The few independents.

First paintings of Dymchurch Wall. Alice and Eric Daglish. Hard up. Lovat sends me a patron. Desmond Coke comes to tea. My landlord introduces a client. The man who wanted to make the mountains go back. We recover gradually.

Discovery of the Chilterns. Our group at Whiteleaf. We lose two friends. The tragedy of Lovat. I go to Lovat's home. I paint The Chestnut Waters. We are lent a studio where we are not happy.

My father's illness. I go to Iver Heath and receive a shock. I get up in the night and fall down. Black out.

2

Margaret takes charge and defies five doctors. I am taken to London. Gordon Holmes. A week passes. I wake up again. The astonishing recovery. We go to live at Dymchurch. I am forbidden to work. Albert Rutherston and other friends come to the rescue.

To avoid 'work' I begin to build theatre models. Models made for two plays by Gordon Bottomley. Exhibited International Theatre Exhibition, Amsterdam, and later at Victoria and Albert Museum. Correspondence with Gordon Craig. I begin painting again. The Sea. The Shore. The Wall. The Marsh. Eddie introduces me to T. E. Lawrence. T. E. L. buys my first sea painting to hang in the Colonial Office and annoy the officials. Correspondence with T. E. L. Decoration for a poet. Ford Madox Ford comes for a night. We visit Oxenbridge and make some new friends. Reappearance of A. B. Clifton. Edie Craig and her circle. Martin Shaw. Visits to Oxenbridge. Lawrence wants me to make illustrations for Seven Pillars. Will I work from his photographs? He comes for a day while we are at Oxenbridge, bringing 200 photographs. I begin a series of drawings. First monograph on my work published with introduction by Anthony Bertram.

3

We go to live in a cottage. Finishing work for Leicester Galleries exhibition. I engrave Genesis for Nonesuch Press. Work for the Players Shakespeare. The Dream and King Lear. Russell Thorndyke. First visit to Paris. I nearly become an art master.

My exhibition at the Leicester Galleries. We go to stay in Cumberland. The Nicholsons and the Carlisles. Tragedy in the North. I become an instructor in design. Royal College of Art. A proposal to conspire over a book with Bernard Shaw. Correspondence with G. B. S. I have the last word. We find a home of our own at Iden. Good-bye to Dymchurch. Paris on the way South. We reach Cros-de-Cagnes and find Dymchurch.

VIII Searching

1

Pension de la Plage. The astonishing clients. Blonde legacy from Ford Madox Ford. We get to know a ghost. Life at Cros-de-Cagnes. Mediterranean landscape, discovery of the Mimosa Wood. Nice Carnival. New series of paintings. Learning to draw again. I sell a painting in England and get an extension. Arrival of my new patroness. Excursions. Monte Carlo. Venice. Gourdon. Champagne picnic. New characters at the pension. The countess who slept with five boarhounds. Polish flapper. The incredible Swiss family. *Les amies.* The Japanese. We visit Florence. Seeing Florence. The fear of Fascism. Bad news from England. We get back to our new home. Making a home at Oxenbridge Cottage. The cloud over everything. M. falls sick. The bad time. Slow recovery. I am elected to the London Artists' Association. Roger Fry has a fit. I am taken up by a new dealer. Dorothy Warren and the Warren Gallery. We are hard up and eat away a drawing. Show of drawings. New patron. Meet Henry Moore. Beginning to succeed. The good life in the country. Caen.

2

Third Exhibition at the Leicester Galleries, 1928. Making a name. Achievement and success. A new vision and a new style. The change begins. 'Northern Adventure' and other adventures. Visits to the Wadsworths at Maresfield. Brandon Davies. New friends. Ed Burra at Springfields. Denis Freeman and The Farley Mummers. Trip to Toulon, incongruous party.

Toulon, Tamaris and Nice. Horace Cole turns up. Déjeuner with a joker. Series of drawings. I fall sick and am hurried home. Signs of trouble but they pass. Margaret's ordeal. We lose her mother. My father is ill, we go to Iver Heath. Father dies in his eightieth year. Bird garden. No country peace any more, troubles pile up. We lose three homes.

3

New home in a country town. New House. Rye. New friends and neighbours. Una, Lady Troubridge and Radcliffe Hall. Yogi and Yeats Brown. Conrad and Clarissa Aiken. New work. Experiments in abstraction. Thirty drawings for Urne Burial and the Garden of Cyrus. Essays in art criticism. I join the *Weekend Review;* various reactions more or less violent. Invitation to America as British representative. International Jury, 30th Carnegie Exhibition, Pittsburgh. Margaret is fitted in. We sail for New York by the *Mauretania.* We embark overnight by special arrangement. The other Jurors. The pleasant voyage. The lonely birds. Ship architecture. First signs of America. We arrive with thunder and lightning. Impressions of New York, rubber neck drive. Empire State Building. We face the New York Press. Feting begins. Century Club luncheon. I meet James Thurber and make a new friend. Surprising results from being interviewed by the Press. We are entertained intensively. Departure at midnight. The terrifying detonations. We rally round Oppo, the Italian representative. False alarm. We start for Pittsburgh. Mary St Gaudens as train hostess. The mysteries of prohibition continue. The country club. The wild day. The long drive in the storm. The indiscreet supper. Various disasters. The foreign representatives are photographed at breakfast. My adventures in Pittsburgh. Tough time. Final banquet. We entrain for other cities. Impressions of Virginia. The persistence of George Washington. Mount Vernon. The perfect day. We lunch at a famous country house. On again. I discover American art. Washington. Conflicting impressions. We lunch with Mr Mellon. Mr Mellon's collection. Other collections. Too much art. We return to New York. Margaret's adventures. We find Harlem. More parties and people. Voyage down the Hudson. Tea at Long Island at the Morgans. New York from the Hudson. We go to stay in Park Avenue. Our new friends. More parties and 'contacts'. It all comes to an end. We sail humbly and slowly home, singing the Blues. The family at home surprises us. Settling down. New

ventures. I become art critic to *The Listener* with Herbert Read. Publication of *Room and Book*, my essays on Decoration. Zwemmer exhibition to launch the book. Making the designs for Urne Burial. Research and contemplation. The series slowly unfolds. Retrospective exhibition at Oxford. Exhibition of book illustrations, etc., at Batsfords. Edward James wants a glass bathroom for Tilly Losch. I meet Tilly and decide. New problems. Difficulties of technique. Successful experiment. Life at Rye is a strain. Sudden fear for Mr Odeh. He becomes seriously ill. Merciful death. We find ourselves together. We both want a rest. Exhibition of drawings and publication of Urne Burial. Trip to the North. London New Year's Eve. Charles Laughton's party at the Café Royal. Return to Rye. We are both ill, but now we can make a new life. Plans to leave Rye.

IX Finding

1

How our plans were defeated. I become ill. Asthma. First stages. Our real troubles begin. Treatment at Tunbridge Wells. Life at Tunbridge Wells. Rather better. We come home. Continued improvement. Founding Unit One. Complications. Cross currents. We sell New House. Ruth and I visit Marlborough. I discover Avebury. First photographs. Enchanting holiday. Meet Robert Byrons. Visit to Whitecliff. The Dorset scene. More photographs. A new eye. I feel better and am supposed to be cured. Our plans—Paris—Avignon and so to Spain. Paris. Meeting Max Ernst, new friends. Avignon. No autumn glow. Foul weather. Life at the Crillon. Mimosa Bonaparte-Wise. Exploring the Midi. The trouble breaks out again. We have to change plans. Flight to Nice.

2

We find a doctor. Diagnosis and prescription. Christmas with the Zombies. We hunt an hotel. We discover an ideal abode and settle in. Life at Nice. New paintings. Landscape of the Megaliths. We visit Matisse. Monotonous cleansing continues. I am introduced to M. Papin. M. Papin discovers 'les polypes' and begins operations. M. Papin's superb technique. Nasal ordeal. Mat Smith at Cagnes. We make a wrong decision. Good-bye to Nice. We enjoy Marseilles and a voyage beyond. Arrival in Gibraltar. Treacherous weather. Asthma revives. I find I can photograph. We go to Algeciras. Impressions and records. Visit to Ronda. The wild beauty of Spain. Origins

of Picasso. Voyage to Africa. We stay at Tetuan. Series of drawings and photographs. Gibraltar again. Voyage home. Arctic June.

3

Romney Marsh revisited. A visit to Owley. Small-Hythe interlude. Mary finds us a cottage. I find an object, *Marsh Personage*, by the river, which begins a new view. Preoccupations at Potter's Heath. The Council for Art and Industry. Visit to Snape. Fighting asthma. We find a weapon. We are lent a house by the sea. Blessed escape. Enchantment of the Ballard. I am commissioned to make a guide to Dorset. Researches and records. Finding new friends. Archie Russell and his treasures. Christmas party and some good hock. Discovering Dorset. Finding new forms; a new world opening. New paintings. No. 3 The Parade. Redfern Exhibition of water-colours. Happy success. Return to Swanage. I find an object by the sea. Seaside Surrealism. London again. Christmas disaster. We are frightened from the sea. Finding a new home. Invitation to Surrealism. I join the committee for the International Exhibition in London. I find new inspiration. Edward James increases his collection. André Breton and Paul Eluard. 3 Eldon Road. The beautiful house. Drastic cure for asthma. Highest hopes. Robert Donat. I plan a new exhibition with Nan Kivel. Pause to look round – back and ahead. Life at 3 Eldon Grove and so on (1936-1939).

EXTRACTS FROM THE LETTERS OF PAUL NASH TO HIS WIFE, 1917–1918

WITH AN INTRODUCTORY NOTE

BY MARGARET NASH

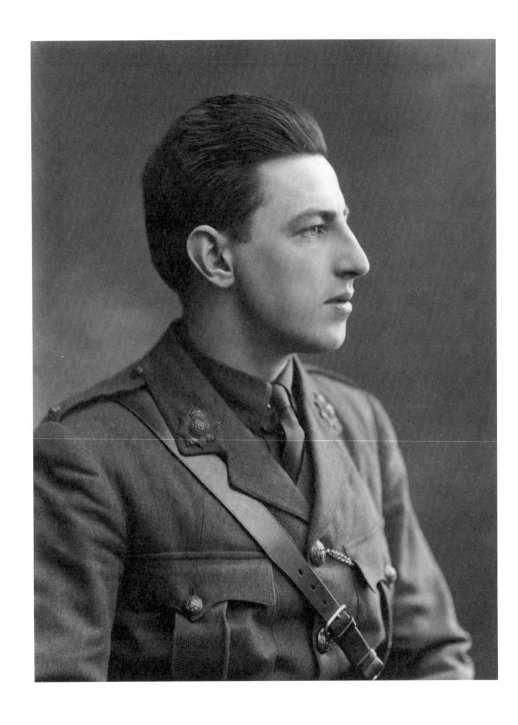

Bassano Ltd, *Paul Nash in uniform*, *studio portrait*, *29 April 1918*, photograph,
National Portrait Gallery, London

Introductory Note

BY MARGARET NASH

The outbreak of War in August 1914 occurred while my husband and I were enjoying a wonderful holiday in the Lake District on a visit to his friend Gordon Bottomley. The impact of War seemed quite unreal to both of us, and it interrupted a new and lovely life which we had planned during that year, a life which was to be devoted to an intensive research and development of his work as an artist. As will be seen from the broken fragment of the Autobiography, he was beginning to meet people who were to give him a fresh outlook on life and to encourage him in his development as a painter. All this he put aside without hesitation, though I know only too well what it cost him to make that decision when he enlisted as a private in the Artists' Rifles in August 1914. He felt he had to learn his job as a soldier in the ranks before he was fitted to become an officer with the responsibility of other men's lives on his shoulders. The next few years did not prevent him from continuing to draw and to paint in his spare time and during those rare moments when he was able to escape from his Army duties. In fact, the irksomeness of his duties as a soldier only increased his integrity as an artist. It was during this period that he developed that astonishing industry which afterwards enabled him to work under almost any circumstances, however ugly, noisy or inhibiting. Thus, he managed to produce paintings which were exhibited in the New English Art Club, the London Group and the Friday Club, and showed a vitality which was astonishing when one considers the strain that army life put upon his physique and his spirit.

The letters from which I have made the following extracts, seem to me to be particularly interesting during the year 1917, when he was

commissioned to the 15th Battalion Hampshire Regiment and went out to serve in the Ypres Salient. They show the way in which he was affected by the horrible desolation of the landscape in the Salient, and of its reaction upon the minds and spirits of the men who fought in the trenches.

Editor's Note

Paul Nash arrived in France in late February 1917 and spent the following 14 or so weeks in training, on the front line, and at rest camps. In late May he dislocated a rib in a night-time accident in reserve trenches near the front, shortly before his battalion went into action at the Battle of Messines. He was invalided home and during his period of recovery held a well-received exhibition of watercolours he had made whilst on the Western Front. In October he was almost sent to Egypt on active service, but at the last minute received confirmation of his selection as an official war artist by the Government's propaganda scheme, run from Wellington House by the Scottish politician-novelist John Buchan. Nash returned to the Ypres Salient in November 1917, spending four weeks making first hand studies of the recent Passchendaele offensive, and then a week working for the Canadian war records programme at Vimy Ridge.[1]

The letters printed here are based on those selected by Margaret Nash for the first edition of *Outline*. However, I have returned to the text of Nash's original letters, now in the Tate Gallery Archive, London, to correct various errors in the 1949 text, and to reinstate the more personal comments removed by Margaret Nash. I have also re-dated the letters by combining information in the Nash collection in the TGA with details from the 15th Hampshire Battalion's War Diary; the locations where the letters were written are identified using the same sources.[2] For ease of identification, I have given as an endnote the TGA catalogue reference number for each individual letter. All these letters, together with many others written by Nash over the course of his life, are available to view online at the Tate Gallery website, www.tate.org.uk/art/archive.

Extracts

28 February 1917, No.3 Infantry Base Depot, Rouen, France[3]

My sweet Dove, I suppose all the mails have gone as I haven't had a line from anyone since I got out. You got my letter I hope giving the address <u>No 3 Infantry Base Depot</u> (Rouen) and my battalion is now the 15th Hants [...] I expect to be here until the end of the week or longer. One is not supposed to go up the line until passed thro' the seven days course we are on now. You will be relived to hear this, that my 15th are supposed to be going to have an easier line than normally as they have just been thro' a terrible hammering. Things are going pretty well as you will see by the papers, but it's pretty sure all will be in the melting pot for the 'Great Push'. It's possible the infantry won't have such a fearful task because when our bombardment is done the Huns just give themselves up when we are over the top – it's the odd times that are dangerous & the open warfare which is in the future. I have hunted out Carrington's brother[4] & we dine together. I like him very much. Later, not tonight I don't feel like it, I will write a further sequence of events from the time we entered the Seine. I left my razor on the boat of course, after, as I thought, a most careful packing up and now I must rush to Rouen to buy another. I am anxious to know about your money, love, whether you have enough. My pay for March is due now so I can let you have some [...] Can you send my identity disc thing to wear on my wrist. I can't write more tonight, darling, the days are sunny here & you can feel the spring coming, how good the old woods must look – love to everyone, I am writing a long letter home. Your loving man.

March 1917, Rouen, France[5]

My dearest one, I have been very distressed to keep you so long without another letter. I was so excited to hear from you it seemed ages before the letter came. I was delighted to hear all my dove's doings [...] I have tried to get this letter going for the last few days, the other night we had a most boring evening in dummy trenches & I wrote a certain amount by moonlight but have mislaid it so here goes again. [...] We entered the Seine early in the morning and began to move up slowly between its banks, at that time half-hidden in mists. As they cleared the most enchanting country appeared. At the edge lines of attenuated poplars behind which stood ancient orchards, thro the middle of which generally ran a rough track or road up to the door of an old farm; such a place to live in, sweetheart, often quite low & small with a conical shaped thatched roof & odd little casements, gables & dormer windows. Behind the farm there seemed a misty wood of some sort and then cliffs, generally chalk, with caves in them and overhanging tufts and bushes. Sometimes we passed wide open country of hills & saw the plough & its horses moving on a distant ridge. Other buildings were amusing little villas or still quiet white country houses with terrace lawns stepping down to the water between lines of trees. Once we passed a ferry where a peasant girl gave a ring to the bell to call the ferry. One of the men on board called out 'Ring ze bell again' which was hailed with shouts of laughter. Some way up we passed a village, a gem of a place where the church stood back only a short way from the water with trees on either side of a rough road which sank to a ford on the river. I was enchanted by it all & would have given much to have been dropped on one of these banks with leave to wander as long as I liked. At last the town was reached and I enjoyed my first meal in France. [...]

I am always thinking of you beloved, and bring up to mind all the happy times we have spent. Your letter was helpful & brave – may all be well, after all there is every chance. We must both be strong in faith. Today will be a restful one as I am free from duty after instruction & have been lying late a bed thinking & dreaming of my little Bunty. Kisses for all of you darling, your hair your mouth your little throat & baby breasts. What sweet love we have had my love, a bright memory for ever. Write soon or perhaps you have written often & the letters are gone astray or delayed for who knows how many days, it maddens me. The poor men in their letters which I have been censoring once or twice complain bitterly how they get

no letters from home. Their own letters touch me deeply sometimes, poor men. Now goodbye my love.

From your dear lover Paul.

13 March 1917, No. 3, Infantry Base Depôt, Rouen[6]

My dear beloved, still here, it seems too strange after preparing for such abnormal things to be just dumped down into very much the same conditions as I left behind. And it seems all the duller & more vacant doing quiet ordinary things in the same old security of mind & body yet with one want that makes it strange and uneasy. No one is moving just for a day or two, but I expect to go up [the line] Sunday or Monday. The one really staggering disappointment out here is the complete lack of mails from home. I had never thought of that & it is going to be one of the hardest things to bear for I fear it is going to be a frequent happening. [...] Have just returned from breakfast at the officers' Club, a grateful meal after an early morning march on empty tummy. I shall be here all day, rather a damp, dismal job. Incidentally, the docks are very interesting & I would describe them if it were not incautious to do so. I know I could have spent a very profitable day making drawings here, but it would be unwise. It is a beautiful town & the river at night with the dark shapes of ships & the overhanging hills just looming, make an impressive thing. How is my mouse. Oh how I miss her from my side. I cannot write how I miss her I could only whisper it to her in that tiny ear under the dark hair. Little love be brave & have great faith, meeting again will be worth all. I believe there is a chance of a mail tomorrow – only a faint one, all letters are coming a very round about way. Have you had terrible weather again – here we have suffered falls & falls of snow [and] a plague of bitter wind but now it is warmer. [...] This letter got delayed & I am glad, because last night I got orders to go up. My division is the 41st at present & I believe the battalion is out resting, so I shan't be in the line yet, I expect [...] Your dear lover Paul.

Paul Nash, *Chaos Decoratif*, 1917, ink, pencil and watercolour on paper,
Manchester City Galleries

14 March 1917, Rest Camp, somewhere near the Western Front[7]

Dearest one. Not quite there yet. We left the base on Monday, a wet, unwholesome day, & entrained at 3.30. It was a most strange journey, lumbering along about 2 miles per hour thro' the wet mist. As the night fell we bucked up and moved along at a fair pace, candles were lit in the carriage & we dozed to fitful dreams. [...] Morning dawned still wet & indistinct. The train made another stop & those who were awake got out, discovered a canteen & breakfasted. No one had the decency or else were too wise, to pass the news on, so we learnt too late & had to breakfast with cold eggs & orange filterings. About nine however we again stopped with a terrific shock – all French trains stop this way, you think the engine has hit the back of a goods train or something equally hard & noisy. This time news came that a canteen hut was hard by & there was half an hour to spend. The train emptied like magic & I soon found myself in a cosy shanty, half peaceful cottage, half war-like in construction. An open grate with a log fire glowing, bowls of flowers, attendant nymphs – English ladies in tweedy skirts & country hats, aprons & smiles. The place was half trench-hut, half Irish cabin, but it yawned with kindness & hospitality & best of all the tea was made without sugar. God bless all sporting British ladies in short tweed skirts & tightly veiled country hats who live at odd places on dreary railways in homely huts, half homely cottage, half military canteen & dispensing hot tea without sugar in Normandy, china bowls & good French bread spread with tasty paste & honest butter & stout buns with kind words & English smiles. It may sound rather chaotic but were I Nevinson I would paint it so – a smile shaft piercing an oak beam, a riot of yellow mimosa spots – yawning arcs of sugarless tea in bright coloured bowls, tweed triangles of skirt, trim ankles with flat brogues. I wrote my name in the visitors book just as the train began to move again – it is the last signature on the page and I'm glad I just had time. After that we passed more hours gently bumping thro the soft landscape of _____. By the way, before I forget it, do you remember Nevinson's small etching of the 2nd bombardment (or was it the 1st) of Ypres I should still like to have it if possible. If you ever go to The Grey Room at Goupil see if it is yet unsold dove. Don't forget the title, Bombardment of Ypres, Nevinson will remember it, it is a part of the world I'm interested in. The country now abounded in windmills of all colours, rows of high cropped trees & cosy farms. Not very thrilling, an endless repetition of the same idea. At _____ Sandy & I parted, he to billet there

overnight, and I to go some few miles farther and finally detrain here and walk about half a mile to this Rest Camp, where I had a good, long sleep & this morning free to write to you my sweet, before going up to join the Btn at two o'clock this afternoon. I now possess a perfectly good tin hat. [...] By the way I wish Marchant would try and sell a drawing for me at Goupil – I think I'll write to him from the trenches it might touch his blasted patriotic soul. [...] To conclude this short letter I will quote a verse written by a man whose letter I censored just now. I am afraid I can't resist cribbing it for you:

When Peace again smiles on the land
And the sea from strife is free,
All men will raise their hat to God
And enemies agree. (!!!!!)

I think it is the best vision of the end of the war any man has had yet. Goodbye for the moment, Paul.

21 March 1917, Chippewa Camp, near La Clytte, Belgium[8]

My dearest one, I have felt most guilty & wretched I have kept you waiting for this letter but events of the last few days have kept me rather restless & I was anxious to collect impressions so that you might have an interesting letter. I wrote last I think just before leaving the base & gave my letter to an orderly to post just before the train left I hope you got it. No, I have remembered I wrote again from the Rest Camp & told you something about the journey so now I can start clean from my arrival in _____ when I joined the battalion. [...] Oh my darling dove how I wish you could be out here I have simply been as excited as a schoolboy. The last days have been glorious brightest days and the landscape full of lovely colour. The country is damned flat, tho there seem to be hills & ridges in the distance, perched about these & sometimes near at hand are jolly old windmills with red sails, everywhere are old farms rambling and untidy some of course ruinous and deserted all have red, yellow or green roofs and on a sunny day they look grand. The willows are orange, the poplars carmine with buds, the streams gleam brightest blue and flights of pigeons go wheeling about the fields. Messed up with all this normal beauty of nature you see the strange beauty of war. Trudging along the road you

become gradually aware of a humming in the air, a sound rising & falling on the wind, look up & after a seconds search you can see a gleaming shaft in the blue like a demented silver dart, another, and then another. Then comes a new noise, two or three 'cracks' from somewhere in the rear forms a second & as you gaze the blue sky is charmingly speckled by little shining clouds of white. Nothing could be gayer, the clear blue pierced by silver darts & spangled with baby clouds. Nothing whiter, purer, more full of light than these flaky clouds. And these are anti aircraft guns driving off three enemy aircraft.[9] A comparatively harmless & sporting performance but just veiled behind the scene, old Death in his most awful form. Of course that's just what you don't think about out here – you're all right so long as you don't start moralizing, directly you begin to moralise or philosophise you're going to be miserable. See the beauty of these camps by the roadside all the tents are painted in savage patterns of green, red & black, the bright red rusted corrugated iron roofs have been skillfully mottled with a huge design of black tree shapes spreading over the scarlet rust, making a pattern that would make the Omega shut up shop & yonder marquee a strange nuance of dirty grey green curves and orange spots [would] drive poor old Fry[10] to take up crochet out of sheer envy. How interesting in form these once stiff houses look, a rhythmic river of tumbling forms – what wonderful things are ruins. I begin to believe in the Vorticist doctrine of destruction – almost.

I shall have to cut this letter short or I shall never get it sent off. [...] But I beg & pray of you sweetheart do not worry. When I tell you that only a week, & then only alternate days, out of every five am I in any particular danger surely you can feel happier. The time is divided into work in the line & rests out – a regular routine. I fear I can't go into detail but this should comfort you my darling. No parcel arrived yet, God blast this damned post. This must close now dear one and I will begin another as soon as it is posted. Oh my love don't speak of ageing, keep young, don't fret, I am sure I am going to return to you not long hence. Sweetheart goodbye for a while. Your dear one, Paul.

Late March (posted 6 April) 1917, St Eloi sector, Belgium[11]

My dearest love again I am made sad having a letter from you which upbraids me for not writing. The last week has been one so full that I have literally

been unable to write. My inner excitement & exultation were so great that I have lived in a cloud of thought these last days. This combined with a certain physical strain has hindered & chained me from quiet continuous writing. Oh, these wonderful trenches at night at dawn at sundown. Shall I ever lose the picture they have made in my mind. Imagine a wide landscape flat and scantily wooded & what trees remain blasted & torn, naked & scarred & riddled. The ground for miles around furrowed into trenches, pitted with yawning holes in which the water lies still & cold or heaped with mounds of earth, tangles of rusty wire, tin plates, stakes, sandbags & all the refuse of war. In the distance runs a stream where the stringy poplars & alders lean about dejectedly, & farther a slope rises to a scarred bluff the foot of which is scattered with headless trees standing white & withered, hopeless of any leaves, dumb, dead. As shells fall in the bluff huge spouts of black, brown & orange mould burst into the air amid a volume of white smoke, flinging wide incredible débris while the crack & roar of the explosion reverberates in the valley. In the midst of this strange country, where such things happen, men are living in their narrow ditches hidden from view by every cunning device waiting and always on the watch, yet at the same time easy, careless, well fed, wrapped up in warm clothes, talking, perpetually smoking, and indifferent to anything that occurs unless a shell falls into the trench [and] even this provokes the minimum of excitement. All day long with only a few intervals the shells pass overhead, always the same sound as of a body leaving the sky like canvas & so loud and so easy to follow in imagination that it seems ridiculous that you can never see them. Of course the heavy trench mortars throw over shells that can be plainly seen heaving thro' the air tumbling over & over until they fall and then a second's pause and bang. The earth rises in a complicated eruption of smoke & bits to fall for yards wide splashing into the pools, flinging up the water, rattling on the iron sheets, spattering us & the ground near by.

As night falls the monstrous land takes on a stranger aspect. The sun sinks in a clear evening where smoke hangs in narrow bars of violet & dark. In the clear light the shapes of the trench stand massy and cold, the mud gleams whitely, the sandbags have a hard, rocky look, the works of men look a freak of nature, rather, the landscape is so distorted from its own gentle forms, nothing seems to bear the imprint of God's hand, the whole might be a terrific creation of some malign fiend working a crooked will on the innocent countryside. Twilight quivers above, shrinking into night, and a perfect crescent moon sails uncannily below pale stars. As the dark

gathers, the horizon brightens & again vanishes as the Very lights rise & fall, shedding their weird greenish glare over the land and in acute contrast to their lazy silent flight breaks out the agitated knocking of the machine guns as they sweep the parapets. So night falls gradually becoming quieter as the hours increase, the great quiet of nature's sleep only broken by occasional sniper's shots or distant booming when some 'straffe' is in progress toward the north, and when the restless Maxim shatters silence and again silence only closes in profounder still after the echoes have died away. I go round the slimy duck-boards down the trench with the sergeant seeing all is well, sometimes inciting a listless sniper to fire or the Lewis gunners to play a burst, just to show the Huns we are really awake. At intervals we send up Very lights & the ghastly face of No Man's Land leaps up in the garish light, then as the rocket falls the great shadows flow back shutting it into darkness again.

One could write for ever of these strange sights and what I have scribbled here is only a few half formed thoughts scarce considered, just let tumble as I write. But I am writing these impression of the front line which you shall have later; maybe you can feel something of the weird beauty from this little letter, any how tis to try & interest you dear & give you something to think over in your loneliness. I am never far away sweet, don't lose me – nothing has happened you are still a little mouse by my side, do not disturb yourself with any other thought.

28–31 March 1917, St Eloi sector and Chippewa Camp,
near La Clytte, Belgium[12]

My darling little Bunty you cannot tell the joy I felt when I got two letters from you, such gay sparkling letters too which amused your dove & cheered him up immensely. You will get my letters much quicker now as they come from the Front & yours to me will arrive more punctually. [...] I think perhaps this has been the most interesting week of my life. Oh how I wish you could see it all, only I fear you'd jump when the shells went off – so far it doesn't affect me & I have experienced no nerves or fear, there is only one attitude to adopt, that of complete indifference & a rigid fatalism – you are meant to die or not as God wills. I have no other belief save in His mercy. Of course, one understandably seeks protection – cover, but beyond

the most obvious rules of carefulness & common sense it is really no good taking precautions, and if there is one thing a man is summed up on out here, judged & pronounced good or useless, it is behaviour in danger. At present there is not very much danger – raids are not very feasible & the line is seldom badly shelled. Today for the first time they put over 'stuff' – quite harmless in effect except for one 'rum jar'; the retaliation by our own battery in [the] rear was twice as effective on us – next time we shan't be in a hurry to ring up the battery I assure you; but even this is not a usual occurrence.[13] The things I dislike are machine guns, especially when I go to the House [the lavatory]; I don't mind being shot doing my duty, but not that sort of duty. Snipers too are nasty fellows & of a devilish cunning, it is rather fun potting at them & trying to upset their little games. /// This letter had to stop dove at this point and is now resumed in comfort and security in camp again. This means that for a few weeks I am out of the trenches & only an inconsiderate shell dropping in the immediate vicinity can do me harm, therefore my babe, close your eyelids & loosen your hair as Yanks would say & be at peace. Sweet sweetest heart how I have loved your letters they are the greatest joy to me and always amusing. [. . .]

Separate from this letter come two bits of writing done in the trenches. I have started trying verse again, & as for the drawings I've seen things in the last week that would last me my life as food for paintings & draw-ings. As they are worked up these will dribble home to England I think. [. . .] I am just detailed to go with Coleman on a month's course at the Divisional Schools, which means I miss the line next time, & when I get out the Battalion will probably be out at rest for about three weeks so God knows when I shall see the jolly old trenches again! Still for your sweet sake I am glad my dove you can rest quite sweetly & peaceful with any decent luck. Also I shall get time to work up some drawings to send home. [. . .] O baby love keep gay & young & think your dove will one day return to stroke & fondle you, kiss your soft lips, press you close with eager arms, while love, naughty love, knocks faster, faster at our hearts & as you sway & slip gently down on the gay little couch delicious joy runs over in mad long kisses and embraces of desire. Sweet little breasts, slim body and magical cloud of hair. Goodnight for a tiny time, till my next letter comes, a naughty letter with drawings in it – my Tim will feel so gay but she must kiss & embrace Twit not run out & fling her arms round a nice boy just out of sheer overflowing of spirits! Goodnight my darling. Your very dear Paul.

18 April 1917, Trench Warfare School, 10th Corps,
somewhere near the Western Front[14]

I have been a good deal worried by your letter Hun, for, in spite of your brave efforts at stoicism, I can see things are in a bad way. It is fearfully difficult here to realise [there is] such a great shortage of food as there would seem to be in the country, and it is more than damnable to know this while we are so well fed here. Something there must be shamefully crooked in the works of England. We read about profiteers, we see cartoons depicting them as monsters eating the people's food – but why are they allowed to live! No one in our country ever seems to have the simplest notion of grappling with things. We are a shilly shallying people unable to deal with decision. Determination is our strength – sticking it; we shall starve splendidly, it will bring out all the national grit – in the bread. But apart from any bitter thoughts one may have on the subject, we are all uneasy. 'The letters of Eve'[15] drivel on each week and a new batch of snaky actresses crop up in The Tatler & Sketch – personally I like reading Eve's nonsense & looking at the legs of the pretty actresses, if I'm not thinking of anything at all, but sometimes I sit up with a start and wonder if it's all right. As for the newspapers, I don't know why, but out here they are more maddening than ever. As I read, it just seems as if I heard all the pap being made & dripping, dripping into the foolish blubber mouth of the people which greedily laps it up, loving it so – the great brain fodder, the food of the little gods – I seem to see the label on the bottle, 'specially prepared for His Majesty and all his people by Northcliffe & Co. & the Damned Almighty Press.' Oh it is intolerable – I cannot read the papers – it's just humbug, humbug from end to end. O for a spirit to rise and stamp out cant & lies from England, O for a race of men & women in England to supersede a brood of efts & leeches. You speak of a revolution that will come at home if war grinds us to famine, it would be a pity. Nurse your sorrows & your wrongs my children until your men return, that is when revolution will come. Out here men have been thinking, living so near to silence & death that [their] thoughts have been furious, keen. Living has been alive. Hammering in their minds are a hundred questions, festering in their hearts a thousand wrongs. The most insistent question is 'why am I here?', the greatest wrong, 'I am here still.' But an end will come one day and the next will be a day of reckoning. Everyone knows that out here – do they know it at home I wonder – they will.

Strange for me to burst into a tirade! I must be more careful, but really
you may expect anything from me if we get another week of this weather –
yes, I think the world is going to dissolve in tears or snow or some kind of
utter, endless damp & blind pitiless cold. Think of the men in the trenches
these last days & nights – O dearest let's leave whines & howls & try &
squeeze something sweet from our sour orange. [...] I now have twenty
drawings – when my scrapbook is full I am going to get the C.O. to censor
the packet and send it home to you – if I think any complete enough for
showing, I will mark them. It is damned hard to get any time to work at
this confounded school, I hate the place from uprising to bedtime & shall
be glad to get back to the trenches. Here I am imprisoned by set times,
parades, lectures, mess – all the things I hate. [...] I will write again soon
but the course is horrid, dull & empty – waste of time for me – still I am
safe and that's a comfort for my little dove.

Kisses & kisses – Your dear man.

26 April 1917, Beauvoorde, Belgium[16]

So many thanks for a splendid letter dove, don't be a silly babe you write me
charming letters all full of your own dear peculiar amusing way of saying
things and they make me laugh always [...] The lovely weather of the last
few days has been even harder to bear. We have been out o' doors a good
deal. Saturday & Sunday I spent making drawings in the country here,
which is really attractive when one has time to explore. About the banks
celandine are gleaming. I have found wild periwinkles in the copse, and
to-day the fat buds of the kingcups were bursting in the marshes near the
railway. The buds everywhere make the country just like real spring. I say
'real' advisedly because one feels nothing is real now and this lovely weather
is more maddening than the nightmare of the trenches. I never felt the
terror of dreams so alive even as a child as I feel it here where there is no
waking up. We live carelessly enough here, but even the least emotional of
men is moved at the beauty of these days, & sighs from the bottom of his
heart to hear the guns a few miles away.

On Saturday we got the afternoon off & I persuaded the C.O. here to
excuse me & a friend from the lecture, and after lunch we sallied forth to
walk up to the higher land above B------. The windmills were twirling

their red sails against a grey sky; when the sun came out the clover fields looked a wondrous green, and the trees lit up a rusty red where the buds are thick, and the plough wound pleasantly over the hill. Then suddenly I saw a swallow! How he flashed in the sun & looked so free and gay, ever since he has haunted me, was he on his way skimming those fields, I can't help thinking he may have been on his way to England where my sweet heart is and you may see him just as I did skimming the fields. [...] All love & many lingering kisses for all of my sweetheart. Paul.

2 May 1917, Tourneham-sur-la-Hem, Pas-de-Calais, France[17]

My beloved one, have just got your pathetic little letter. I wrote you the longest letter yet nearly a week ago I can't think why you haven't had it, it contained a lace hanky I bought for you last week. We are now a very long way from the line among rolling hills of pasture land & quiet hamlets. Three days we were on the march and not one man fell out. The men are magnificent, all war worn and ruddy with health. You would admire them no end if you could be by the road side and see a Battalion go by: there is a quiet confident strength, an easy carriage and rough beauty about the men that would make your heart jump & give you a lumpy throat with pride. The other day as I watched them I felt near tears somehow. [...] I can't write of Billie[18] I haven't realised it yet; when these things happen I am always strangely unemotional – at first I feel a sort of clutch at my heart, then nothing but vague, dull thoughts. My Billie, he was such a dear fellow. Yes I will write to his people if I can. [Edward] Thomas's death the same, I brood on it dully – sometimes I am almost afraid, I know not of what. It will not be so very long before we are in the fight. I shall not fear then, but only pray I don't think of you when the moment comes – only of my men. But if I am hit, then it does not matter & I can think of you to the last and ever after till we meet again. Fear not sweet heart I am not morbid and you will never hear me speak of death again; but you have spoken of it, and I may as well just say so much of many thoughts. [...] Good bye until tomorrow, your dove.

13 May 1917, Tournehem-sur-la-Hem, Pas-de-Calais, France[19]

Beloved after all I have been more than two days writing to you again but it is so difficult to find time & words in which to write & so far I have failed. Today is a quiet Sunday & we have only had one parade to disturb us so this evening finds me in the woods above the town overlooking a sun warmed landscape. [. . .] The last week has been entirely pleasant; we work from 5 a.m. till one and the rest of the day is generally clear. The only drawback is that one feels terribly tired after lunch & almost overcome with coma. I fight against this & have struggled on with my drawings, many of which will soon be ready to send you. The beauty of this place is surprising in character. The landscape is not unlike Sussex, great rolling grassland with a patchwork of green, rose, brown & other coloured fields. The woods around are just breaking & the enchantment of May makes one dreamy and dissatisfied. We see all the rarer treasures of Nature that so many folk miss by lying a-bed – dawn over the hills, the woods mysterious mauve, muffled in heavy shadow while the fields are wakened into reality when the sun first touches them, marvellous things my love, as you & I will gaze on together some glad day. We will return to this little town. You cannot imagine a more lovely place to live awhile and work & play. The little river which bubbles along thro' the town is such a jolly bustling fellow, singing thro' the meadows, round the corners like a swallow, head over heels thro the mill & on again past the alders and the willows and on again I don't know where thro' this sunny valley. I've longed for a boat and a voyage of exploration. The whole country, the quiet of it, the sweet springtime, the hours of leisure when everyone can roam abroad, have all combined to make us sad & sick with longing for the end of the awful unending madness – I can't get things straight at all. What is God about, is He creating out of all this? I have given up thinking, it is futile, one's mind widens out here alarmingly & I begin to think in much, much larger forms. I confess to you this thing that brings men to fight & suffer together, no matter from what original or subsequent motives, is a very great and healthy force. The cause of war was probably quite futile and mean, but the effect is huge, no terrors will ever frighten me into regret – what are the closing lines of Tennyson's 'Maud': 'I have felt . . . I am one with my native land.'[20] That is the emotion & it is a satisfying one to rest with when every other has turned bitter and dead. The men, you know, make me think I have been very lucky in joining A Company.

I was given the best platoon, which is probably the smartest platoon in the battalion. They had not had an officer regularly in charge of them for some time & at first were disposed to try it on a little with me. I jumped on this at once, & in such a way as left no doubt of my intentions; they immediately came to hand & now, after about ten days' work under me each day, I could not want a better disciplined crew, and I believe when the time comes, they will follow me to a man. I do not mean to take much credit for this, because they are all old trained soldiers & have seen much service, but it was necessary for a leader to thoroughly take command & they seem to have appreciated it; they are perfectly friendly too, which is what I really wanted; my NCOs are excellent. So let this make you happy, for it has done much to comfort & hearten your man. [...] I don't know that I have done any thing of much use out here as yet I never was any use at making sketches, but my store of notes mental & in line would give me material for fine things to create afterwards & there's the difficulty. What I want is to have another tour in the line, go thro' an action & presently be wounded, come home & work out my designs. [...]

21 May 1917, Reserve trench, St Eloi sector, Belgium[21]

My darling babe I am so sorry you have had to go so long without another letter. They stopped the post a day before we left – and it was impossible to write again till we got back to our old haunts. We are all sad to leave the quiet of that untroubled country, where such pleasant days have been spent. We could not have hit upon a better time for we saw all the change of trees & fields & hills from bleakness to fresh green & warm lovely lights. More than ever do I feel you & I must return to these landscapes about the hills. Just before I left I came upon a bank where real French violets grew, you know those dark ones that have such an intoxicating smell, the kind you little women wear in the spring so that when we are near you the scent goes to our heads & makes us want to have you much more nearer – alas I was with the Company at the time, & tho' I meant to hunt out the bank after & send some flowers to you I never had time. Flowers bloom everywhere [and] we have just come up to the trenches for a time & where I sit now in the Reserve Line the place is just joyous, the dandelions are bright gold over the parapet & near by a lilac bush is breaking into bloom;

in a wood passed thro' on our way up, a place with an evil name, pitted & pocked with shells, the trees torn to shreds, often reeking with poison gas – a most desolate ruinous place two months back, to-day it was a vivid green; the brokenest trees even had sprouted somewhere and in the midst, from the depth of the wood's bruised heart, poured out the throbbing song of a nightingale. Ridiculous mad incongruity! One can't think which is the more absurd, the War or Nature; the former has become a habit so confirmed, inevitable, it hath its grip on the world just as surely as spring or summer. Thus we poor beings are doubly in thrall. At the mercy of the old elements which we take pains to study, avoid, build & dress for and in the power of something far more pitiless, cruel and malignant, and so must study further, build ten times as strong, dress cunningly & creep about like rats always overshadowed by this new terror. Of course we shall get used to it just as we are almost accustomed to the damnable climate of England. Already man has assumed an indifference quite extraordinary to shells, fire, mines and other horrors. It's just as well because it is going to be our daily bread for months & months to come.

I am rather pleased with myself just to-day because yesterday I sent off six finished sketches to you which after much labour I have managed to work up to a pitch of presentability. The CO has seen them & enclosed a note saying they are of no military importance & as they are marked 'drawings' on the outside & registered & stamped by the Field Censor, I shouldn't wonder if they arrived unmolested.[22] If they do, herewith a detail of orders for their disposition. They are numbered from 1 to 6 but my servant, usually intelligent, stupidly packed my notes about them, so I must describe them as best I can.

No. 1, as far as I can remember is one of trenches under a bloody sort of sunset with a crescent moon sailing above. To be titled 'Winter Trenches', price £5.5 mounted by Rowley if he still exists on cream spacer board frame 24 x 19 or smaller if necessary plain, unstained oak wood if possible.
No. 2 is a ragged looking landscape with a scarred hill in the background & stick-like trees. Title 'Desolate Landscape', price £5.5.
No. 3 of a ruined church. Title 'Ruined Church, Belgium' price £5.5.
No. 4. Trenches in a wood. Title _____ £5.5.
No. 5. A trench landscape mostly sandbags & a sky with a few stumps of trees & a moon. Title 'Trench Landscape.' Price £4.4.

No. 6. A pool under evening sky. Title 'The Pool.' Price £4.4. Or if you prefer sweetheart, keep this for yourself, I have always thought of it as the one for you, if you'd like to have it.[23]

When the drawings are mounted & framed they should go to Goupil,[24] I am writing to Marchant about them – I will also write to Rowley. In a month or less I shall have another bunch for you. Here in the back garden of the trenches it is amazingly beautiful – the mud is dried to a pinky colour and upon the parapet & thro the sandbags even the green grass pushes up & waves in the breeze while clots of bright dandelions, clover, thistles & twenty other plants flourish luxuriantly, brilliant growths of bright green against the pink earth. Nearly all the battered trees have come out and the birds sing all day in spite of shells & shrapnel. I have made three more drawings all of wonderful ruinous forms which excite me so much here. We are just by a tumbled village, just heaps of bricks, toast-rackety roofs & halves of houses here & there among the bright trees & what remains of the orchards. The dug-out I am writing in must stand in what was once a snug cottage garden in hillocky ground that slopes down to the stream. The apple trees, fat with bloom, straggle about outside the door, one has been knocked by a shell but continues flowering on its head. A green garden gate, swung off its fence, leans up against the sand bags. I think it is the only significant landmark left. Our table inside is gay with a bunch of flowers – lilac, globe flowers & white narcissi found blooming near my trench which is adjacent to the old village cottage gardens half a mile away. This place is the mess & where I spend most of the time, tho' my actual responsibilities lie in M__ trench which is held by my platoon. I feel very happy these days, in fact, I believe I am happier in the trenches than anywhere out here. It sounds absurd, but life has a greater meaning there and a new zest, beauty there is more poignant – I never feel dull or careless, always alive to the significance of nature, who under these conditions is full of surprises for me. I can't quite explain, not having yet troubled to analyse my emotions about it all. Last night there was a heavy shelling, in fact the line isn't the place it was, the Bosche is very restive & jumpy & I am not surprised – the clouds roll up in these parts and their shadow already falls on us – don't fear, hun, I have no fear. I know there are numberless things I want to say to you, but my mind wanders to-day – it's raining & the earth & trees & all green things exude a [illegible] perfume and makes the soul dream wearily.

Before I forget it again I must touch on business a moment. About those damned bills. Rave must be paid, Barker can either wait or be paid something on account, the others must either wait or have a small amount on account […] I am spending nothing here except on smokes & my messing, the latter rather mounted up while we were out at Rest but is settling down again now. Of course with luck I may sell one or two of the Drawings. In the utmost extremity I must apply to Dad but don't want to if I can avoid it. […] In the *New Statesman* you sent was a short notice upon Edward Thomas saying the best thing he did was the verse [written] while he was in the Artists – he wrote under the name of Edward Eastaway.[25] If you can procure any of his poems I should so much like to read them. Some of my surplus kit has been sent home & soon I am going to post back all my books & get you to send me a few new ones which I will mention later. I read very little now as a matter of fact for between my drawing & writing letters my spare hours are pretty well filled. […]

This shall end now & I will write a better letter later in my own dug out when it is quiet. Long, long kisses, all the most lovely embraces & all the sweet, naughtiest things my baby Bunty, from your dear lover, Paul.

31 May 1917, No.14 General Hospital, Boulogne, France[26]

Here is a surprise for us, for I am writing this by the seashore, the wind wailing round the house and the waves sighing one long sigh in my ears. I feel rather like Lord Foppington[27]: – 'If I don't wake soon, stap my vitals, this is likely to prove the most impudent dream I have dreamed for a long time, strike me ugly' – but not with retrospection. This morning, after a night's rest, I can recall the incidents too clearly to make anything supernatural or magical out of them. On Friday (25th) we were in the dug-out by the line, sitting and talking late after dinner. One of us went outside to see the results of a short bombardment over the enemy lines. He called to me to come and look. I did not notice how black the night had fallen since the moon had gone down, and I took three steps out. The earth opened suddenly & I disappeared amid a roar of laughter. I suppose all very sudden disappearances are funny but from my point of view it wasn't humorous at all because I was jammed in a narrow trench & had a sharp pain in my side. So when they saw that they soon helped me out amid much sympathy & I limped back into the dugout feeling rather as

Paul Nash, *Shellburst, Zillebeke*, 1917, coloured chalks on brown paper, private collection

if I had broken in the middle like a doll. It hurt lying down that night &
in the afternoon going out from the line, carrying a heavy pack & other
things, didn't improve it. So that evening I jokingly suggested the doc
should tickle my ribs & he was rather surprised when I hollered, so he said
he must examine me. Together we came to the conclusion something was
loose & hurt when prodded & to my amazement by Sunday afternoon I
was packed off to the casualty clearing station with a dislocated 9th rib. I
remained there till the next morning, was bound up with bands like a fat
lady in tight stays & together with some few others sent down in a train
to the base & here I am at No. 14 General Hospital, B.E.F., the last place
before England. Don't get excited, Tim darling, it's a 5 to 1 chance against
my getting [sent] over. I haven't got a wound & it may be easily put right
– in fact I know that of all the men who came with me to No. 14 I stand
the least chance of Blighty. Of course it's simply bloody – sheer blood &
anguish to lie here looking across the sea. I daren't say 'Oh sea that heaves
as if for love twixt her and me, tell her I come.' The bitter beauty of those
lines of Patmore came suddenly to me. I can only recall fragments of lines
here and there. It is called 'The day after to-morrow' and I remember it as
one of the most intensely quiet passionate things I have ever heard. It is
like an exquisite pain, a pain that is also a tingling joy. I only say it is bitter
because the words are such mockery here. . . . I even think I may get leave
about September, anyhow before the year is out. Leave is already open
and the first officer has gone, but since the Army I belong to has given no
leave to its men for months, everyone on the battalion is overdue and there
are 12 officers before me. Never mind, every day I get some new drawings
done and by Christmas I shall have something to show for my work here.
[…] If my rib is nothing much, I shall only be here a few days, if it is
complicated, then I have a chance of getting sent over. Somehow I do
not feel they mean to send me, so I am building a philosophic calm ready
to withstand any blow of disappointment. I got your long letter when I
returned from the trenches on Saturday, and when I got sent away the only
thing that at first made me think I might get home was reading that you
had gone away to Tunbridge – it would be so typical to arrive in London
& find my dove away! I am to be X rayed now & can not tell you yet what
is to become of me. Opposite is a funny old Canadian Tunneller with a
fractured arm & wound from a machine gun. He is going to England
where he doesn't know a soul & is just as fed up as any man I ever saw. I
offered to give him your address so you might cheer him up but he is very

wild & shy & is used to living in a bush or jungle or something & has thanked me but refused. Think of it he would give anything to go back to the trenches as soon as possible! I must wind this up it's not a brave letter at all. Later in the day I will write about other things. I will send this letter by old Tunneller as he goes over this afternoon. I fear I have no more hope. Write me a little letter here so I get it while I am still at the sea. Good bye my dear, dear, little Tim from your poor old Man.

October 1917, Gosport, Hampshire[28]

My darling I have had a miracle of an escape. At about 9 o'clock this morning the officers warned for Egypt, who included myself, received orders to report at Southampton ready to sail by 2 o'clock! five hours notice. Almost at the same time came a wire from the War Office cancelling my name from the list. Otherwise I should have been gone by now without seeing you, my love, or Father or anyone, & equipped somewhat over simply with an old tunic, no cool clothes, no helmet & a few odd winter vests & breeches. However as it is I cannot but rejoice, for it must mean that the W[ar] O[ffice] will let me be sent to France to do drawings. I hope to hear from Buchan shortly – would you like to ring him up and worship him over the phone! he deserves it. I still have a fearful feeling I shall be suddenly ordered off at an hours notice (quite an impossible thing really I should think), so do find out from Buchan what has happened & wire me – 'All's well' or some such reassuring message. [...] All love my dearest, Your Paul.

5 November 1917, Intelligence H.Q., France[29]

My darling little one just a short letter in case you think your dove is not thinking of you. I have really barely had time to sit down & write & in the evenings have felt profoundly sleepy after motoring in the keen air. I waited also until I could see Jack[30] & so give you news of him. Whatever

Paul Nash, *A Farm, Wytschaete*, 1917, ink, chalk and watercolour on paper, private collection

powers work for good & mercy have indeed favoured our little family. I must not say much but I can tell you Jack has been miraculously spared in that he did not 'go over' this time, and it is not a slight on him, rather he was kept back because he is a very useful man. I found the dear old fellow at last after a day's search, looking very well – a bronzed & tattered soldier, with incredible hands, all rough & overgrown with cuticle at the nails – his eyes, I thought, less shy; very blue & bright, thin in the face but not drawn or strained; voice rather weak as always but giving out the same wit & humour as of old. He was very happy and tho' I listened with horror & wonder to all he had seen & felt he seemed to have been only intensely interested, enjoyed the hundreds of humorous things that happened, only he confessed the sight of wounded & dying men upset unnerved him. He said he was quite well now & not tired. At present he is on a Trench Mortar course far behind the line where he will be a fortnight. After that the battalion may be out for a rest – there are so few left I should think it unlikely he will go up the line yet. We had a jolly day together it being Sunday so he was free – motoring through the pleasant lands of France. I am going to try & push on his course by seeing his Company Commander. To day I have seen one of the latest & most terrible battlefields of Flanders, where I return tomorrow to do more drawings. It is indescribable. So soon as I have a minute's rest I will write a decent letter, this one is done in the car while we dodge in & out of the traffic – I have been painfully writing it all day. I have an excellent Driver who does the most amazing things. He also has the reputation of being able to show one every pretty girl in this part of France so I am all right I think. The French are robbers & annoy me intensely by their cupidity. Masterman won't like the bill. How is my sweet, how lovely it will be to get home to you. Can't write any more car doing about 45 & the light failing. Now we have stopped a moment. Love to you darling. I hope I shall get a letter somehow thro' GHQ but I dash about something awful. It's very disturbing to one's spiritual integrity, it will take all mine to stand it [. . .] Many kisses from your Dove.

13 November 1917, somewhere near the Western Front[31]

My beloved I hope you got my letter. I am settled here for a week so very soon expect letters will come thro' to me as I have wired GHQ my address.

Yesterday I made 12 drawings, nine of different aspects of one of the most famous battlefields, the battle I just missed.[32] The day was perishing cold but wondrously changeable in colour and light so I was able to get some useful looking sketches. This afternoon I go up the line to stay at a Brigade HQ for a night or two, from where I shall see wonderful things. Everyone has been charming especially our friends the Australians. I had a little trouble at first way back behind the lines, chiefly thro' slackness on the part of a rather indifferent officer, but a splendid old colonel stepped in and greeted me with great enthusiasm and many valuable suggestions which I am carrying out now. I also met Neville Lytton,[33] brother of your friend, and he spread himself on my behalf & will help me to the best of his power which is considerable. He had his ivory flute with him, wasn't it splendid! Unluckily there was no time to get him to play, but I shall try to persuade him when I see him again. / 3 days lapse / I have had to postpone this letter. It is even more difficult to write now than it was when I was out last. I start off directly after breakfast and do not get home till dinner time, and after that work on my drawings till about eleven when I feel very sleepy, & go to bed. [. . .]

I have just returned (last night) from a visit to Brigade HQ up the line & I shall not forget it as long as I live. I have seen the most frightful nightmare of a country ever conceived by Dante or Poe – unspeakable, utterly indescribable. In the 15 drawings I made I may give you some vague idea of its horror but only being in it and of it can ever make you sensible of its dreadful nature & what men in France have to face. We all have a vague notion of the terrors of a battle & can conjure up with the aid of some of the more inspired war correspondents and the pictures in the Daily Mirror some vision of a battle field; but no pen or drawing can convey this country – the normal setting of the battles taking place day & night, month after month. Evil and the incarnate Fiend alone can be master of the ceremonies in this war: no glimmer of God's hand is seen. Sunset & sunrise are blasphemous mockeries to man; only the black rain out of the bruised & swollen clouds or thro' the bitter black of night is fit atmosphere in such a land. The rain drives on; the stinking mud becomes more evilly yellow, the shell holes fill up with green white water, the roads & tracks are covered in inches of slime, the black dying trees ooze & sweat and the shells never cease. They whine & plunge over head, tearing away the rotting tree stumps, breaking the plank roads, striking down horses & mules; annihilating, maiming, maddening; they plunge into the grave which is

this land, one huge grave, and cast up the poor dead. O it is unspeakable, Godless, hopeless. I am no longer an artist interested & curious, I am a messenger who will bring back word from men fighting to those who want the war to last for ever. Feeble, inarticulate will be my message but it will have a bitter truth and may it burn their lousy souls.

No letters at all yet. I wish they would send them on. Be kind to your dove & chide him not for writing so little he had written to no one else yet. In one day or two he will have more to say & not so gloomy. I am longing to hear all about my darling. [. . .] For a little time adieu my sweet little baby, with a long long kiss the kind only we can give, from your most loving idolatrous lover, Paul.

MEMOIRS OF PAUL NASH, 1913–1946, BY MARGARET NASH[1]

1 1913–1918. War period

The war of 1914, which broke out on August 4th, found Paul and myself staying with Gordon and Emily Bottomley at Silverdale on the edge of the Lake District, where we were spending a lovely summer holiday. Gordon had obviously sensed the approaching tragedy of war and managed to keep us ignorant of the news by hiding the daily papers, in which we were not interested, since we had so much to plan for a future life devoted to art and travel. We had no income on which to marry, but I was full of confidence in Paul's genius and ability to quickly make a yearly income which would meet our very simple needs. [...] We immediately returned to London on realizing the war situation, and when we got out at St. Pancras station we found small boys marching down the street with toy drums which they were beating and bugles which they were blowing, and the pathetic martial air of these children as they played at the war game terrified us. On arriving at my flat opposite the station,[2] we turned to one another, silently comforting each the other, as the full meaning of separation dawned upon as.

The impact of war came as a tremendous shock to me, because I was in those days an ardent believer in both the uselessness and utter impossibility of so barbaric a solution of world problems. To Paul, it was more simple, for he immediately felt that as an Englishman it was his duty to fight for his country. He had a very clear and simple conception of his duty towards his country, which he passionately loved, and although he was the last human being in the world to tolerate the horror and cruelty of war, he had an immediate and firm conviction that he must fight for England.

As I remember him now, there comes back to me an Elizabethan atmosphere about his few remarks on the necessity of fighting for a country which meant poetry and beauty to him as an artist, and freedom of thought

and action to him as an Englishman. And so I dumbly accepted his deci-
sion to enlist at once in the Artists' Rifles, the depot of which was round
the corner from my flat [. . .] That autumn presents a series of frightening
pictures to me of Paul escaping for his leave from the camp in Richmond
Park and coming up to my flat, tired out with the unaccustomed physical
exertion, his hands roughened by various Army jobs to which he was put
as a private, and his soul sickened by the routine and daily discipline of
Army life. It took a great deal of courage for him, who had always been
so free in his own home, except for the horrible short period of purgatory
while he was training as a cadet for the Navy, a period which he so viv-
idly describes in his own autobiography as having been an experience of
continuous hell. This time he faced his duties with the same independent
spirit, but with perhaps more ability to accept the irksome discipline of his
life. In all his spare moments he painted and drew, almost feverishly, when
the news was bad from the front, especially when our first clash with the
Germans had cost us the lives of a number of our best young men. It was
merciful that he was not sent out immediately, but this was only owing to
a series of accidents, and not from his own choice.

We decided to get married before the New Year, as it seemed possible
that he would be sent out to France at any time; so we were married on
December 17th 1914, in the lovely church of St. Martin's in the Fields [. . .]
The honeymoon was spent at a friend's house in Somerset, which she very
kindly lent me for the occasion. Thus our married life started auspiciously,
with a sense of leisure and peace and almost of luxury in that comfortable,
simple country home. After ten days he had to go back to the Army but
now he was full of curiosity about his new life and at this time he pro-
duced a number of pictures which were shown in the New English Art
Club, the Friday Club, and these won him considerable praise and encour-
agement. [. . .] After the first eighteen months of drilling, marching and
keeping guard, firstly in London and afterwards in various places along the
south coast, Paul was sent on a special course to study Map Instruction. It
was while he was on this course at Romford Camp that he met Edward
Thomas[3] and formed a very close friendship with him. They enjoyed the
exciting experience of night route marching, and during their spare hours
in the day they would go for long walks into the country, stopping at the
local pubs from time to time [. . .] Unfortunately Thomas was sent out to
the Ypres Salient towards the end of the year, and there he lost his life
before Paul arrived in the Salient in 1917. [. . .]

As 1916 approached it became obvious that Paul must take his commission, as officers were very badly needed, owing to the enormous loss of trained men in France. He did not take a commission straightaway because he preferred to learn his job in the ranks before he was placed in the responsible position of an officer, but he had always been quite prepared to go out to France serving in the ranks. At the Staff College at Camberley he sat for his examination, and was granted a commission in the 3rd Hampshire Battalion which he immediately joined at their Headquarters at Gosport. There he waited for his turn to go on one of the drafts either to Mesopotamia or to the Ypres Salient. [. . .]

A merciful providence protected Paul while he was up the line in the Salient; it was a period of comparative quiet during which both sides prepared for a fresh and bloody onslaught. His experience of actual fighting was consequently slight, but of course he took part in the nightly raids and the daily skirmishes. It is curious how he was able to study his surroundings with a quiet detachment, and this attitude of mind is reflected in some of the water colours of this period such as *Trench in a Wood, The Pool*, or again, in the *Old Front Line, St. Eloise, Ypres Salient*. His letters to me which I have quoted in *Outline* show that he was passionately interested in the life and deeply moved by pity for the mental sufferings of the men under his command. He was thrilled with a boyish pride in the whole heroic adventure of the war. He saw its ugliness, but he also saw its haunting beauty and drama, and I have always been so thankful that he had no experience at this time which shattered that inner sense of beauty and mystery.

As I was exhausted with my heavy work in London and the incessant and gnawing anxiety about Paul's safety, I became so tired that I had to escape for a rest. So I went down to a Rest Home near Tunbridge Wells [. . .] Suddenly, one night, I realised something had happened to him and instead of staying on for another week, as I had arranged, I packed up and immediately returned to London.

This curious sense of danger and tension stopped when I settled into my flat, and within half an hour a War Office telegram was dropped through the door informing me that he had met with an accident in the trenches and that he was invalided back to England. This was followed by a telephone message from the Swedish Hospital to say that he had just arrived and was in the care of Dr Cyriac and would I go down to see him at the hospital that night.[4] I went over to find him in pain and nervy, but quite in

command of himself. He was suffering from a broken, floating rib, which Dr Cyriac discovered in the X-ray photograph, and not as the report from the Base Hospital had it, from merely a misplaced cartilage.

This accident had occurred just before the attack on Hill 60, during which Paul's own Company practically disappeared under an overwhelming barrage which had caught them in the advance. In anticipation of this imminent attack the Medical Officer at the clearing station had sent him back to Base, as they had to keep the beds free for the wounded from the battle. The accident occurred because he jumped up on to the parapet to draw the Very Lights which were showing over No-Man's Land during the night, and stepped back while drawing, forgetting how near he was to the edge of trench, and fell, catching his rib on a projection, straight into the trench. He suffered a good deal of pain, and of course the injury was not properly treated until he reached London, so that he was in a certain amount of danger through having the loose floating rib not properly bandaged. The jar to his spine was considerable, and I realised that he had had a nasty accident which ultimately caused an injury to the base of the lung. But it saved his life, and resulted in his appointment as a war artist on the Western Front instead of returning to the front Line as an Officer.

I had been trying to arrange an exhibition before leaving London, for the group of water colours he had managed to send home to me from the front. I knew that the Ministry of Information had just been formed for the purpose of commissioning artists and writers to give an account of the war upon the Western and the Mesopotamian Fronts, but hitherto only men not actually engaged in the fighting line or else invalided out of the army, had been appointed to these posts. John Buchan, who was in charge of the Ministry, was very anxious to secure the best artists and writers, to work for the Ministry, and he began to choose man on active service for this propaganda work. Paul's little exhibition which was gathered together eventually was shown in an upper room of the Goupil Gallery in 1917, and was entitled *Landscapes of the Ypres Salient*. Since these water colours were actually done in Paul's spare time in the fighting line, they were small and simple, but they caught the imagination of John Drinkwater,[5] who came to see them, and then of John Buchan, whom he brought along to look at them. So he was invited to send in his application for the post of war artist on the Western Front. He was taken aback at this idea, since he did not feel that his pictures were sufficiently impressive, but at the same time he

was excited to think that he could go out to the Salient as an artist and so achieve his great ambition to show the inner spirit of the war.

He collected a number of letters from various people to testify to his ability for this post, among them being a very enthusiastic letter of recommendation from Roger Fry, and of course a friendly, sympathetic one from William Rothenstein, besides letters from well-known writers, artists and art critics. In fact, John Buchan, when Paul went to see him, seemed staggered by the enthusiasm of the recommendations, as well as by the number of important people who supported his application [. . .] and eventually he was seconded for special duty to the Foreign Office, as Official Artist on the Western Front. His interviews with Charles Masterman, who was now in charge, was most successful and resulted in his arranging to visit the Ypres Salient. He already knew exactly the kind of pictures he wished to draw, as be had been studying the Salient while he was on active service, but he returned to France, with the difficult task of escaping from the area of G.H.Q.

Paul's overmastering passion for the front line trenches defeated all attempts to keep him in the back areas of the war. His painting at the Imperial War Museum entitled *The Menin Road,* shows the very road along which he drove in a special staff car, with a mad Irishman as chauffeur, who took no notice of danger, and pilotted the car so skilfully, that he timed the constant shell bursts on the road, any of which might immediately have killed both of them. In fact, for the few weeks as he was drawing out in the front line of the salient, Paul was in far greater danger than he had ever been while engaged in trench warfare. As he explains in his Notes, he found it difficult, as an Infantry Subaltern, to behave like a staff Captain, but he managed, with his special hypnotic technique and driving will, to penetrate to any part of the line he wished to visit, whether it was his business to be there or not. This determination to see the war, combined with, an astonishing outburst of energy, enabled him to do anything up to 60 to 70 drawings in the actual front line within a week. Some of these water colours, which were afterwards sold at the Leicester Galleries in the 1918 Exhibition, actually had mud spattered upon them from nearby exploding shells, which he at times worked in to help with the colour of the drawing.

When he arrived on the field of Passchendaele (the painting entitled *Void* was evolved from his drawings made on the battlefield), it was about twelve hours after the battle, and there was a thin vapour of gas hanging

about which unfortunately he absorbed, inadvertently, while he was at studying this awful scene of devastation. It was believed by the doctor who saw him in 1933 in France, and later by Lord Horder[6] in 1945, that this gas began the trouble with his bronchial tubes, resulting eventually in the crippling asthmatic condition which came upon him in later life – for he was not a true asthmatic in the medical sense. Certainly, after his return from France I noticed that he used frequently to cough, and for the first time he was inclined to get a great deal of trouble with his chest whenever he developed a cold. [...]

He now realised that he must have a longer period in France as there was a great deal more to see and to study, so he set up house with the aid of his chauffeur, who found him a first class cook as batmen. In this way he was free to roam about the front line and spend all day doing rapid sketches and building up the series of drawings for the exhibition held later at the Leicester Galleries in 1918. [...] Finally his time was up and he had to return to England, very dubious as to whether he had really succeeded in his work as an official artist and whether the kind of things that he was bringing back would satisfy the official mind and give to the public the message he felt they should receive from their men fighting in that appalling war of slime, dirt, cold, ever present death, and unheroic small privations which ate their souls. [...]

I have, in writing about this period of the war, passed over numbers of incidents which are reflected in the letters Paul wrote to me at this time between 1914–1917 [...] They reflect the extraordinary childlike trust with which he accepted his life in the army, banishing from his mind as much as possible resentment against our separation and our loss of the first years of our happy marriage. For it was a happy marriage, since it was not only concerned with passion, but by the very circumstances of the war, we were comrades, determined to help each other and to spare one another as much as lay within our power. It strengthened and emphasized our mutual trust in each other and in our future life together. I never felt that Paul would be taken from me and from his work, and I suppose it was our simple belief in our future life together which sustained us. We never talked about religion, but we understood about that spiritual protection to which one is forced to turn when everything else has failed. The experience of all this separation, anxiety, privation, sometimes unavoidable wild apprehension, developed in both of us an early reliance on that spiritual understanding. I do not mean that the conventional religious practices meant much to us,

nor do I mean that we talked about our religious beliefs, although both of us were the children of deeply religious fathers and mothers, who openly practiced their faith in the simple accustomed manner of their generation. Both Paul and I had a revulsion from formal religion, and this was curious since both of us had a disciplined pattern of life. On looking at his work at this period one realises the immense importance of its line and plan, but I think that that formal aspect of his work came from a sudden unaccustomed acceptance of a highly disciplined life in order to meet something that had hitherto never come into his experience: – fear, danger, death, and that experience included himself and me.

When he returned from the horrifying pictorial vision of the war gained during the few weeks in which he roamed about the Ypres Salient making his drawings, he was in an exhausted emotional state, and this manifested itself in the fevered tension with which he carried out his work for the Leicester Galleries Exhibition of 1918. He has described in the letters quoted in *Outline* how he wondered whether his point of view of the war would be acceptable to the authorities in the Ministry of Information. His only disagreeable contact with the Ministry came not from the men who first saw his designs and who were enthusiastic about them, but over the question of financial support for the exhibition at the Leicester Galleries. [...]

A curious situation arose when he was told that the exhibition must be financed by him personally; that he must pay for the framing of the pictures, a very considerable strain on our mutual resources, since he only had his pay as a Subaltern and I was earning just sufficient money to keep myself in a very modest way in my London flat. [...] Paul was met by the Financial Adviser to the Ministry with a most extraordinary suggestion that they should buy for the War Records of the country a limited number of his paintings and water-colours, to be chosen before the exhibition opened, at 40% off the selling price at the Leicester Galleries. Since they undertook no expense in producing the exhibition, and he had to pay the Leicester Galleries a 25% commission on all sales in addition to the framing, this meant almost a state of bankruptcy had he held the show under such conditions. It was pointed out to him that he had been taken out of the fighting line, which possibly saved his life, a totally untrue statement since he was actually in more danger drawing in the front line than he had ever been in the trenches. It is true that he had been spared the appalling battles such as Passchendaele, but he had in no way avoided considerable risks while collecting his material at the request

of the authorities at home. This led on his part to a firm protest as to the
unfairness of this arrangement, and eventually he sold a certain number of
water-colours and two or three paintings to the Ministry on rather more
favourable terms, though I cannot now remember the exact commission
they eventually demanded. At no time were his prices high and, so far
as I can ascertain from the accounts which I have managed to discover,
the show gave us a profit, after paying all expenses, of exactly £10. [...] I
may say that all the work for the exhibition at the Leicester Galleries was
carried out in this small flat in Judd Street, and he did not have a proper
studio until he reached the point where he had to do the big painting
called *The Menin Road*.

We now had to find a studio for Paul and this caused us to go to
Gerrard's Cross, where my sister-in-law, Mrs John Nash, was living. She
helped us to find a room in the house of a Belgian violinist at Chalfont
St. Peter. He happened to have not only a house but a large empty shed,
of enormous proportions, where he was drying medicinal herbs, as his
contribution to the war. [...] Gradually we acquired a few friends in the
neighbourhood, and eventually we were able to hire a small house, where
I had a very severe attack of influenza, at the peak of the after-war epi-
demic. We were at Chalfont St Peter when peace was declared in 1918,
and curiously enough I cannot remember any kind of emotion of pleasure
or excitement when the news came through, as we were all so tired and
exhausted by the struggle for existence; we just dumbly relaxed, and then
began to worry about the future. Peace meant to us, that Paul's income
stopped abruptly, and he had immediately to begin to worry about a living
while his war pictures were still unfinished. Luckily his big painting of
the war – *The Menin Road*, was separated from the arrangement by which
he only received an Officer's pay while working for the Ministry. He was
specially commissioned for *The Menin Road*, receiving £150, on which we
had to live until it was finished, about a year's work.

For personal reasons it became impossible for us to stay on in Chalfont
St. Peter after the war, and we decided to return to my flat in London,
which had been let during most of the period we were away, and find a
studio in the neighbourhood.

We came up to London at the beginning of 1919, and Paul eventually hired a room in a house in Gower Street, where he had to paint *The Menin Road*, which was too big for the room. He was only able to see it at a distance by climbing out through the window on to a flat lead roof projecting over a bay window below, and peering at the picture through the window of the room. [...]

The return to London in 1919 (a date which does not agree with Paul's statement at the end of his Chapter 6 'Making a New World', in which he suggests that we came back before the end of the war, November 1918), found him confronted by crippling financial difficulties, which he briefly describes as 'A war artist without a war'. He had to meet, in addition to the antagonism of Roger Fry, that of the whole Bloomsbury Group, whose aesthetic opinions Fry then controlled. In 1913 Roger had been very friendly to Paul, hoping to convert him, as he had Duncan Grant and other young artists, to the particular aesthetic faith he was preaching at that period in London. He was shocked to find that in spite of his patronage – a most useful patronage to an unknown young artist – Paul still preserved an independent mind and conscientiously rejected Fry's attempt to manipulate his aesthetic outlook. With Paul's entry into the army at the beginning of the war, and his subsequent appointment as War Artist on the Western Front, the break with Fry was complete.

[...] Fry's antagonism to Paul centred on the fact that he had painted his war pictures in a spirit of propaganda, and therefore they were classed as journalistic and without aesthetic value. Fry's persecution followed Paul into civilian life and he did everything he could to prevent him earning his living as an artist. Since he controlled the minds and purses of most

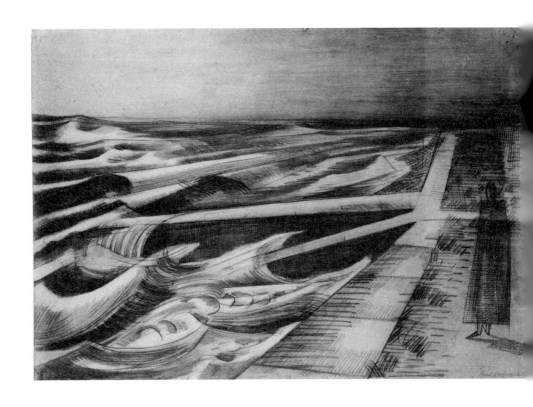

Paul Nash, *Night Tide, Dymchurch*, 1922, pencil and wash on paper, private collection

of the prominent picture buyers is London it was not so very difficult for him to starve Paul out by incessantly disparaging his work at public exhibitions and whenever he encountered it in the private houses of various buyers. This forced Paul to accept a commission for a war painting for the Canadian Government after the war was over, and also forced him to try and keep himself alive by embarking on commercial designing. He was elected a member of the New English Art Club at this time, and we also let our small flat and went to live in Wyndham Tryon's studio in Fitzroy Street, which he most kindly lent to us.[7] It was a great barrack of a place, not sympathetic to live and work in, but it enabled us to cut down our expenses to the minimum and survive the financial depression. *The Menin Road* was eventually shown, with other war pictures, at Burlington House, towards the end of 1919, and was acclaimed by Walter Sickert amongst other people, as not only a war picture but a fine work of art. This triumph and vindication of Paul's work as a war artist redoubled the attacks on his of Fry and his satellites, and also earned the jealousy of Wyndham Lewis, who tried to alienate the friendship of Osbert and Sacheverell Sitwell and other important friends of ours.

Paul began to design for the theatre; he was encouraged to do this by Gordon Craig, who later invited him to exhibit in the International Theatre Exhibition at Amsterdam, and endeavoured to persuade him to come into the theatre and work there as a scenic designer. He met about this time Karsavina,[8] and was invited to do the set for *The Truth about the Russian Dancers*, a short ballet written for her by James Barrie, which was to be produced at the Coliseum [...] and although the carrying out of the production proved a great strain upon him, since he was quite unacquainted with this kind of work, he did very much enjoy the experience. I think at the end of it he felt that he would rather not become closely associated with the theatre world, since it was really outside his fundamental interests as an artist, and led him into far too much social life in London. In fact the years from 1919–1921 were too hectic for Paul after the strain of the war, as we had to enter constantly into London life, with its parties, late nights, and incessant invasions and expenses.

[...] Through Harold Scott, whom we had met, we became friends with Raymonde Collignon, a lovely French diseuse, who had been brought up in England and was very much admired by Ezra Pound and some of the intellectuals of the period. She invited us to stay with her at Dymchurch-under-the-wall, and we had our first sight of that lovely coast, stretching

Paul Nash, *Oh Dear! What Can the Matter Be?*, J. & W. Chester Ltd, London, 1920,
private collection

from Folkestone to Rye, with the beautiful mysterious Romney Marsh in the background. [...] At that time Dymchurch was the centre for a delightful group of people including Lovat Fraser[9] and his wife, Athene Seyler, Sybil Thorndike and Russell Thorndike, also Mrs Edith Nesbit of child-story fame.

It was towards the end of 1919 that Paul encountered a disagreeable experience over a Private Exhibition of drawings held at Fitzroy Street. He had been writing criticisms of art exhibitions for *The Weekend Review* and he unfortunately made the mistake, since he was exhibiting in one of these shows, of mentioning his own picture, doing no more than stating that it was included in the exhibition. This fact was seized upon by Wyndham Lewis, who pointed it out to Edward Wadsworth, over whom at that time he exercised a great deal of influence, and by cleverly presenting to Wadsworth that Paul had committed a great breach of manners as an art critic in mentioning his own picture in the course of a review on a mixed exhibition, induced Wadsworth to come in and publicly attack him at the Private View of his own exhibition in the Studio. It must be remembered that this public attack was done in the presence of a great many people, and is a very brutal manner, and it was obvious to me, who witnessed it, that the whole thing was the result of acute spite on the part of Wyndham Lewis, since Wadsworth was obviously acting under his influence. It gave Paul such a shock to find that a perfectly innocent action of his could be so misinterpreted, that he determined at the time to give up all contact with art criticism, which to my mind was unfortunate since he really was a very good critic. The kindness and friendship of Sickert, who himself had not infrequently suffered from such attacks, helped him to recover his sense of proportion, but it really was the reason why he resisted all attempts of Arnold Bennett to induce him to edit an art magazine which Bennett wanted to back financially. Bennett recognized his craft as a writer and his very great sense of integrity as a critic, but Paul, who was not at all well and suffering badly from overstrain, refused any kind of job which would keep him in London. He was longing for the peace and solitude of the country, and for the time to re-examine his work and his future development as an artist.

The clashing art politics of the period and the snobbish intellectualism of the Bloomsbury Group, led by the Jesuitically-minded Roger Fry, made social intercourse in London tiresome and, not infrequently, dangerous, for someone so single-minded and so outspoken as Paul. He

was never at any time that curious being a 'high-brow', and his approach to his particular job of painting and designing was very spontaneous and not invaded at this period by the over-intellectual or, as the French put it 'cérèbrale' approach of the Paris school of painters. Paul was able to extract from his later contact with the French school such ideas as were useful to him, but he was not prepared to become a wholesale imitator, nor was he prepared to accept their aesthetic pronouncements as interpreted by Roger Fry, Clive Bell and other vociferous members of the Bloomsbury Group, without reservations, and not infrequently with indifference. [...]

Our first stay out of London was actually at Whiteleaf, near Princes Risborough, and with it came the discovery of the wonderful Chiltern country. [...] John Nash had a small cottage at Whiteleaf, and so we all met on the lovely Chiltern Hills and wandered about over the country, which includes Ivinghoe Beacon, the landscape Paul used in his picture *Wood on the Downs*. This country gave him great inspiration, and the series of landscapes belonging to this immediate period after the war from 1919–21 show his reaction to a landscape full of design and subtlety of colour, and are amongst the best paintings of his career.

About 1920 we decided to go down to Dymchurch, as he wanted to see that coast again, which had already fired his imagination [...] We found a small cottage, as we were very poor at the time, and by letting my flat, we were able to live on a minute income, which saved Paul from the strain of commercial art and the somewhat dubious career of art criticism. While we were there, Lovat Fraser and his wife came down for a holiday during the summer months, and there occurred a tragic incident which gave Paul a severe mental shock and helped to bring about the dangerous illness which he experienced in 1921. Lovat had hardly been at Dymchurch more than three weeks when he became dangerously ill, and it was obvious to us that he was in immediate peril and needed expert medical help such as the local doctor could not offer him. His poor wife brought down a London specialist, and his London doctor, and Lovat was removed to a Nursing Home near Folkestone, where an immediate major operation had to be performed. This resulted in his death within twenty-four hours of the operation, as there was a complication of delayed war strain. [...] The whole tragedy gave Paul such an emotional shock that, on top of the war strain and the trying period in London which followed the war, it added the final damage to his over-tired body and somewhat over-excited imagination. [...]

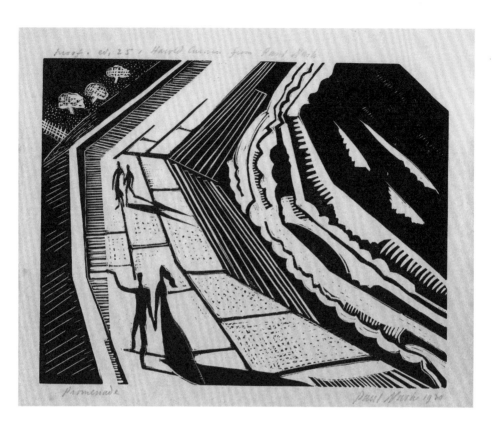

Paul Nash, *Promenade*, 1920, woodcut, private collection

It seemed as if 1921 was a fatal year to both of us, since I was continually ill, and Paul was unable to work in any kind of peace or with any clear vision. Not long after Christmas we went down to stay with my parents at Hillingdon, near Uxbridge [...] and while there, Paul went over to see his father at Iver Heath, as he was told that he was not in good health. While on that visit he had a severe mental shock, as his father, who had been suffering from an attack of influenza, had a sudden heart attack during the afternoon, and Paul came into the room and saw him, as he thought lying dead on the floor. The effect of this was to make him so ill himself that when he came back to me at Hillingdon, he suddenly became unconscious and remained in that state for over a week. My father summoned three ordinary practitioners and two specialists in the neighbourhood, and I felt, when I came to confer with these five doctors, that none of them realised the nature of Paul's illness. [...] I felt quite convinced that the whole history of the illness had its origin in this final shock following on the dreadful strain he had been through over the war and then over Lovat's death. We eventually found ourselves at the Queen Square Hospital for Nervous Diseases, and I was able to place the case in the capable hands of Mr Gordon Holmes. It did not take him very long to arrive at a simple explanation of the nature of Paul's illness, and he gave me instructions to sit by Paul day and night until he recovered consciousness, in order to reassure him, since he would find himself occupying a public ward, with screens round him, obviously a terrifying experience. In Mr Holmes' opinion the whole thing had come about as the result of a continuous series of frightening images presented to a highly imaginative mind, starting from the period of his work as a War Artist, and ending is the emotional shock of his father's illness.

I may explain that there are few parents and children who had so strong an affection for one another as Paul felt for his father and his father for him. They were more like brothers than father and son, and since they had in the past suffered a great tragedy and anxiety together, they had a very special understanding of one another. We never allowed his father to know that Paul was ill, and I was able to keep this secret from him, as Paul made a quick and perfect recovery once he regained consciousness. Mr Holmes' opinion was, that this illness would benefit his health so long as he went away into the country and led a really quiet life, and got on with his work on its creative side rather than on its commercial side.

3 1921–1925

Within four weeks of his recovery we were in Dymchurch again, and there we lived for the next four years, during which time Paul produced a number of his most remarkable paintings. Our immediate financial worries were relieved with the help of such good friends as Albert Rutherston,[10] who secured sufficient money to enable Paul to rest for nine months and work when he felt inclined, or go out and roam about over the Marsh when he needed change of air. In fact, friendship was shown to us on every side at this time, and gradually our worries disappeared and the way became more easy.

It was in the first nine months that, as a result of an invitation from Gordon Craig, Paul became interested in making models for stage designs [. . .] Alongside this interest in stage designing Paul discovered a new and great imaginative stimulus. The architecture of the Dymchurch Wall with its majestic sweep facing the approaching and receding sea: this provided him with endless designs and ideas for pictures. He was able to turn to the lovely landscape inland when he wearied of the coast-line, and one of his best known oils, *Sandling Park*, near Hythe, now in the possession of The Manchester City Art Gallery, shows the inspiration that he derived from the landscape which lay between Dymchurch and Canterbury, and on the hills at Lympne.

It was now that we paid a series of visits to France, starting with a brief trip about Christmas of 1922 with our friend Claude Miller, who knew Paris very well and introduced us to many of his amusing friends, especially Madame Marguerite Prassinos, later a collector of his work. We spent no time on this visit looking at modern pictures, but studied the treasures of the Louvre. I mention this fact because *Nostalgic Landscape*,

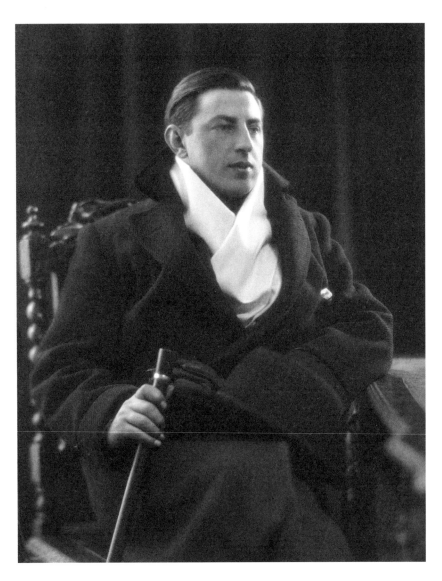

Bassano Ltd, *Paul Nash, 30 October 1922*, photograph,
National Portrait Gallery, London

Bassano Ltd, *Margaret Nash, 30 August 1922*, photograph,
National Portrait Gallery, London

which was conceived in 1923 and put aside to be completed in 1938, has been attributed to inspiration of Chirico's paintings,[11] whereas it is an independent idea of Paul's and actually bears no origin to the work of the Surrealist painters. He did not take any interest in Surrealism until a very much later period, about 1934, when it suddenly attracted his attention on account of the concern of its adherents with the imaginative idea of the dream. Paul had painted dreams throughout his early life, and it was really the suggestion that the dream could assume irrational forms, that interested him in Surrealism, since he had no affection for its psychoanalytical point of view which was repugnant to his poetic mind.

Sir Edward Marsh[12] brought him into contact with T.E. Lawrence, who bought his first Dymchurch sea painting [...] He eventually commissioned Paul to paint some landscapes for inclusion in *The Seven Pillars of Wisdom*. They were to be landscapes particularly concerned with Petra, and he arrived one day at our friend Colonel Bertram Buchanan's house at Oxenbridge Farm, Iden, near Rye, where we were staying, with about two hundred photographs which he had taken himself of Petra and other remarkable places in the desert lying between Egypt and Palestine. [...]

The other interesting book Paul was asked to illustrate was for the poet Ford Madox Ford, who came over and spent the night with us at Dymchurch, in our rooms overlooking the shore, past one of the large Martello towers on the coast. This book was called *Mr. Bosphorous and the Muses*, and I shall never forget the fascinating yet exhausting experience of sitting on the floor during a whole evening and well on into the early hours of the morning, while Ford read the poem aloud from end to end, in his strange monotonous, soporific voice. Paul had himself written a few poems, the only ones he ever published, which are to be found in a book entitled *Places*, published in 1922 by Heinemann, and illustrated by his first woodcuts, to which the poems were an accompaniment. The one entitled 'Winter Wood' was one of his most successful woodcuts and his most convincing poem, and this was also the opinion of Ford, who encouraged him very much to write as well as to paint. He perceived even at that date, that Paul had a considerable power of expression in words as well as pictorially. [...]

[H]e had undertaken to teach once a week at the Royal College of Art, at the invitation of William Rothenstein. He was Design Master for nearly a year at the Royal College and so successful a teacher, that before he resigned, he was invited by the Board of Education to become an Inspector of Art Schools, an invitation which he refused. [...]

4 1925

It was in 1924 that we decided to spend the winter in the South of France and go on, if possible, to Florence. Our financial resources at this time were extremely small, and we were only able to raise enough money to stay down in the little fishing village of Cros de Cagnes, about three miles outside Nice [...] Our arrival at Cros de Cagnes revealed to us the sunny shores of the Riviera, with a climate exactly resembling our beloved Dymchurch, with its pitiless winter rain and fog and mist. We reached it in December 1924, and it was rather a shock to find that the Riviera could be cold and wet. But soon the sun burst out and the whole landscape changed: the sparkling blue sea, the radiant sky, and the delicately coloured shades filled Paul with an urge to paint this new country. [...]

It was such a lovely winter, in which, for the first time, we were able, because of the very profitable rate of exchange, to travel about in a certain amount of comfort, and see a great deal of the lovely country behind us, at places like Vence and St Paul, and wander about in the early spring of January and February, through valleys where we found primroses and white and yellow narcissi, and exquisite spring flowers of every kind. [...] Paul was fascinated by the landscape and produced a never-ending series of water-colours and paintings; the paintings, for the most part, were not completed until he reached England in 1925, as we had to return in the spring of that year on account of bad news about my mother's health. We managed to go to Genoa and on to Florence, as a kind friend of ours in England sent along a lady who proved one of Paul's most faithful collectors in later years, called Mrs Hilda Felce [...] She had a lovely sense of friendship, generous, happy, unfettered by ceremony, and she did much to help Paul to expand his experience of this new world of the South, with its

exquisite, delicate colour, for there is nothing hot about the Riviera despite its constant sunshine and gaiety. [. . .]

The experience in Italy following this amusing French life was not quite so happy, as the poor Italians had just come under the heel of the Fascist regime, and we suffered for the first time from the experience of a totalitarian state, run by people such as the Italians who only understood how to be either brutally tyrannical or unscrupulously cynical about it. [. . .] We made a careful study of the Galleries, the Churches, and other notable monuments [in Florence], but we were relieved to escape to Sienna for a short time, where the painters of the Primitive Siennese School and the superb architecture of the Cathedral, set in that landscape which is sheer poetry, especially as we saw it in the spring, proved a great relief to us after the tortuous mentality of Florence.

I think that Siena made more impression upon Paul as an artist than anything he had seen in Italy, and the only regret was that we could not go back to live there, which he had hoped to do the following winter. He was not on the whole so fond of Italy, as he naturally felt uneasy in the oppressive political atmosphere which surrounded us and to which he was quite distinctly sensitive, although he never concerned himself to any degree with political opinions and disputes.

We found by April of 1925 that we had to return home to England, and after being nearly shot up at Ventimile Railway Station where there was an appalling row just as we were getting on the train, causing one of the Italian carabineer on guard at the station, to flourish a pistol, fully loaded, in my face, we retired thankfully to the happy, gay atmosphere of the French Riviera and Paris.

5 1925–1928

On reaching London my father met us with the distressing news that my mother had to face a serious operation for cancer. I felt far from well and the shock of my mother's illness did not help me. I hurried down to Hillingdon, near Uxbridge, where my parents lived, and within a few days I was suddenly taken desperately ill. The cause was a serious miscarriage which came on unexpectedly as a result of shock over my mother's condition.

We left Hillingdon after my partial recovery and took up life in our new home, which was 'Iden Cottage', at Iden, near Rye, in Sussex. This lovely little place was rented to us by a great friend, Colonel Bertram Buchanan, and we spent five happy years there from June of 1925 to August of 1930, when we moved to New House Rye, which we bought in order to house my father with us, as he was by then alone, my mother having died in 1928.

The cottage was situated, with a beautiful orchard lying between us and the main road, between Rye and Tenterden. It was served by a well from which we got our water, and beyond the garden was the Iden Pond, with its beautiful trees surrounding it, which Paul has painted on several occasions [...] From our windows in the room where he painted we had a thirteen mile view, stretching over the whole of the country, with its undulating hills in the distance, and woods within sight of our windows. Stretching out in front of our cottage was a great open space of fields, and one or two other small labourers' cottages low down in the landscape. It is not surprising that this proved to be one of Paul's creative periods as an artist, for he was able to work here in complete freedom, since we lived on a very small income, about £4. a week for everything, and with any number of interesting friends to visit us in the neighbourhood.

Edward Burra,[13] who lived in a large, expensive house, 'Springfields', on the high road to Rye, was one of our constant weekly visitors, and [...] Edward Wadsworth drove over from time to time in his white Rolls Royce, and I always felt that he almost envied Paul's free life in our little cottage, dressed in his simple fisherman's kit of brown tunic and brown French linen trousers, with a gay red silk handkerchief round his neck. His studio in those days was always full of work; an important oil painting on the easel, designs for book illustrations on another easel, other odd work waiting to be carried out during the evening when we lit the oil lamp, and I settled down to secretarial duties or read a book to him while he carried out a textile design.

[...] The Autumn of 1929 found us longing to escape from England, and we went for an amusing expedition accompanied by our friend Ruth Clark, who had just recovered from a very serious operation and, of all strange people, Edward Burra, who certainly proved at times an alarming fellow traveller. Previous to our visit to France Paul had carried out his painting *Northern Adventure* [...] The painting is important because it was his first attempt at constructional, almost Surrealist creation, and was a breakaway from the extremely popular landscape designing and painting which he had shown in the 1928 show at the Leicester Galleries. He realised that the popularity of that show was dangerous to him, as it might have induced him to settle down into a delightful but unenterprising way of painting which would have secured him a very large income in a short time. Paul was always aware of the spiritual danger of ease and money, and he quite deliberately turned his back from the moment the exhibition closed on that kind of artistic expression. It is true that later he still painted lovely landscapes of various kinds, some in France and some in England, but he never quite returned to the most representational period of his work which was shown in that exhibition.

Our stay in Paris brought us into contact with many friends who happened to be visiting at the same time, and we also met a number of French artists – Max Ernst, Jean Arp, Albert Gleizes, André Masson, Ossip Zadkin, the sculptor, Picasso, and others whose names I cannot remember now. Paul, for the first time, became really interested in an aspect of Surrealist painting, namely, the release of the dream. [...] Edward Burra wanted to visit Toulon and stay at the hotel which he had visited the previous summer in company with Jean Cocteau and his strange menagerie of

Paul Nash, *Harbour and Room*, 1931, watercolour and pencil on paper,
private collection

friends. Accordingly we found ourselves at the Hotel du Port, which over-looked the harbour of Toulon, and in the distance, on the other side of the harbour, lay the French Fleet. Two paintings resulted from our stay in this Hotel, one, *The Voyages of the Moon*, later shown in 1938 at the Leicester Galleries. It was based on the long high-walled restaurant, with its entire covering of mirrors that reflected, in a strange astronomical manner, the repeated reflection of large white electric globes which were placed along the ceiling and looked like moons receding into the distance. The other painting was called *Harbour and Room*, and is to my mind a very beautiful picture, depicting a French Man o' War sailing into our bedroom; the idea resulting from the reflection of one of the ships in the very large mirror which hung in front of our bed. [...]

It was while we were at Toulon that Paul manifested the first signs of serious bronchial trouble. We had [...] decided to go to Nice, where I hoped the climate would suit him better than the trying mistral which was blowing over Toulon Harbour. [...] The weather was not good, and eventually Paul developed first of all what looked like a second attack of influenza, which later proved to be the beginnings of asthma. I became seriously alarmed when I saw this persistent breathlessness and bronchial wheezing, and hurried him home, as the Riviera at that time of the year, February to March, could be a dangerous place for such an illness. [...]

It was in February of 1929 that the alarming news burst upon us of old Mr Nash's serious illness, and we instantly left the cottage and went to Wood Lane House, Iver Heath, Bucks. There we found poor Audrey, Paul's stepmother, in a distracted state and old Mr Nash in the throes of bronchial pneumonia. We had to stop in the house and take charge, as it was obvious that the poor old man was dying. He [...] was 80 at this time, and although he made a gallant struggle to recover, I fear that nothing could be done [...] Paul and I felt he was happier out of the irksome worry of invalidism, as he had never been seriously ill before and was a man of immense physical energy as well as possessing his full mental fac-ulties and a vivid interest in life. [...]

As I have already explained, there existed between Paul and his father a bond of deep devotion far beyond the usual affection between father and son, and I think nothing so profoundly affected him in the course of all our married life, as his father's death. I much regret that the long exchange of letters which passed between them for years, in which Paul wrote freely, amusingly and seriously upon all sorts of subjects and happenings, giving

his father a sense of never being separated from him in his new life, have unfortunately been destroyed with the breakup of the family home. I would give a great deal to possess them now, as they revealed is a special way, that tenderness in Paul's nature which was so integral a part of his character; that tenderness which, in a man, when it exists, is far more pro-found than in a woman.

My father-in-law's death meant the loss of Wood Lane House, the family home at Iver Heath, and the break with the past life which is so fully described in *Outline*; a life which had begun in the lovely old 18th-century house at Langley where he used to visit his grandfather. It was a life of ease, with comfortable, not to say luxurious surroundings. It had its spacious gardens and solid, simple food, happy service, lovely country pursuits, and all the accompaniment of a gentleman's existence. There never had been any extravagant display or desire for social climbing in the Nash family, as they were assured enough of their position to live their lives happily and independently, helping when needed their neigh-bours and dependents. It is what I would call the 'good life', known only to those who experienced it before 1914, and only partially known to a few after 1918; a life which has now practically disappeared, since the solid middle class and professional men and women who enjoyed it have now been driven out of their independence.

The death of my father-in-law involved Paul in months of worry with legal matters, also with having to face the painful task of inducing his stepmother, Audrey, to leave Wood Lane House, as we were obliged to sell it. [. . .] The division of our inheritance, such as was left of it, between the three children, Paul, John and Barbara, meant that Paul and John received about £3000 of capital each and Barbara enough to enable her to secure an income of £150 a year and build herself a small house is the country.

As Paul so pathetically states in his brief *Outline* under the title 'Searching', we lost three homes in 1930 – our little cottage at Iden, Paul's home at Iver Heath, and finally my father had to leave his home at Hillingdon, as his heart had become so dangerously affected, that he could no longer work at the Infirmary at Uxbridge.

We were immediately faced with the problem of looking after my father, who by now had developed the early stages of angina and so could not be left to live alone. After Paul had settled the family estate, we decided, with my father's help, to buy a house in Rye and bring him down to live with us. This saw the end of our peace in the country and was the beginning

Unknown photographer, *Paul Nash*, c.1930–32, photograph,
National Portrait Gallery, London

of a long strain, both financially and psychologically. We had to take a sufficiently large house to accommodate two separate flats, my father preferring to have his own rooms where he could be quiet and yet be able to come down and be with us when he felt well enough to do so; he came to us an invalid, and a daily anxiety to me.

We finally selected a strange looking place called New House, Rye; a very tall house of three floors, with [. . .] a magnificent view from the back windows over the Romney Marsh towards the flashing lights of Cape Gris Nez on the French coast. [. . .] We spent our first Christmas at New House, Rye, at the end of 1930, with our friends Conrad and Clarissa Aiken. Conrad Aiken,[14] who had a considerable reputation as a poet and novelist in America and in this country, owned a lovely old house in Mermaid Street, named 'Jeake's House'. [. . .] At this time Conrad formed a very close and delightful friendship with Paul, in which they mutually helped one another in their aesthetic expression, and Paul found in him one of the most sympathetic minds he had hitherto encountered. Conrad revived Paul's natural love of poetry and helped to bring out in Paul's work a surer form of poetic expression; an expression which was strictly visual and not literary, but which had behind it this very strong poetic vision. I have always been grateful to Conrad for releasing in Paul what up to that time had perhaps been held back since the war of 1914/18. He helped to bring Paul back to his real world, the world of poetic vision expressed through the dream, often the fantasy; a world which existed alongside of his natural simple reaction to straightforward landscape, painting.

We made many new friends in Rye. Amongst the most remarkable was perhaps Una, Lady Troubridge,[15] whom Paul had known far back in his young days, as she was the daughter of Mrs Harry Taylor, who gave him his first important introduction to Sir William Richmond. [. . .] She acquired some of Paul's most important paintings during the years 1931 to 1938, such as *Winter Sea*, *Token*, and a very exquisite flower painting called *Dahlias*, besides a certain number of water colours. Her solid financial backing was a great help to us during this time, as my father's illness was becoming progressively more serious and involved us in heavy extra expenses. Those liabilities were met by undertaking commercial work such as designing for posters, textiles, etc.

Paul now made experiments in abstraction, of which the most notable painting is *Kinetic Feature*, in my possession, and began his series of art criticisms in the *Weekend Review*, which eventually brought him to blows

with Jacob Epstein, over a criticism of one of his exhibitions of sculpture, in which he described Epstein's attitude to painting as that of a good sportsman whose batsmanship was heralded with cheers by the onlookers. This article produced a violent reaction in Epstein, since it obviously had a nasty element of truth, and he never ceased after its publication to attack Paul, even carrying his resentment on to a vicious attack on him in his Autobiography, written at a later date. I must say that Paul took the whole business light-heartedly, as he had become hardened by now to vicious reactions on the part of certain of his contemporaries, either from motives of jealousy or from understandable fury when he used his pen too wittily and perhaps too truthfully.

All these activities during the year 1931 were very stimulating to him as an artist, and in spite of our difficult problem owing to my father's state of invalidism, Paul was able to work in his lovely studio of which a painting has been reproduced in *Outline*,[16] with much more freedom and far less interruption than had hitherto been his lot.

7 1930–1933

The first breakup of this peaceful life was occasioned by an invitation from the authorities in charge of the Carnegie Exhibition in Pittsburgh, who invited him to visit the United States in the role of British Representative on the International Jury of the Carnegie Exhibition. [...] We arrived in New York in September, during a heat-wave that broke that morning with a terrific thunderstorm [...] Passing through the Customs was a mere form, as we were distinguished guests of this strange crazy country, and we were hustled into high-powered cars, on the roof of which thundered the rain-drops. We reached the Biltmore Hotel which was to be our home for a few days, and were immediately shot into a lift, or, as they call them, elevators, which elevated us to the 44th floor, and then threw us out into Mr Homer Saint-Gaudens'[17] room, accompanied by a large Gladstone bag whose ominous clinking revealed eventually six bottles of whisky, five of gin, and a few other strange American drinks. It was prohibition time, and so for ever after we were accompanied wherever we visited in the town, whether the restaurants or private clubs, by this strange Gladstone bag, which the chauffeur always lifted in and out, accompanied by facetious remarks and a broad grin. In fact, Americans of that particular period who were indeed most hospitable to us and perfectly charming in their entertainment, were mainly concerned with seeing that we had enough to drink on all occasions, in season and out of season. [...]

Our first drive in New York [...] revealed to my consternation, a great city laid out in mathematical crosslines of streets running from north to south in parallel lines, being crossed at regular chessboard intervals by streets running from east to west. How I longed for just one curved line in the whole damned business [...] The impression was horrible to both Paul

and myself, of these soaring rectangular buildings with their regular lines and windows, also soaring one above the other, and the entire absence of any flowers, any curves, or any colour except black, white and grey. [...]

After rather an alarming catechism from the New York press, the overwhelming American entertainment began, and we were fêted morning, noon and night, for a week, until the Jurors had to leave for Pittsburgh where their real work began of choosing the 1930/31 International Carnegie Exhibition. We met an endless procession of distinguished and, in many cases, delightful American notables, and Paul penetrated to the sacred precincts of the Century Club, where he was invited to a lunch party, at which were present the most distinguished American artists and writers and newspaper men. He was invited to take a guest along to the luncheon and having just picked up in one of the book shops James Thurber's new book *Is Sex Necessary?*, which vastly amused him, he selected him as his guest. Thurber was then writing and drawing for the New Yorker, and his cartoons, with their brilliant, alive line and witty commentary, delighted Paul. He found in him a real, original, creative artist, who gave him far more pleasure than the acknowledged portrait and landscape painters of the American school, with their sham Matisse-cum-Picasso-cum-Max Ernst echoes. In fact it was very difficult at that date to discover an original American artist, for although they painted with the greatest of skill and devoted many hours a day to producing pictures, one began to feel after a time it would have been so much better if they had devoted all their energies to developing something else.

If the American artists disappointed Paul, their writers and poets enchanted him, and certainly Thurber was one of their most witty, as well as one of their most able writers. He had already learnt to appreciate their splendid literature with the help of Conrad Aiken, and this prepared him to find good painting in America, but I am afraid that in that matter he was sadly disappointed. Thurber at that date was regarded by the Century Club highlights as just an amusing rattle, only worthy of the pages of the *New Yorker*, with which they refreshed themselves in an off moment, but it immediately struck Paul that he was really an important artist, both as a writer and as a draftsman, and Thurber never forgot that instant recognition of his genius. I may add that it did not improve Paul's relationships with the professional artists in America that he should have emphasized the importance of people like James Thurber and the strip writers Milt Gross and Otto Soglow, and this perverse importance which he seemed

Helen Muspratt, *Paul Nash, studio portrait, 1932*, photograph,
National Portrait Gallery, London

to attach to the work of these men and the fact that he wrote an article on their work, I fear instantly antagonized the regular professional artists personally against him, and possibly against his work. With their usual American suspicion they thought the whole thing was a leg-pull, and I do know that the officials of the Museum of Modern Art were so far shocked by his attitude as to have refused ever to purchase a picture of his for that collection. I am afraid it was an instance of single-hearted honesty not tempered by diplomatic handling of the situation, which made Paul's visit to America very unprofitable to him both commercially and socially.

After a week of intensive visiting in New York the Jurors left for Pittsburgh [. . .] I regret to say I have not got a very clear impression of what happened to Paul during the few days that he was in Pittsburgh beyond a half-remembered description of acrimonious arguments which went on between the European Jurors and the American representatives when it came to the selection of pictures for the various large money prizes which were always given to the winning artists according to Mr Carnegie's bequest. I think that the European Jurors were frankly horrified to find that the American artists had no sense of chivalry towards the works of European painters and quite determinedly kept all money prizes for their own countrymen. [. . .]

Paul made every effort to study aspects of American art, as he was anxious to arrange for an exhibition in this country which would show the history of American art from its first beginnings up to 1931. He was very delighted by some of the paintings of the eighteenth and early nineteenth century American artists, but he was rather taken aback at the obvious lack of independent personality in the later skilful painting of his contemporaries. I do know that he was most anxious to find good work in America, but he was not at all impressed by the majority of it after he had carefully examined it. This may have accounted for why he did not pursue this matter of bringing over an exhibition to London. After a surfeit of visits to great collections, of which Mr Mellon's was the most important, he returned to New York, exhausted by the turmoil of new impressions. [. . .]

Paul insisted on seeing Harlem, and we had a wonderful evening, in which we visited the principal night life, ending up with the Club where Duke Ellington's band performed its nostalgic music. I think it was a painful sight to me, to feel that the negroes were subjected to an insolent treatment, as the white Americans seemed to me quite prepared to enjoy the entertainment offered to them in the negro dance clubs, but were

certainly not prepared to treat them with civility. This made me feel there
was hidden underneath an antagonism between the two races which I,
who had lived in my childhood in an oriental country, could only deplore.
I am quite aware of the fact that there is a considerable difference between
relationships with the Arabs and with the negroes, but I cannot ever accept
the attitude of contempt and dislike for a people who were dignified, cour-
teous and obviously unhappy in this atmosphere of antagonism. [. . .]

At last our third class passage on the returning cabin boat faced us,
and we were seen off by our American friends, overwhelmed with pre-
sents of exotic flowers and enormous boxes of chocolates and preserved
fruits, which sat somewhat oddly on our humble berths [. . .] And so
we arrived in England, and our first impression of London was that
the buildings had shrunk and looked like cottages after the towering
monsters of New York. But the air was balmy and the light was delicate
and diffused; the grass looked so beautifully green in the parks, and the
trees and flowers welcomed us in Kensington Gardens. I must confess,
for the first time I realized why Americans preferred England to their
own country.

The return to New House, Rye, which was our home until 1933, meant a
fresh start for Paul in his career, so pleasantly interrupted by the American
visit. He now had to set himself to the arduous task of making a larger
income, since what had sufficed us in our little Iden cottage, in no way
met the heavy expenditure of the big house in Rye and the more elaborate
social life in which we were now involved. It is true that my father was able
to pay for his flat in the house, but the general scale of life rose sharply, and
we could no longer live our simple country way, with its homely pleasures
and kindly people around us. So Paul first of all turned his attention to
writing, which had always interested him, and in which he found he could
express himself through a new medium. First of all he exercised it in jour-
nalism and became art critic to *The Listener* alternately with Herbert Read.
This meant a fortnightly visit to London, which kept him in touch with
the commercial work he was obliged to seek now in order to earn an extra
income. He had always been interested is the problem of the pictorial side
of advertising, and he met in Jack Beddington, who was then Director of
Advertising at Shell-Mex, a most sympathetic and original collaborator.
Beddington later secured him as author of the *Dorset Shell-Mex Guide*,
which proved a great success, and he now gave him posters to do for direct
advertising purposes. Paul also wrote and published *Room and Book*, which

consisted of essays on decoration he had collected and put together with further material, and this little contribution to the problem of interior decoration was launched by an exhibition at Zwemmer's which was quite successful.

Now there came the most marvelous relief from this intensive commercial work, as he was invited by Desmond Flower, of Messrs Cassells, the great publishing firm, to submit a special book of his own choice, which he was to illustrate. He chose Sir Thomas Brown's *Urne Buriall* and *The Garden of Cyrus*, and with the scholarly introduction by John Carter, it became an extremely important special edition, for which Paul carried out 32 of his most important and imaginative designs. The book was printed with the help of Oliver Simon and his expert staff at the Curwen Press, and Paul's elaborate drawings were reproduced in collotype and coloured by hand in the press, following a key hand-coloured design which he executed himself. The decoration on the cover was also drawn by him, and the whole book was a joy to him while he worked on it and helped to liberate his imagination and encourage the highly poetic vision which permeated his early work and a great deal of his subsequent paintings. He speaks of it in his notes as a period of research and contemplation, and he obviously felt that the slow unfolding of this series of designs was a very important turning point in his career as an artist. [...]

It was during this time, 1932, that Paul embarked on his only attempt at forming an Art Club. He had always exhibited with the various modern Art Clubs such as The New English, the London Group, the Friday Club, the London Artists Association, to mention a few, but his instinct was to keep himself free from adopting any particular aesthetic dogma, such as Cubism, Vorticism, so-called Abstraction, or rather Constructivism, and Surrealism. His own development as an artist had a constant experimental element in it, although he was always quite aware at the back of his mind, in which direction he would ultimately go. The very first exhibition in the Carfax [Gallery in 1912], with their immature, delicately linear, and highly poetic presentation, became ultimately, in his last years, from 1936–1946, his final vision, intensified in the full maturity of his experience as an artist. His paintings and water colours in the last years lost the wiry linear technique, but presented the same vigorous basic design allied to the persistent poetic vision which really never left him throughout his life. His final paintings such as *The Eclipse of the Sunflower* and the *Solstice of the Sunflower*, have, of course,

an added mystical meaning which gradually become more apparent in his work from 1933 onwards.

Unit One consisted of a group of artists including Ben Nicholson, Henry Moore, Edward Burra, Colin Lucas, the architect, Welles Coates, and Paul, all of whom had completely divergent methods in expressing their ideas and technique, but were bound together in this group by the imaginative approach to the aesthetic problem, whether it concerned painting, designing or architecture. This bond of the imaginative approach was sufficient to keep these very individual personalities from clashing, and it was also Paul's quieting and tolerant influence which kept the various members of the group in harmonious collaboration and good fellowship. He had indeed a genius for friendship, and tolerance, the basis of true friendship, and so long as a human being was sincere and single-minded in his method of expressing himself, whether as an artist, a musician or a writer, Paul was prepared to accept his point of view and to study it, even if he did not understand it or wholly agree with it. I think this is an attitude which is unusual in an artist. I feel that Paul was exceptional in rising above the temptation to personal jealousy and violent prejudices, for he held there are many ways leading to Truth, and truth was his ultimate goal. He had passionate and persistent love for Truth, believing that only sincerity and single-mindedness could bring enquirers to their goal. It was unfortunate that Unit One only held one exhibition, which proved both interesting and successful, but it produced one book in which the various artists expressed, in excellent literary style – since artists frequently write with a natural directness and simplicity – their individual points of view concerning their aesthetic belief. This slim volume was edited by Herbert Read, who was an enthusiastic supporter of the group.

Unfortunately for the experiment a private tragedy entered into our lives which diverted Paul's attention, as he had to support me and help me over the final distressing illness which attacked my poor father. Life at Rye became a terrible strain, as my father developed the worst form of angina and mercifully his agony, both mental and physical, continued for only a short while, ending in his death in August of 1932.

We now found ourselves for the first time in many years with a small private income, as I was my father's only child and I inherited everything that belonged to him. It looked as if we were to have some rest after the long strain of two years and a half at the New House, Rye, during which my father's health had rapidly deteriorated and our finances had been strained to the utmost by the extra burden of a large house which we had

to undertake in order to bring him to live with us. [...]

We were able, after the many troublesome legal affairs had been completed, to look forward to a period of rest and travel, and the publication at this moment of *Urne Buriall* and *The Garden of Cyrus* by Messrs Cassells, brought Paul a great deal of prestige which consoled him. It was an exceptionally beautiful publication, printed and produced by the Curwen Press, with all the scholarship and impeccable taste that Oliver Simon, as Printer and Director of that Press, brought to bear upon a book in which he delighted and in which he wholeheartedly co-operated with Paul.

The paintings and drawings of this particular year are not very numerous, as owing to the interruption of my father's illness in the early part of the year, Paul had found it difficult to work, and after his death he felt able to retire within himself and rest and contemplate, seeking a new path, which seemed to unfold before him, for fresh experiment and research.

We paid a visit to York in November and visited Anthony Bertram,[18] and enjoyed the society of the delightful friends to whom he and his wife introduced us. Unfortunately it was at the end of that visit that Paul must have caught a severe chill, and when we got back to London at the beginning of December, he was suffering from an abnormally severe attack of influenza. This particular attack manifested alarming symptoms of a severe bronchial nature, and although he managed to shake it off by the New Year, so that we were able to attend a New Year's party given by Charles Laughton[19] at the Café Royal, I became afraid of his obviously tired physical and mental condition. It was as if the strain of the last six months of 1932 had proved too much for him, and so I hurried him back to our lovely house in Rye, hoping that rest and good air would soon restore him.

Our return to Rye proved at first successful, for I also was suffering the after-effects of the year's strain, but about February we had to encounter the noted east wind which can devastate that part of the Romney Marsh and the coast, and Paul suddenly became ill after one of our expeditions across the Marsh [...] and took to his bed with a terrifying attack of asthma. The local doctor was unable to cope with it; the attack became worse. I frankly confess I had hardly any physical vitality left to cope with the nursing, and the doctor, who was not one of the reassuring type, although quite competent, told me brutally, that he would never get over it unless he immediately left England, and especially left Rye.

I began to realise, and I am afraid so did Paul, although I tried to save him from the knowledge, that something had happened to us which was

to ultimately defeat all our plans for the good life. The good life meant to us peace of mind, some money secured to us without having to earn it, more time for Paul to reflect and develop his ideas in painting and, above all, a wider opportunity for travel, and finding in other countries a new way of life. It was perhaps a selfish point of view, but we had longed for it from the first moment when we had become engaged in 1913, and so far we had been defeated at every turn; first by war, then by poverty, and finally by family cares. I do not mean that the years before this illness had been unhappy years, but they had been full of strain, anxiety, and frustration for Paul in his life and in his worldly success. The one thing these trials had done for us, was to develop a keen sense of enjoyment in anything that life had to offer to us that was gay and free, however simple might be the enjoyment. So that I think we both thought at this time it was a cruel turn of fate to deny us, in middle life, the legitimate fruits of our struggles and of our attempts to bear the trials which had come upon us patiently and with fortitude. It was obviously my duty immediately to encourage him in every possible way, and so I took him from the pessimistic local doctor and placed him in the care of Dr Cameron, at that time a well-known London specialist, who [. . .] had a clinic at Tunbridge Wells. I remember the eager hope with which Paul jumped at this opportunity to recover from the appalling strangulation of his particular disease. [. . .]

I determined, backed by Dr Cameron's opinion, as well as by the local GP's brutally expressed advice, that we ought to leave the neighbourhood, which obviously was climatically harmful to him. Also the house was by now far too big for us, and I did not feel able to undertake the strain of letting part of it to strangers, with all the complications and jarring personalities at close proximity to ourselves. Regretfully we put the house up for sale. [. . .] Just about this time Paul also became worried owing to the breakdown of relationships amongst the various artists of Unit One, who, without his soothing influence and, on occasion, good hard-headed reasoning, found they could no longer work together in harmony. It became obvious that the group would have to dissolve into its separate elements in the near future; but he was far too exhausted from his recent experience at the clinic to take any further part in the cross-currents of these artistic politics. So a great friend of ours, Ruth Clark, arranged to have a special holiday from her work and take him away to stay at Marlborough while I packed up the house in the remaining three or four weeks at my disposal. This was a tremendous relief to my mind, as Ruth [. . .] was the

only person I could trust who would really take care of him and see that he did not over-exert himself or expose himself to any unwise climatic conditions.

It is this visit to Marlborough which delighted him, for it was the most enchanting holiday, and in the course of it he discovered Avebury and Colonel Keiller,[20] who lived in the neighbourhood, in a lovely manor house where he had an extensive collection of early archaeological finds. Paul found in Colonel Keiller's enthusiasm for the Avebury remains a new stimulus to his fantasy and love of the archaic, and the sight of the great Monolith induced him to take his first important photographs of the stones and later of Stonehenge. These were not really his first photographs, since he had taken a few on board the cabin boat on which we returned from the United States in the previous October. They were interesting studies on board ship, and some of them formed the basis for certain important water colours, such as the one entitled *Atlantic,* to name the most beautiful of them. He had also the great pleasure of meeting Robert Byron,[21] with whom he made great friends, and this brought him into touch with the amazing Savernake Forest, where the Byrons had their home, and gave him the wonderful design for the oil entitled *Savernake.* Mrs Felce, his patron and good friend, invited him over to see Whitecliffe, in the Purbeck Isle, where she had a superb little Tudor manor house which overlooked the Swanage Bay, with the majestic Ballard Down rising behind it. This was Paul's first glimpse of Dorset and of the magnificent coast which stretches from Swanage right round to Lyme Regis, with its haunted headlands and its Kimmeridge clay rocks and its uncanny petrified forest near Lulworth, ending with the superb Chesil Bank leading to Portland. It was later to be our home, and he realised for the first time while staying with Mrs Felce, that here lay one of the most important sources of inspiration for him in his new development as artist. He brought back many photographs from this holiday, as he now often felt unable to stand and make his notes and rapid sketches which had always been his custom when he visited new scenery. He describes this was his new eye, and indeed the photographs which were henceforth taken over a period of ten years, form a very important part of his aesthetic research. [. . .] He gradually cominated [sic] the camera, so that his photographs, although taken in the most simple and direct manner, with the most unpretentious camera, Kodak No. 2, generally an instantaneous exposure, begin after a time to take on the appearance of his drawings, and lose any suggestion of

Paul Nash, *Avebury Sentinel*, 1933, photograph, private collection

a mechanical agency. For this reason they were greatly valued by Francis Bruguière[22] and Man Ray and André Breton when he showed them at the International Surrealist Exhibition in 1936.

I, in the meantime, struggled desperately with the packing up of New House, Rye, and in [...] three weeks the house was empty, and we left Rye for ever, and also our lovely Romney Marsh and our good life in the country, with its simple, honest friendships, and its happy country pursuits. We never lived in the country again, except for brief visits, such as our stay at Whitecliffe, on the Ballard Down, in 1934–1935, and short visits that we were able to pay to friends when they invited us to stay with them.

We now started out, in November of 1933, full of hope, since Paul was decidedly very much better than he had been at the beginning of the year, for a prolonged stay in the South of Spain – Malaga – which had been suggested to me by Dr Cameron as a suitable place for a good winter climate. We arrived in Paris at the start of the trouble which developed later into the Stavisky Riots. It was very exciting to feel that we had become wanderers with enough money behind us to prevent us worrying about ways and means, and the whole of the world open before us for adventure and travel. We were both tremendously exhilarated by this turn of events, and our hopes bounded high as we bought our Kilometric tickets for Spain; tickets which would take us everywhere so long as we had the health and strength to travel in the strange Spanish trains. [...]

Paris had a turbulent, unhappy atmosphere at that moment, and I saw the ugly head of German intrigue appearing on the horizon. [...] Then, to our horror, a sudden cold weather blast descended on Paris, with sleet and snow, and I rushed Paul into the Gard [sic] de Lyons and into a train for the South, as he began to cough and wheeze ominously in this blighting weather threat. We reached Avignon still pursued by the worst winter that France had experienced for many years, and it became obvious to me that he was far too ill to continue his journey beyond that point [...] We set-tled ourselves in the most expensive hotel in the town, the Hotel Crillon, and since the weather which followed us from Paris became worse and worse, so that the central fountains of a neighbouring Square were frozen stiff, an unheard of event so far south as Avignon, we were interned in the Crillon, paying the earth, for a hotel life, which, though delightful, was

far beyond our means. Paul immediately developed very alarming new symptoms and it was obvious that he was on the verge of a bronchial, if not a pneumonia attack. I kept him indoors for three weeks, and to my great relief we found, living in the hotel, a most delightful young married couple, bearing the aristocratic name of Bonaparte-Wyse. [. . .]

We were able at the end of the three weeks, to explore the lovely environments of Avignon [. . .] But Paul again showed alarming symptoms of the return of both the bronchitis and asthma, and as the weather had now become quite mild, I packed up our things, got him into the train, and took him straight to Nice, where I knew I should be able to get expert medical attention. [. . .]

We eventually discovered our ideal abode in the Hotel des princes, where the sympathetic co-operation of the proprietress enabled as to find a lovely large room with tall double windows opening on to a small iron balcony that hung over the sparkling blue waters of the Baie des Anges; blue waters which never seemed to lose their colour, since the sun shone perpetually upon them, and at last the bad winter had ceased to torment us. [. . .] We began to make a few friends, and one of our most delightful experiences was a visit to M. Henri Matisse's studio where he implored Paul to procure a strange rowing gadget which he placed in front of him on the floor and then excitedly showed him how the fixed oars were worked, in order to expand your chest and improve your breathing. As M. Matisse was descended from men who had always had to do with the sea and with boats, he himself possessed the robust physique which enabled him to practice this artificial rowing with great profit to his general health. It was obvious that Paul would suffer considerably if he tried this strange exercise, and as poor M. Matisse was disappointed to find that his demonstration was to no purpose. He did, however, introduce us to the most amazing special French restaurant in the Marché des Fleurs, called 'Victor', where he invariably had his dèjeuner. He described how he would eat dèjeuner there like a lion, but that was his only meal in the day, and he strongly recommended Paul to follow his example. [. . .]

We made numbers of expeditions by car, and when Paul got stronger, by autobus, up to Éze, where we found Augustus John dispensing liberal hospitality to all and sundry, while his beautiful wife watched the scene sitting framed in the window, as if she was posing for one of her husband's famous paintings of her. We got to the snow line at Piérra Cavé, but Paul did not very much care for that show landscape, which he felt lacked variety and

form. Curiously enough snow never attracted him as a painter, since it did
not present him with sufficient basic design or subtlety of colour; but then
of course he never saw the region of the great Alps. We spent one lovely
day with Mat Smith[23] at Cagnes, and he drove us somewhat hazardously,
since Mat's eyesight was not too good, up to St-Paul-de-Vence, and then
on to Vence. [. . .]

Paul at this time began his new series of the Megalith paintings, starting
with the well-known water colour *Landscape of the Megaliths*, which was
afterwards used for a school lithograph published by School Prints. He
also carried out some of his Riviera landscape, but he was really far more
absorbed in this new pursuit of the early pre-historic monuments which
had started to excite him when he visited Avebury in the previous year.
There was one amusing incident which suddenly comes to my memory,
when a certain American lady visitor hearing that a famous British artist
was living in Nice, came over to see him from Monte Carlo, and was
shown to her utter astonishment not the nostalgic Riviera landscapes she
had hoped to buy, but very austere studies of the megalith period. I could
see that she was completely baffled by Paul's art, and eventually she came
out with a naive question – 'Well Mr Nash, I am deeply obliged to you for
your courtesy in showing me your paintings, but why do you paint?' Paul,
for the only time in his life that I can remember, was so taken aback by
this direct question, that he lamely answered, 'I am afraid I cannot explain
why I paint.' There the question and answer ceased, and the poor lady went
away somewhat like one of Edward Lear's delightful birds, with this great
problem unsolved. [. . .]

Paul was so much better that we decided we would try and use the
Kilometric tickets we had bought so hopefully in Paris, in order to
reach the south of Spain. We now decided we would approach Spain via
Gibraltar, as the sea journey appeared to us less strenuous than the com-
plicated railway travelling which meant taking the train along the whole
length of the Riviera and again approaching Barcelona via Avignon and
Tarascon. So we regretfully packed up our belongings and said goodbye
to our beloved Nice and the many charming friends we had made there,
and journeyed to Marseilles, where we arranged to board the steamer for
Gibraltar.

Marseilles proved an exciting experience, and we visited a great deal
of the country around, which we had been unable to see up to now, and
after a week went on board full of hope for our expedition into Spain. But

alas, as we approached Gibraltar the treacherous rain came upon us again, although it was nearly the end of March, and we found ourselves once more in an hotel in Gibraltar, with Paul miserably coughing and sitting up with bad asthma throughout the night. [. . .] In the years to come we were resigned to these setbacks and gradually accepted the discipline that bad health had placed upon Paul, a discipline to which he bowed with courage and patience; I might say with infinite, unbelievable patience, far greater than any I could muster in the face of these bitter disappointments. It was this magnificent acceptance of his fate, without murmur and without fuss, which I believe brought him the regard, in his later life, of accomplishing his best work as a painter, since that is the opinion of most people who have seen the range of his work since his death.

Paul was determined to try and see something of Spain, as he felt that I, as well as himself, was badly disappointed in not visiting the country, even though we could not travel all over Spain as we had originally planned. He now began to more consistently photograph things which interested him, starting in Gibraltar where the massive Rock, with its strange chambers high up, forming the galleries through which the guns that defend Gibraltar are fired, and going on to photograph odd objects, like a stretched sheepskin on the side of a wharf, with a photo-montage imposed on the photograph, of a delicate little sapling, which I have entitled *Spanish Dream*. We went over to Algeciras where we stayed in the delightful and comfortable Hotel Londres, and here Paul was utterly fascinated by the wild, savage beauty of the people in the streets, and the exquisite simple lines of the half Moorish-Spanish buildings. He wandered about the streets, and although the asthma was still very troublesome, since at this time he had no help such as I found for him later in a very effective inhalant – the discovery of an Austrian doctor – which immediately held up the attack so that he could walk about, he was able at this time, with care, to wander about and for the first time feast his eyes on Spain.

Presently we decided to visit Ronda, and there [. . .] we found the ancient capital of the Moorish Kingdom in Spain, nestling on the edge of a rocky eminence, surrounded by wild astonishing mountains, with great gorges that fell away from the town to an incredible depth. The Ronda Bridge, which connects one section of the town to the other, since the rock on which it is built has a great chasm going down to the edge of the Toja River, was like an unreal dream in it a remoteness from the normal world of our experience. Paul managed, with a struggle, to descend and

ascend the 365 steps that led down to the river, and when you reach the bottom of the steps you see in front of you a boiling, surging volume of water, rushing over great rocks towards the mountains. Anyone who looks at his photograph of the 18th-century Bull Ring will realise how he must have enjoyed the simple lines, with their instinctive good design of those Spanish builders. The stay in Ronda had to be short, as our money was getting very low, but we just saved enough to be able to take the boat from Gibralter over to Ceuta, the African port in Spanish Morocco, and from there we went by autobus to Tetuan, the present Moorish capital of Spanish Morocco.

Here Paul felt very well, as we were greeted in that lovely April by a glowing sun and a light, refreshing breeze which came from the Atlas Mountains, still snow covered, and towering above the town and the harbour. He found instant inspiration for a series of drawings and photographs, and it was then that we spoke of the plan which gradually matured in our minds, of returning to spend a winter in Marakeesh.

Paul had been told by Lord Sandwich, who collected his work and was very distressed when he first started this trouble with asthma, that if he could live on the edge of the desert, and he actually named Marakeesh, it would probably entirely cure him. It is true that at that time the air of North Africa benefited him enormously, and I never will cease to regret that the circumstances of the next five years, ending with the outbreak of war, prevented us from returning to North Africa. But he had already realised, after speaking to one of the French specialists whom he had seen in Paris on his way South in '33, that there was something far more serious the matter with him, of which asthma was only a symptom, developing as a result of the gradual deterioration of the tissue of the bronchial tubes. In this doctor's opinion, and in the opinion later of Lord Horder, this condition probably arose from contact with gas in 1917, when he was doing his drawings in the Ypres Salient for the Ministry of Information. The French specialist was very emphatic on this point because, after he had made a careful examination, he told me that he found in Paul exactly the same condition of the bronchial tubes, only as the gas had been very much milder it had taken longer to develop, as he found in acute cases of gas poisoning in men who had been exposed to the full attack before respirators were served out to them. I repeat this fact because it was evident to any doctor who examined Paul, that he was in no sense a neurotic asthma case, and Lord Horder, when I put that question to him replied, 'I would

Paul Nash, *Margaret Nash at a café in the south of France*, 1936, photograph,
Tate, London

be thankful if I had his steady nerve and his beautifully balanced mind.'

We at last had to leave our lovely Tetuan and return to Gibraltar, as we had booked a passage on one of the Dutch Liners homeward bound from the Dutch East Indies [...] On arriving in London it looked as if our trip abroad had done him very little good. A sense of despair began to overcome him, as he felt that at any moment the attacks to which he was becoming subject might prevent him working. It was just at this juncture that I, mercifully, with the help of Dick Sheppard,[24] who himself had recently discovered a German inhalant through one of his specialists, was given the address of the firm which was importing it to London. This meant that I was able to find a weapon which helped Paul to ward off crippling and prolonged attacks, and the use of this inhalant freed him to the end of his life sufficiently to enable him to work.

The weather of June 1934 was arctic and I was anxious to get Paul out of London where the dust and the petrol fumes irritated the asthmatic condition, and the shut-in streets, combined, with the tiny space in our little flat, oppressed him after our big room at the hotel in Nice with the sparkling Mediterranean and the bright skies, So a friend of ours, Colonel Dick Rendel, invited us down to stay at Owley in the Romney Marsh. [...] There we found another friend, Mary Eversley, [...] and she made it her business to secure us a cottage at Potter's Heath, near to Ellen Terry's old home.

We moved into the cottage in July, but alas, it proved very claustrophobic [...] Also the climate of Small Hythe and its depressing proximity to the river, was fatal to asthma. Paul did find one curious inspiration in the flat countryside, as it was here that he discovered *Marsh Personage*. We were walking along the riverbank one hot July afternoon and there lay *Marsh Personage*, his most thrilling *objet trouvé*: it consisted of a strange decayed trunk and a curved wooden bark which lay nearby, and it gave him a fascinating assembled object, which now stands on my mantelpiece, and has all the qualities of an ancient Chinese wood carving. [...]

Our return to London towards the end of August found Paul met with a request to become the President of The Society of Industrial Artists. It was obvious that he could not stay in London for the winter, as the November fog was certainly dangerous to him, and we made our escape to the seaside to secure a better climate. We had some very useful interviews with Mr Francis Riddell, who had brought over his new palliative The Riddell Inhalant, to London, and who had a specialized knowledge of

its application in the asthma clinic up in the mountains outside Munich. With his sympathetic advice as to how to apply this new relief, Paul gradually evolved a good technique for warding off prolonged attacks, and the psychological assurance that he could ward off attacks helped enormously.

Now our charming friend, Mrs Felce, the lady whom we had met in 1925 when we were staying at Cros de Cagnes, who had by now become his most constant patron, offered us her lovely little manor house 'Whitecliffe', which was situated on the side of the Ballard Down, facing Swanage Bay. She suggested that we should occupy it during the winter from October, while she was abroad on the Riviera, and that we should stay there until her return in February. Naturally we thankfully accepted her invitation and found ourselves established in this paradise of luxury, with two assiduous maids whom she had left behind to look after us, and the most glorious view of the Swanage Bay and the Isle of Wight in the distance, constantly before our eyes. 'Whitecliffe' was a Tudor manor house, built on the site of an ancient Roman Villa, and alongside the well-stocked vegetable garden was to be found the remains of a Roman wall, ending in a beautiful little stone summerhouse, built up on pillars so that it commanded a fall view of the bay. The sun poured into the house, and the winter of 1934/35 was sunny and very mild, so balmy that in that beautiful Dorset country primroses appeared in the garden, together with roses in the month of January.

We very soon made delightful friends in the neighbourhood, the most important and lasting one was Archibald Russell, Lancaster Herald,[25] who lived at Scarbank, in a house he had built for himself on the cliff overlooking the Swanage Bay. Friendship with him meant Paul meeting an enthusiastic art collector whose treasures included some of the finest early Italian drawings I have ever seen, and whose knowledge of Blake was unsurpassed. His home was always open to us whenever we chose to visit there, and Paul quickly enlisted the sympathy of his wife, Janet, in an amusing project which was made to him by Jack Beddington, of Shell-Mex. This was to compile an illustrated Guide Book to Dorset which was to contain a large number of photographs taken by himself of outstanding archaeological and architectural features in the county, as well as reproductions of a few of his personal drawings of places like Bradbury Ring. Janet was delighted to drive us all over the county in their car, and as she had already been well trained by Archie in long distance driving, since he was an enthusiastic collector of rare English moths which are found almost exclusively in certain parts of Dorset, she was not only a

delightful companion but an extremely long-suffering and expert driver. This enabled Paul to make wonderful and extensive studies of Dorset, and he collected a large number of photographs with his beloved Kodak No.2, and also produced an astonishing number of drawings and water colours. Gradually he recovered his vitality and the work poured out in every kind of experiment, especially in the direction of Surrealism, which at this time had begun to stimulate his imagination. His exhibitions of these paintings at the Redfern were highly successful, and our financial position was considerably eased, so that when Mrs Felce returned to her house in February, we could afford to stay at No. 2, The Parade, on the Swanage Front. [...]

Paul at this time began to write more imaginatively than he had hitherto done. He began with a short series of imaginative essays, some of which appeared in *The Architectural Review*, who were his firm supporters. These included *Unseen Landscape, Swanage or Seaside Surrealism, The Giant's Stride,* and there were other articles, some of which I have lost sight of. He also conceived his first idea of writing his autobiography, now known as *Outline*, but then called *Genius Loci*.

We were supremely happy at Swanage [...] The only cloud on our horizon was the tragic death of T.E. Lawrence, just at the moment when we were invited to go over and see him at his cottage at Clouds Hill. It was particularly painful to me to lose him, as I had been friends with him in his early Oxford days when he came up to the University and came to my father for instruction in colloquial Arabic. [...] We attended his simple funeral in the churchyard. The little country church was filled with the most distinguished men and women in England, and I could hardly believe that Lawrence was dead, so powerful was the atmosphere of his personality.

Shortly after this we had to come to London, and unfortunately we encountered the first of the pea-soup fogs while we were staying in town for a few days just before Christmas. I shall never forget the appalling soot-ridden atmosphere which we met at Waterloo, and within twenty-four hours, starting on Christmas Eve and continuing throughout Christmas Day, Paul for the first time terrified me by the ferocity of the asthma attack which seized upon him. I was quite helpless, as no doctor was available owing to the Christmas Festival, and after sitting up with him the whole of Christmas night, I managed to get an oxygen tube from the chemist, who opened especially to let me have it, and eventually found a doctor in the district who came and gave him an injection of morphia. The doctor

declared the climate of the Purbeck Isle was disastrous for this particular complaint, and certainly the second winter we had there was not so good, as we were hemmed in by sea fog and incessant rain, quite a different experience from our first lovely sunny winter. The doctor who seemed very knowledgable about the whole illness strongly advised me to take him to Hampstead to live, as it was the most noted health spot for asthmatics in England. I was so terrified by the utter absence of proper medical care, which was practically unobtainable until one reached Bournemouth, many miles away, that I felt we ought to move back to London and endeavour to get to Hampstead, which I realised was high up and right out of the London fog.

So we had at last to say goodbye to our beloved Dorset and the Purbeck Isle, and take train for London, weighed down with an enormous packing case of special shells and stones which Paul had found in the course of his wanderings on the Dorset shore. Some of these, such as *Objet trouvé*, *Burnt Offering*, have subsequently appeared in his paintings, and were shown as found objects in the Surrealist Exhibition of 1936. In fact his return to London in January of 1936 was synonymous with an invitation to join the Committee which launched the International Surrealist Exhibition at the New Burlington. We went up to stay in the Rosslyn Lodge Hotel in Lyndhurst Road, Hampstead, and began our search for a new home. [. . .]

Our move into No. 3, Eldon Grove, coincided with the Surrealist International Exhibition in the New Burlington Galleries, and since Paul was a member of the Committee we found ourselves presently entertaining André Breton and Paul Eluard, Salvador Dali, Max Ernst, and all the strange and varied promoters of the exhibition who came over from Paris for the period of the show. Before this actually opened, Paul had to have a very drastic treatment for asthma, which had been successfully tried on Robert Donat,[26] who highly recommended it to him and most generously paid for the treatment by buying a set of designs for the King Lear which Paul had carried out for *The Players Shakespeare*, published by Ernest Benn. At the same time Edward James[27] purchased the *Environment of Two Objects* and *Harbour and Room*, as well as four or five drawings, and this excellent financial start enabled us to meet the new adventure we had undertaken in Eldon Grove.

In fact everything looked promising, excepting that the treatment, which consisted of being shut up in a room all night with a frightening machine which poured out a kind of inhalation of vapourized tar, did Paul very little good, and wore me out, since I had to constantly visit him during the night to make sure that he had not passed out with asphyxiation, as the room had to be hermetically sealed so that he could inhale the vapour to its full strength. After this somewhat surrealist adventure which lasted six weeks, Paul returned to a normal bedroom and I was able to have a full night's rest, rather shattered by the strain of the treatment.

The exhibition with Nan Kivell[28] which took place in 1937 in the Redfern Gallery, was also very successful financially, and life began to look much brighter and more hopeful, as the Hampstead air certainly revived Paul

considerably, and he poured out paintings and water colours, a selection of which were shown in his 1938 exhibition in the Leicester Galleries. André Breton was particularly sympathetic to his work and claimed him as an original contributor to the Surrealist Movement, since he maintained that his pictures showed not only a dream-like quality at this period, but were impregnated with a very strong poetic vision. He was particularly impressed by *Landscape from a Dream*, now in the possession of the Tate, and Paul felt, for the first time, the warmth of real interest in his painting and of sound critical appreciation of his point of view from a man distinguished in the world of art. Paul valued and respected this appreciation and it gave him more courage to pursue his experiments in the field of Surrealism, or, as he preferred to call it, in the sphere of imaginative painting. The life at Eldon Grove was delightful if only it could have continued, but already in March of 1939 I, at least, could feel the shadow of war, and began to make preparations for an early removal from our beloved house.

10 1939–1946

The opening months of 1939 found Paul very exhausted after the effort of holding his important exhibition of 1938 at the Leicester Galleries. He had been working intensively from the beginning of 1937 since the International Surrealist Exhibition took up a good deal of both our time with entertaining our foreign guests; and he also served on various committees of art societies, and became visitor to the Royal College of Art, which meant fortnightly visits to the College for the purpose of criticism. He contributed an important group of 27 water-colours and paintings to the 21st Biennale Exhibition at Venice in 1938, to which he was invited but had to refuse. He also held important exhibitions in 1939 at Messrs. Arthur Tooth & Sons and at the British pavilion, New York World Fair. All these activities went on alongside his regular output, and he now devoted a certain number of hours daily to the writing of his autobiography under the title of *Genius Loci,* having signed a contract with Cobden-Sanderson in 1938. He used to write every morning from about half past six to nine o' clock when his breakfast was served. He found the uninterrupted early hours an aid to the imaginative process of re-creating the past. It has always struck me that this quality of contemplation and detached selection had made the story vivid, dramatic, and convincingly alive. [. . .]

About March of 1939 it became necessary for Paul to undertake further treatment, and we consulted our dear old general practitioner, Dr Haskins, who had been a pillar of strength ever since we settled at Eldon Grove, as to what further medical help could be given to him. He was an excellent old doctor, [. . .] shrewd enough to know that Paul would never stop working, since to stop painting was for him practically to stop living. So he suggested a short stay at a curious Nursing Home, which I think was in

Kent or Surrey, and which was under the direction of a religious community called The Seventh Day Adventists. [. . .]

When we returned to London Dr Haskins' next step was to have him examined by the well-known specialist at Guy's Hospital, who was an expert on allergy, This examination revealed the fact that Paul was allergic to dust, but fortunately not to pollen or to any special kind of food, or indeed to any of the ordinary allergies which bother the truly asthmatic patient. The allergy to dust was extremely difficult to cope with since it necessitated repeated inoculations and apparently that particular treatment was not at all certain as to results.

While all this was going on Paul continued his ordinary work and gradually we both became convinced that it was best to face the possibility of war in the near future. I do not know what particular sense convinced me that war was coming by the autumn, since most people stoutly denied the possibility of immediate war with Germany, but I was so convinced of its approach that I persuaded Paul to allow me to remove most of the furniture and all the most important books and indeed pictures, from Eldon Grove and store them in Pickford's Depository at Oxford. Our dear house was gutted, all but two rooms and the kitchen, by March 1939. The examinations connected with the Guy's Hospital specialist took place during the end of May and June, and by the middle of August we went down to stay at the Randolph Hotel at Oxford, and prepared to find ourselves a new home.

Our stay at Oxford was delightful, for there was just a moment of peace and leisure before the final blow, and we began to make friends and wander about the lovely college gardens, and it helped to reconcile us to losing our beautiful house. We were at the Randolph Hotel when war broke out, and I must confess that it was no surprise to either of us, although Paul was horror-struck to think that this poor country had to face another gigantic struggle for its life. [. . .] And he said to me, 'I wonder whether this lovely Island will now go down for ever, although it seems impossible to believe that England can be defeated?'

I had to make instant arrangements for the final closing of the house, and so I went to Pickford's manager and handed the keys of the house to his charming foreman, who took up the last two vans which were able to go to London, and with the help of our beloved housekeeper, Mrs Earl, who slept at the house until it was emptied, packed up our remaining possessions and brought them down to the store. And so that phase of

our life ended. We never lived in London again, only visited London, and the whole of that happy, prosperous life which had lain before us between 1936 and September 1939 abruptly ended. I do not think that either of us wasted any time on regrets, for we had too many problems to solve; the paramount one being to find a suitable place in which to live where Paul could work, in Oxford.

The next year has always seemed to me to be a year of miracles, for neither of us could see how we were going to secure accommodation in a city which had become an evacuation centre, also the centre for nearly all the important Government offices, and the Mecca, apparently, of all fleeing Jews – German, Polish, Russian or Austrian, who managed to reach the shores of this country. Paul was never a person to waste time on apprehension; he always acted quickly in a crisis.

He was very much better in Oxford, as the slightly humid climate helped to keep the atmosphere clear of the particularly irritating dust, and I imagine the injections did help him as he seemed really to practically lose the insistent asthma attacks. It soon became evident, however, that we were in for a formidable struggle, and as the news worsened every day Paul became absolutely overwhelmed with distress of mind and a natural worry about our financial position. Although I had a certain amount of capital of my own, he never forgot the appalling difficulties we had been up against during and after the first world war, and naturally, realizing how unable he was to take on any kind of ordinary work, especially anything which involved a strain upon him physically, he began to speculate how we could live through another war cataclysm. I must confess that I am one of those people who do not worry about the future, as throughout my life I have always found that the problem of how to live is more or less solved for me by a strange kind of protection, or is it by my real faith in such protection? The real physical distress from which Paul had suffered for the last three years, had to a certain degree unnerved him, and I confess that he went through a very bad time after the declaration of war in September, so that I encouraged him to try and do something which would be of active use to his fellow artists, and would make him feel that he was contributing his share towards the fighting. Out of this tension and anxiety quickly grew the idea of the Arts Bureau at Oxford, which he started with the help of a charming young man called Maurice Cardiff.[29] Maurice and his dear little wife Leonora were newly married and they had come down to stay at Oxford, also at the Randolph, where we met them shortly after our arrival

in August. [. . .] They joined us and we all moved into rooms in Beaumont Street as the Randolph Hotel had been commandeered for army officers and Government officials.

In Beaumont Street was started the beginnings of the Arts Bureau, the object of which was to find suitable employment for artists, designers, etc., and so save them from being wasted by the army authorities, and being merely used as cannon fodder. The scheme was immediately backed in Oxford by the Vice-Chancellor, Professor G.S. Gordon, and by the Head of Chatham House, and some important people in the University and in the town. The scheme was to provide a list and information about important artists in the country of military age, and give the War Office, Admiralty, and other Ministry Departments, an idea of what they could undertake to do as artists in support of the war effort. [. . .]

About October of '39 we decided that it was wise to get a house, as even rooms were unsafe if requisitioning became general in the town. We were scheduled as an evacuation area and very soon Oxford was made a subsidiary capital in case of extensive bombing, which would cripple the activities of the various Government Departments in Whitehall. This dispersal of Government Departments resulted in Oxford receiving a very big share of them, and it soon became crowded with people, so that we only just found a furnished house in time at No. 62, Holywell Street, and there we were joined by Maurice Cardiff and his wife. The winter of '39 to '40 was very trying to Paul, as it was an extremely wet and rather unhealthy one in Oxford, but he was so interested in the activities of the Arts Bureau that he was more or less carried over the wearing period before he was himself invited to become official artist to the Air Force, which happened early in 1940. [. . .]

Paul's work for the R.A.F. started somewhere about February to March 1940, and he began to collect his material by visiting the nearby aerodromes such as Abingdon and Harwell, and by interviewing some of the prominent bomber pilots who were able to give him vivid descriptions of the air fighting in which they had been engaged. This preliminary gathering of material gave him a kind of new fillip for his work and gradually he evolved his personal attitude as an artist to the war in the air. In his various essays such as *Personality of Planes,* and in his final essay called *Aerial Flowers* by Counterpoint Press, he explains how he felt that the aerial warfare was a matter of the machine versus the man, almost as if the machine took charge of men, so that man became its servant and its guardian at

one and the same time. This attitude of his was quite misunderstood by the particular officers in the Air Ministry who had to deal with him as their artist, since they were really interested in the individual pilots and their achievements, and quite missed the imaginative approach he made to the warfare in the air. It was not surprising that they proved unsympathetic and, in fact, were rather shocked at his unsporting presentation of the German planes on the ground, such as he made in his series called *Fighting Against Germany*, which contains such water-colours as *Bomber on the Moor*, *Bomber in the Wood* and *Bomber on the Shore*.

As the obvious indifference of the Air Ministry to his work damped Paul's enthusiasm while working for them, he looked around to find any other body of people with whom he could get into touch who would give him more encouragement and be more prepared to show his pictures in the right manner. This quickly brought him into contact with Sir Kenneth Clark's new Committee called The War Artists Advisory Committee, of which Sir Kenneth Clark was the Chairman, and which gave special advice to the Ministry of Information upon the artists they should employ for purposes of psychological warfare and propaganda. So after about six or seven months his connection with the Air Ministry ceased and he was commissioned by the War [Artists] Advisory Committee on behalf of the Ministry of Information, to paint a series of three large canvasses. He also presented them with the small canvas *Totes Meer* which he had been completing for the Air Ministry, but which he felt would be very much better appreciated by the War [Artists] Advisory Committee. This they purchased immediately, and he then began on his series of important canvasses, namely – *Battle of Britain, Defence of Albion, Battle of Germany.* [. . .]

It was while he was working for the Air Ministry that they granted him a special room in their establishment in Woburn Place, as he needed a studio when he visited London. So we used to stay at the Russell Hotel and he did spend a certain amount of time working in this studio, but did not find the arrangement very satisfactory, as London raids proved a bad accompaniment to intensive mental concentration. Fortunately I managed in April 1940 to find our flat at 106, Banbury Road, Oxford, while Paul was having a small but necessary operation on his sinus in the Nuffield section of the London Hospital. [. . .] While Paul was in hospital I had, on an impulse, rung up one of the local agents at above five minutes to six in the evening and asked them if they could find me an empty flat consisting of three rooms, with a garden and, if possible, garage for storage, situated

not too far from the centre of the City and preferably in North Oxford. The agent remarked that this was almost an impossible thing to find, and again, on an impulse, I said, 'Look in your letter-box.' He took out one letter which had been overlooked, in which was contained the advertisement for the flat at 106, Banbury Road. He was so thunderstruck by this almost psychic manifestation, that he gave me the address at once, and I took the flat within an hour, thankful to have found a large enough room in which Paul could carry out his new commission for the WAAC. We had to do some preliminary redecoration, so we did not move in until after Dunkirk, and almost the first words I heard on the wireless in the sitting-room was Churchill's appeal to France to join us in the fight, and his declaration that we, rather than surrender, would fight on the beaches, fight in the air and fight in the streets of London, but would never surrender.

During the period of the Battle of Britain, our flat was always being visited by pilots who had been taking part in it, and Paul made a number of personal visits to the nearby aerodromes such as Abingdon, Harwell, etc, and we did make one wonderful visit over to Dover, as he wished to see the Spitfires actually fighting over the channel. All these excursions and also a certain number of journeys to London in order to consult the very extensive photographic records of the Air Ministry, were directed towards the production of his first big painting *Battle of Britain*, followed by the *Defence of Albion*, as well as in the carrying out of a very considerable number of water colours. Alongside his war pictures there poured out a number of his finest civilian pictures. They show an increasing freedom of technique and a poetry in conception which seemed released in him by the great efforts of the war and his passionate interest in the exploits of the heroic airmen whose personal visits inspired him to work so passionately for them.

We were from time to time is London during some of the severe bombing, but fortunately the Russell Hotel, where we always stayed, was never actually hit and the whole courageous atmosphere one experienced in London at that time proved a tremendous stimulus to Paul in his work, making him feel in spite of his illness, he was still in close touch with life and the adventure of life.

It was very pleasant living in Oxford, and our particular friends, Roy Harrod and his wife, brought us into contact with a number of interesting people in the University; also Paul was made a member of High Table at Christ Church. Although he was not sufficiently well to be able to

stand any extensive social life he did meet extremely interesting and stim-
ulating people and found himself in a very sympathetic mental atmos-
phere, in spite of the war and its trying conditions. He became friends
with Lord David Cecil, for example, and he got to know John Betjeman
rather better, although he had met him previous to the war. He also met
Lord Cherwell on several occasions, and Professor Gilbert Murray, and
eventually we went to stay from time to time on Boars Hill with our
charming friend Mrs Hilda Harrison, whose house had from its windows
a magnificent view of the Wittenham Clumps and the beautiful country
which lay between them and Oxford; a view which began to appear in
his pictures, such as the *Vernal Equinox, Summer Solstice, Michaelmas
Landscape, November Moon,* and other well-known paintings of this later
period. In Hilda Harrison I found a charming friend, who was always
most sympathetic to Paul and only too delighted to have him staying in
her house. She was also a very sensible friend who was able to look after
him, so that I could occasionally leave him there when I had to go to
London to carry out some business for him. He also became interested
in a particular kind of remedial treatment being given by Mrs Freeman at
the Head Injuries Hospital, which was near to us in St Margaret's Road.
He would go down there sometimes to talk to the injured men, to whom
she was teaching drawing and painting, about their work and about the
whole business of art, and I believe that he was able to give them very
special help at this time, since he always had healing atmosphere and
was quite wonderful when he came into contact with people suffering
either mentally or physically. I think it was Paul's complete absorption in
this vision of beauty which was always before him, and in this conscious
relationship with creation which grew stronger and stranger within him
as he became older, that enabled him to detach himself from sickness,
petty worries, and the ordinary sordid things of life which usually absorb
our minds and seem to overwhelm our vision of that other world of the
spirit. The fact that he had to constantly discipline himself in the face of
his own permanent and distressing illness, enabled him during these later
years, to appear almost unconscious of it. It is remarkable that he never
spoke about it, and that he was always able to put it aside and think of
that lovely creative world which was constantly developing in his mind,
and this indifference to what after all are only really minor details in life,
made him a wonderful companion during the period when people were
shattered by the small things of life, such as discomfort, anxiety of every

kind about their relatives, frequently needless anxiety, and even the discomfort of the lack of proper food.

The progress of the war with its violent, dramatic events such as the air-raids on London, the terror raid on Coventry, the thrilling story of the North African campaign, and the battle of El Alamein, and all the various heroic deeds whose Elizabethan atmosphere appealed to the poetic imagination, produced in Paul an astonishing mental vitality and a clarity of vision which enabled him to work unceasing in producing a series of extremely important paintings right up to the end of 1945 within a few weeks of his last illness. It seemed to me that his failing bodily strength was no longer able to chain his spirit, and gradually the spirit rose out of the hampering material surroundings and became strong and free and happy. For I am thankful to say that almost his last words to me on the evening before he died in the early hours of the morning, assured me that life had been good for him in the last few years, and that he had been able to extract what he needed from it to feed his imagination and to carry on the unceasing creation which had been his goal from boyhood.

The actual events of these last years from 1941 to July 11th 1946 are not very significant, and curiously enough although they are so close to me in matter of time, they do not come to my memory so easily as the happenings of the first war and the uneasy period of peace which followed it. Paul was now more complete both as a man and as an artist, and there gradually came to us a knowledge that he was nearing the end of this material life, but was not at the end of his personal existence. It seemed to me as if we lived in two worlds, a restricted, drab, cruel world of war, and the lovely other world which was quite clearly on the other side of life, in which he and I were quite free in our minds and able to enjoy and perceive more clearly than ever before an esoteric beauty in life, in matter, and in people. Certainly I entered that world through his mind, and whenever material circumstances such as my own tiredness, exhaustion and sometimes despair, seemed to invade me, he immediately lifted me out of it. It was as if these things could no longer touch him, as if he had felt the strength of the spirit dominating the body, and the wings of the spirit were like the wings of those aerial monsters he loved to draw, sufficiently powerful to carry him to the ends of the world.

1943 found us in London on our way to see his Retrospective Exhibition at Temple Newsam, Leeds, and from there we went on for a delightful holiday in Sheffield, to stay with his old pupil and devoted admirer Richard

Seddon.[30] [...] The Exhibition at Temple Newsam was an extremely successful one, but one thing slightly marred it, namely, the very inept and I might say frivolous commentary upon it by Philip Hendy in *Horizon*. I have never known Paul upset by art criticism until this moment, and it was because of the utter meaningless brutality of the criticism that he was temporarily wounded, and even aroused to anger.[31] It was a criticism which was quite unworthy of the Exhibition he had sent to Leeds, and it reflected the shallow, unintelligent nature of Philip Hendy's mind.

At the beginning of the war Paul had paid some delightful visits to Mr & Mrs Charles Neilson's home at Newent in Gloucestershire, visits which enabled him, with Mrs Neilson's help, to see the Forest of Dean and some of the scenery of the Wye Valley, as well as the Severn Bore, which is a wonderful sight viewed from a point below Gloucester. The other visits he was able to pay into the country were mainly to Cheltenham, where our dear friend Lady Agnew, who lived near us in Oxford, recommended us to a restful hotel called 'The Rising Sun' on Cleeve Hill outside Cheltenham. We stayed there from December to the end of January of 1944, and again visited the hotel in the summer of 1944 when a Retrospective Show was held with the help of Mr Herdman, Head of the Cheltenham Public Library and Art Gallery. There were most interesting guests staying in the hotel, and as it was perched on Cleeve Hill, with Richmond Hill lying to the right of it and the full extent of the plain in which gleamed the towers of Tewkesbury Abbey, with the blue black line of the Welsh hills in the distance, Paul was able to enjoy this magnificent scenery and paint from the windows of the sittingroom or his very large bedroom, without too much exertion. The series of *Sunrise* and *Sunset* water colours, as well as many other landscapes of the plain, form a wonderful record of these holidays and should be seen in a single exhibition together, in order to realise their range and power of expression.

He was certainly never very well on Cleeve Hill, as it was there that he first manifested the disturbing symptoms of heart strain, which drove me to taking him to Lord Horder in the early part of 1945. In June of 1945 he visited Lord Horder, who prescribed a complete rest, preferably in a Nursing Home, as he considered that it was impossible for Paul to stop working if he lived in his studio. Paul insisted that he must finish two important paintings which are *Eclipse of the Sunflower* and *Solstice of the Sunflower*, and which were to form a series of four paintings on that subject. So he did not retire to the Acland Home until November 1945, and

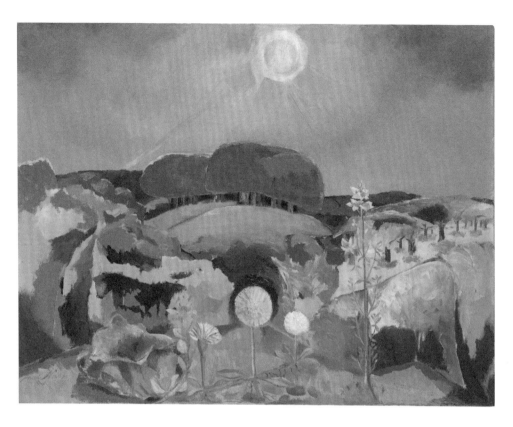

Paul Nash, *Landscape of the Summer Solstice*, 1943, oil on canvas,
National Gallery of Victoria, Melbourne

he remained there for the first time completely resting and not working until a week before Christmas, when he returned to Banbury Road, where we stayed for Christmas.

Even this rest was broken by a certain amount of worry, as his step-mother, The Hon. Mrs Audrey Nash, was found dead in her bedroom in her home near Slough, having had a serious blood clot which moved to the brain. The poor old lady was nearly blind, was over 80, and it was a merciful release that she went so suddenly. [. . .]

We had acquired about April of 1945, a second floor flat at Banbury Road, as in view of Paul's failing strength I had a scheme of letting rooms to cover our rent and heavy expenses [. . .] I was immediately able to let one room in the flat to relations of Mrs Powell who lived on the top floor, and we had a feeling of expansion from the ground floor flat when we were able to move into the upper rooms and use the big room over the studio as Paul's bedroom, while I slept next door to him in a smaller room. This move greatly cheered him and he was full of hope that he would soon recover from the condition of strain.

Unfortunately 1946 proved our fateful year, and Paul had only seen three weeks of it when he became dangerously ill with pneumonia. The illness was very widespread in Oxford, and had been brought over from Germany by the troops stationed there, and Paul caught an infection in some way which can never be explained. I still had the backing of a certain amount of capital since we had sold our lovely Hampstead house at the beginning of 1944, a few days before the flying bomb attack on London. This enabled me to meet this severe illness with a certain amount of financial backing which proved an immense blessing, since it continued for ten weeks while Paul fought death with his usual heroism and calm determination.

He had so much to do, so much which interested him in life, so many new aspects were appearing to him in connection with his research and paintings, and he was now beginning to write more frequently, so that life was very sweet to him in spite of the appalling toll his thirteen years of illness had taken of his vigorous body. He made a miraculous recovery and by April we left Banbury Road to stay in some rooms in Parks Road belonging to two sympathetic and charming Scotch ladies, who had University lodgings and took in outsiders during the vacation. I noticed that Paul's heart was very bad, his breathing obviously impeded by a tre-mendous heart strain, which was not to be wondered at considering that he had had nearly ten weeks of M & B treatment[32] as well as the strain of

a very high temperature; but he was able to walk about quietly and to feel a returning strength which was quite astonishing.

After this short rest we returned to Banbury Road and his doctor urged me to take him down to the sea for a change of air. So we set out at the end of June for an hotel at Boscombe near Bournemouth, also near Christchurch Priory, which in the past had been restored with the help of his uncle, The Reverand Zacharias Nash, who was Vicar of Christchurch. Paul was very thrilled at the idea of staying at Boscombe, which was close to the Shelley family seat, and indeed our hotel was actually built on the land which had at one time belonged to the Shelley estate.[33] After we arrived there he insisted on going out daily in a comfortable car, and we drove over to Christchurch Priory and round the remains of the Shelley estate, and once we managed to drive over to Corfe to see some friends who lived nearby at Warring. So we managed to visit his beloved Dorset coast and see Swanage once more and the heights of Worth Matravers; but we never got over to Scarbank, Archie Russell's beautiful home, perched above Swanage, because Paul was dead by the early hours of the morning of the day we should have lunched with Archie.

He had been working on the delightful balcony overlooking the Channel and the Isle of Wight in the distance, and I have that last water colour, unfinished, but full of vitality and charm, and he lay down his brush that evening and wrote a letter to his brother, and then went to bed and fell asleep and never awoke. The doctor who was brought in at half past eight in the morning turned to me after he had examined him and said, 'Please don't distress yourself, this is how good men die; and I would say that your husband was a very good man, for he has fallen asleep like a child, and he must have had the heart of a child.'

Those words comforted me more than anything that has ever been said to me about Paul, as they were spoken by a man who judged him without knowing him, from the evidence that lay before him of his personality and his character.

I was alone at the hotel when this all occurred and Archie Russell came over to lunch with me, as I had telephoned the news to him, and helped me over the arrangements for his removal to the mortuary chapel of the dear old undertaker, who gave his own coffin so that Paul should have a beautiful seasoned wood for his burial. After some trouble with the Coronor, his body was brought to Langley Church, where he was buried a few days after, the service being attended by his personal friends and

relations in the old Church in which he used to sing in the choir when he was a little boy. In the graves nearby are buried his grandfather and grandmother, many of his uncles and aunts, and his own grave lies at the foot of his father's grave.

MARGARET NASH.

Notes

INTRODUCTION

1. Margaret Nash, 'Memoirs of Paul Nash, 1913–1946,' Tate Gallery Archive MS769.2.6 and pp 84 and 246 in this publication.

2. Ben Nicholson (1894–1982); Stanley Spencer (1891–1959); Mark Gertler (1891–1939); C.R.W. Nevinson (1889–1946); David Bomberg (1890–1957); Dora Carrington (1893–1932); Gordon Craig (1872–1966).

3. Nash, *Outline, An Autobiography and Other Writings*, Faber and Faber, London, 1939. All citations in *Outline* are quoted from the reproduction included in this present volume. For this quotation see p.43.

4. Dion Clayton Calthrop (1878–1937), *My Own Trumpet: Being the Story of My Life*, Hutchinson & Co., London, 1935, p.64.

5. M. Nash, 'Memoirs of Paul Nash', TGA MS 769.2.6, pp 44–5ff.

6. Nash, *Outline*, p.23.

7. John Rothenstein, *Modern English Painters: Sickert to Moore*, Eyre and Spottiswoode, London, 1957, p.340.

8. Nash, *Outline*, p.139.

9. Nash, *Outline*, pp 25 and 45.

10. Caroline Maude Nash, death certificate, West St Pancras, London, February 1910.

11. Rothenstein, *Modern English Painters*, pp 343–4.

12. Paul Nash, *Dorset: Shell Guide*, Faber and Faber, London, 1936; *Places: 7 Prints Reproduced from Woodblocks Designed and Engraved by Paul Nash, with Illustrations in Prose*, W. Heinemann Ltd, London, 1922.

13. Andrew Causey (ed.), *Paul Nash: Outline*, Columbus Books, London, 1988, p.ii.

14. Paul Nash to Gordon Bottomley, in Claude C. Abbott and Anthony Bertram, *Poet and Painter: Being the Correspondence between Gordon Bottomley and Paul Nash, 1910-1946*, Oxford University Press, London, 1955, p.219.

15. Nash, *Outline*, p.110.

16. The Reverend Naser Odeh, obituary, *The Times*, 12 August 1932.

17. Margaret's obituary gives her college as St Hugh's, but this is incorrect. *The Times*, 6 October 1960.

18. Lance Sieveking, *The Eye of the Beholder*, Hulton Press, London, 1957, pp 50, 54–5.

19. *The Times*, obituary, 6 October 1960.

20. *Ibid*.

OUTLINE

LEARNING

1. James Grey Jackson, *An Account of the Empire of Marocco, and the District of Suse: Compiled from Miscellaneous Observations Made During a Long Residence In, and Various Journeys Through, Those Countries. To which is Added an Account of Timbuctoo, the Great Emporium of Central Africa*, London, 1809, printed for the author by W. Bulmer and Co.

2. Benjamin Disraeli (1804–81), 1st Earl of Beaconsfield and twice Prime Minister of Great Britain.

3. Established in 1884, from 1891 to 1968 Colet Court was situated on Hammersmith Road. In its early years the school was known simply as Bewsher's, after its founder and first Headmaster, Samuel Bewsher. In 1884 St Paul's School had relocated from central London to new buildings (since demolished) in Hammersmith, designed by Alfred Waterhouse.

4. The future actor Donald Ernest Clayton Calthrop (1888–1940), whose roles would include Bob Cratchit in the 1935 film, *Scrooge*.

5. Frederick William Walker (1830–1910), High Master of St Paul's School, 1877–1905. Nash left St Paul's for Greenwich in April 1903, and was readmitted in September 1904.

6. In fact Walker retired in 1905, the year following Nash's return; he did not die until 1910.

7. The artist Eric Kennington (1888–1960).

OPENINGS

1. Stanley J. Weyman (1855–1928): hugely popular in his lifetime for historical romance novels such as *Under the Red Robe* (1894), Weyman had initially studied for the bar, where he may have met Nash's father.

2. Smith's authors included Sir Arthur Conan Doyle.

3. Samuel Johnson (1709–84), the author and lexicographer, lived at Bolt Court from 1776 until his death.

4. Dante Gabriel Rossetti (1828–82), English painter and poet who helped found the

Pre-Raphaelite Brotherhood, a group of painters who treated religious and moral subjects in a non-academic manner. Rossetti's work always closely intertwined poetry and imagery.

5. Sir William Rothenstein (1872–1945), artist, and keen supporter of the younger generation. Gordon Craig, influential theatre director, designer and wood engraver.

6. Robert Calverly Trevelyan (1872–1951), classical scholar and poet, father of the artist Julian Trevelyan. The Shiffolds was Trevelyan's home near Leith Hill, Surrey.

7. British-born artists Charles Conder (1868–1909); Augustus John (1878–1961); Philip Wilson Steer (1860–1942).

8. Charles Elkin Matthews (1851–1921), publisher who, with John Lane from 1894, published Aubrey Beardsley's infamous periodical, *The Yellow Book*, and who went on to publish W.B. Yeats, James Joyce and Ezra Pound, among others.

9. The work referred to here is probably *Vision at Evening* (1911), now in the Victoria and Albert Museum.

10. Henry Tonks (1862–1937), painter and draughtsman, drawing master at the Slade, 1892–1918, and subsequently Slade Prefessor, 1918–1930.

11. Eleanor Love Slingsby Bethell was the daughter of Lord Westbury's second son, and thus a niece of Nash's aunt, Augusta Nash, née Bethell.

12. Fry, who was then lecturing at the Slade on Renaissance art, curated the exhibition 'Manet and the Post-Impressionists' at the Grafton Galleries in November 1910. As well as works by Manet it included paintings by Gaugin, van Gogh, Picasso, Matisse and other continental avant garde artists. A second Post-Impressionist exhibition of British, French and Russian artists followed in October 1912, after Nash had left the Slade.

13. The Hon. Mrs Audrey Handcock (not Hancock) (b.1861), Nash's future step-mother. She was the eldest daughter of the diplomat Charles Abbott, 3rd baron Tenterden, and widow of Major Robert Gordon Handcock (d.1906) of the Indian Army; in July 1915 she and Nash's father married. See *Kelly's Handbook to the Titled, Landed and Official Classes for 1909*, Kelly's Directories, London, 1909; Abbott and Bertram, *Poet and Painter*, 1955, pp 40, 41.

14. The lines are from 'The Departure,' by the English poet Coventry Patmore (1823–96).

15. Rupert Lee (1887–1959), painter and sculptor.

BEGINNINGS

1. William Holman Hunt (1829–1910), *The Hireling Shepherd* (1851), Manchester City Galleries.

2. John Constable (1776–1837), who grew up in Suffolk but went to school nearby in Dedham, Essex.

3. Conrad Noel (1869–1942), known as the 'Red Vicar of Thaxted' on account of his radical political views.

4. Charles Masterman (1873–1927), Liberal politician and MP, later head of the War Propaganda Bureau, see p.185.

5. The visit was to Sinodun House, near Wallingford, home of Nash's great-uncle, Alfred Wells (not Welles).

6. The Prix de Rome was a scholarship offering art students in various disciplines the opportunity to live and study at the British School in Rome.

7. Robert Gibbings (1889–1958), Irish artist and author.

END OF A WORLD

1. John Cournos (1881–1966), a Russian-Jewish writer, translator and Imagist poet.

LETTERS

1. For the best recent account of the British and Canadian war art programmes, see Sue Malvern, *Modern Art, Britain and the Great War*, Yale University Press, New Haven and London, 2004.

2. The War Diary of the 15th Battalion, Hampshire Regiment, is in the National Archives, Kew, reference WO 95/2634/5. Though Nash clearly served with the Battalion, among all the recorded comings and goings of junior officers his name does not appear anywhere in it.

3. TGA 8313/1/1/134.

4. Noel Carrington (1895–1989), younger brother of Nash's friend, the artist Dora Carrington.

5. TGA 8313/1/1/135.

6. TGA 8313/1/1/137.

7. TGA 8313/1/1/138.

8. TGA 8313/1/1/139.

9. This is probably the dogfight mentioned in the Battalion War Diary on 10 March 1917: 'Three of our own and one of the enemy's aeroplanes was visible, in which two of our machines were brought down, the third one escaping.' National Archives, WO 95/2634/5.

10. Nash worked briefly for Fry at the Omega Workshop in Bloomsbury before the outbreak of the war.

11. TGA 8313/1/1/141.

12. TGA 8313/1/1/140.

13. Nash is probably referring to an incident of 'friendly fire' mentioned in the

Battalion War Diary on 28 March 1917, when during German 'Trench Mortar Activity' in the morning and afternoon the battalion suffered five casualties (one fatal), 'three of which were caused by one of our shells falling short'. National Archives, WO 95/2634/5.

14. TGA 8313/1/1/143.

15. A column about daily life on the home front written by Olivia Maitland-Davidson and illustrated by Annie Fish, it appeared weekly in *The Tatler*.

16. TGA 8313/1/1/144.

17. TGA 8313/1/1/145.

18. Unfortunately it has not been possible to identify Nash's friend Billie, but clearly he was a recent casualty of the war.

19. TGA 8313/1/1/145: this letter mistakenly has the same catalogue reference as the previous letter of the 2 May. The end appears to be missing from the TGA; Margaret Nash dated it 12 May 1917, but as Nash states it was written on a Sunday, which was the 13th.

20. These lines are from the revised ending to the 1856 edition of 'Maud' by Alfred Tennyson (1809–92): 'It is better to fight for the good, than to rail at the ill; / I have felt with my native land, I am one with my kind. / I embrace the purpose of God, and the doom assign'd.'

21. TGA 8313/1/1/136.

22. A letter dated 20 May 1917, signed by Lt Col Cary-Barnard, 15th Hampshire Battalion, states that Nash's drawings are 'of no importance from a military point of view': TGA 8313/1/1/146.

23. Margaret Nash kept *The Pool, Ypres*, for the rest of her life, and bequeathed it to the Victoria and Albert Museum (V&A Museum No. P.23-1960).

24. The Goupil Gallery, 5 Regent Street, London, managed by William Marchant (1868–1925).

25. Nash had met the writer Edward Thomas early in the war, when they were serving with the Artists' Rifles. Thomas was killed in action on the Western Front on 9 April 1917, a month after this letter was written.

26. TGA 8313/1/1/148: sections of the original letter appear to be missing from the TGA, and parts are therefore reproduced only from the 1949 edition of *Outline*.

27. A comic character in John Vanbrugh's 1697 play, *The Relapse*.

28. TGA 8313/1/1/160.

29. TGA 8313/1/1/161.

30. Paul's brother, John Nash (1893–1977), then serving at the front as a sergeant in the Artists' Rifles.

31. TGA 8313/1/1/162.

32. The battle of Messines, 7–14 June 1917, in which the British Second Army

recaptured the Messines-Wytschaete Ridge.

33. Neville Bulwer-Lytton (1879–1951), 3rd Earl of Lytton, army officer, war correspondent and artist.

MEMOIRS OF PAUL NASH

1. Editor's Note: The original 'Memoir' is fractionally over 40,000 words in length, of which 23,000 words are reproduced here. I have only removed material that is digressive, repetitive or not strictly relevant to Paul Nash's life. All cuts made in the text are marked thus [. . .]. It is to be hoped that in due course the entire memoir will be made available online by the Tate Gallery Archive.

2. Margaret's flat was at 176 Queen Alexandra Mansions, Judd Street, St Pancras. The Nashes owned it till 1936, and the building is now marked with an English Heritage blue plaque.

3. The author and poet Edward Thomas (1879-1917), referred to in Nash's war letters.

4. The orthopaedic specialist, Edgar Ferdinand Cyriax (1874–1955).

5. John Drinkwater (1882–1937), poet and playwright.

6. The noted physician Thomas Horder, 1st Baron Horder (1871–1955).

7. Wyndham Tryon (1883–1942), artist, had studied at the Slade, 1906-11.

8. Tamara Karsavina (1885–1978), the Russian ballerina.

9. Claud Lovat Fraser (1890–1921), artist and writer.

10. Albert Rutherston (1881–1954), artist, younger brother of William Rothenstein.

11. The Italian artist and proto-Surrealist, Giorgio de Chirico (1888–1978).

12. The collector and patron Sir Edward Marsh (1872–1953), mentioned in *Outline*.

13. The artist Edward Burra (1905–1976), particularly well known for his watercolours.

14. Conrad Aiken (1889–1973), wealthy American writer and friend of T. S. Eliot.

15. Una Vincenzo (1887–1963), Lady Troubridge, English sculptor and partner of the writer Radclyffe Hall, who also lived in Rye.

16. This refers to the *Studio at New House, Rye*, 1932, now in the Victoria and Albert Museum (V&A Museum No.8.18-1962).

17. Homer Saint-Gaudens (1880–1958), Director of the art museum of the Carnegie Institute and the driving force behind the annual international exhibition.

18. Anthony Bertram (1897–1978), British author and Nash's first biographer.

19. Charles Laughton (1899–1962), English film actor, screenwriter and director.

20. Alexander Keiller (1889-1955), Scottish archaeologist.

21. Robert Byron (1905–41), writer, author of *The Birth of Western Painting* (1930).

22. Francis Bruguière (1879–1945), American-born photographer who moved to

London 1927, where he collaborated with Lance Sieveking on the book *Beyond this Point* (1929).

23. The English artist Matthew Smith (1879–1959).

24. Dick Sheppard (1880–1937), Anglican priest, prominent pacifist and asthma sufferer; an old friend of Margaret's, he had taken the Nash's wedding service in 1914.

25. Archibald Russell (1879–1955), writer and art historian whose books included *The Letters of William Blake* (1906).

26. Robert Donat (1905–1958), English actor (and asthma sufferer) most famous for his leading role in Alfred Hitchcock's film, *The 39 Steps*.

27. Edward James (1907–84), poet and patron of the arts.

28. Rex Nan Kivell (1898–1977), New Zealand-born British art collector, and managing director of the Redfern Gallery, Cork Street, London.

29. Maurice Cardiff (1915–2006), writer, soldier and British Council officer.

30. Richard Seddon (1915–2002), artist and Director of Sheffield City Art Galleries.

31. Philip Hendy, 'Temple Newsam Exhibitions I – Paul Nash', in *Horizon*, June 1943, 413–17. Hendy (1900–1980) was then Director of Leeds City Art Gallery. Though there are a couple of references to the sometimes 'varying quality' in the span of Nash's artistic career, there is nothing apparent in it that seems to warrant Margaret Nash's accusation of 'meaningless brutality'.

32. The antibacterial drug sulphapyridine, known as M&B after its manufacturer, May and Baker Ltd; widely used in the late 1930s and '40s to treat pneumonia and other flu-like infections.

33. Percy Florence Shelley (1819–89), only surviving child of writers Percy and Mary Shelley, purchased Boscombe Manor in 1849.

Further Reading

Abbott, Claude Colleer, and Anthony Bertram (eds), *Poet and Painter: Letters between Gordon Bottomley and Paul Nash, 1910-1946*, Oxford University Press, London, 1955

Bertram, Anthony, *Paul Nash: The Portrait of an Artist*, Faber and Faber, London, 1955

Blythe, Ronald (ed.) *First Friends: Paul and Bunty, John and Christine – and Carrington*, Fleece Press, Huddersfield, 1997

Boulton, Janet (ed.), *Dear Mercia: Paul Nash Letters to Mercia Oakley, 1909-18*, Fleece Press, Wakefield, 1991

Cardinal, Roger, *The Landscape Vision of Paul Nash*, Reaktion, London, 1989

Causey, Andrew, *Paul Nash's Photographs: Document and Image*, Tate Gallery Publishing, London, 1973

Causey, Andrew, *Paul Nash: A Catalogue Raisonné*, The Clarendon Press, Oxford, 1980

Causey, Andrew (ed.), *Paul Nash: Writings on Art*, Oxford University Press, Oxford, 2000

Causey, Andrew, *Paul Nash: Landscape and the Life of Objects*, Lund Humphries, Farnham, 2013

Denton, Pennie, *Seaside Surrealism: Paul Nash in Swanage*, Peveril, Swanage, 2002

Haycock, David Boyd, *A Crisis of Brilliance: Five Young British Artists and the Great War*, Old Street Publishing, London, 2009

Haycock, David Boyd, *Paul Nash Watercolours, 1910-1946: Another Life, Another World*, Piano Nobile, London, 2014

Haycock, David Boyd, *Paul Nash*, Tate Publishing, London, 2016

Jenkins, David Fraser (ed.), *Paul Nash: The Elements*, Scala Publishers, London, 2010

King, James, *Interior Landscapes: A Life of Paul Nash*, Weidenfeld and Nicolson, London, 1987

Webb, Brian, and Peyton Skipwith, *Design: Paul Nash, John Nash*, Antique Collectors' Club, Woodbridge, 2006

Acknowledgements

I would like to thank Piano Nobile Gallery, London, Nick Higbee and various private collectors who wish to remain anonymous for their generous permission to reproduce works by Paul Nash from their collections; Matthew Bailey, Rights and Images Manager at the National Portrait Gallery, for his assistance in obtaining portraits of Paul and Margaret Nash; and Alice Murray at Christie's for kind permission to reproduce *Promenade* (page 205). Also for their input at various stages in my research I am grateful to Christopher Baines and Brian Webb; and lastly many thanks to Lucy Myers at Lund Humphries, for inviting me to undertake this very enjoyable project, and to Sarah Thorowgood for seeing it through production.

Index

Note: In a few instances names have been spelled incorrectly by Paul Nash in his text, which are reflected in the index. Numbers in *italics* indicate illustrations. The letter n following a page number indicates an endnote.